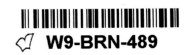

TIME
Great Discoveries

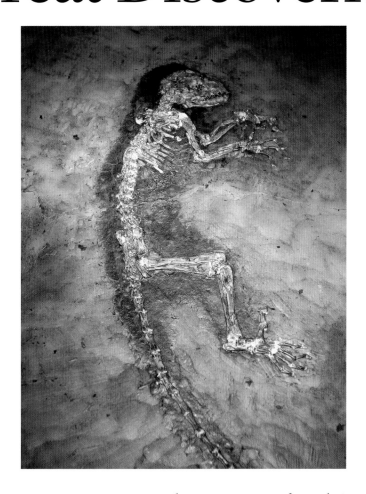

NEW PRIMATE *On May 19, 2009, scientists at the American Museum of Natural History in New York City unveiled the fossilized remains of a 47 million-year-old primate, which they declared was the most complete fossil of an early primate yet found. The specimen, designated* Darwinius masillae, *was found in Germany in 1983; it is a juvenile female about 3 ft. (1 m) long*

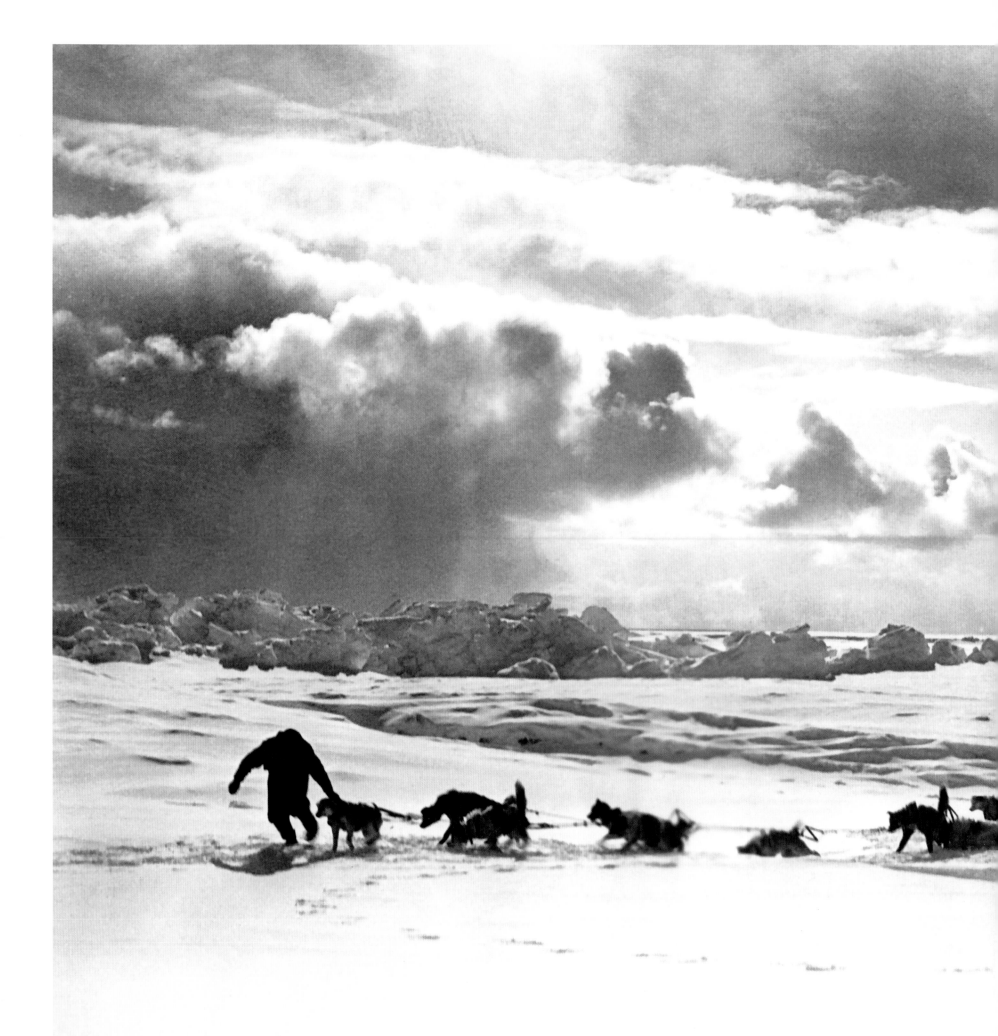

TIME

MANAGING EDITOR Richard Stengel
ART DIRECTOR Arthur Hochstein

Great Discoveries
Explorations That Changed History

EDITOR Kelly Knauer
DESIGNER Ellen Fanning
PICTURE EDITOR Patricia Cadley
RESEARCH/WRITING Matthew P. Wagner, Matthew McCann Fenton
COPY EDITOR Bruce Christopher Carr

TIME INC. HOME ENTERTAINMENT

PUBLISHER Richard Fraiman
GENERAL MANAGER Steven Sandonato
EXECUTIVE DIRECTOR, MARKETING SERVICES Carol Pittard
DIRECTOR, RETAIL & SPECIAL SALES Tom Mifsud
DIRECTOR, NEW PRODUCT DEVELOPMENT Peter Harper
ASSISTANT DIRECTOR, BOOKAZINE MARKETING Laura Adam
ASSISTANT PUBLISHING DIRECTOR, BRAND MARKETING Joy Butts
ASSOCIATE COUNSEL Helen Wan
BOOK PRODUCTION MANAGER Suzanne Janso
DESIGN & PREPRESS MANAGER Anne-Michelle Gallero
ASSOCIATE BRAND MANAGER Michela Wilde
ASSISTANT PREPRESS MANAGER Alex Voznesenskiy

SPECIAL THANKS TO:

Christine Austin, Glenn Buonocore, Jim Childs, Susan Chodakiewicz, Jacqueline Fitzgerald, Rasanah Goss, Lauren Hall, Jennifer Jacobs, Brynn Joyce, Robert Marasco, Amy Migliaccio, Brooke Reger, Ilene Schreider, Adriana Tierno, Sydney Webber

This book includes some material adapted from stories originally published in TIME's weekly edition. Writers include: Egypt: Andrea Dorfman, Jeffrey Kluger, Ishaan Tharoor. Vikings: Michael D. Lemonick, Andrea Dorfman. Jamestown: Richard Brookhiser, Andrea Dorfman, Michael D. Lemonick. H.M.S. *Victory:* Lisa Abend. Tectonics: Jeff Israely, earthquake; Bryan Walsh, tsunami. Lewis and Clark: Walter Kirn, Dierdre van Dyke. Polar exploration: John Skow. Chinese dinosaurs: Maryann Bird, Andrea Dorfman, Michael Lemonick. *Homo floresiensis:* Rory Callinan, Michael D. Lemonick, Bryan Walsh. Mars: Dan Cray, Michael D. Lemonick, Jeffrey Kluger. Kepler Telescope: Jeffrey Kluger.

ISBN 10: 1-60320-083-5
ISBN 13: 978-1-60320-083-7
Library of Congress Control Number: 2009926468
Printed in China

We welcome your comments and suggestions about TIME Books. Please write to us at:
TIME Books, Attention: Book Editors, P.O. Box 11016, Des Moines, IA 50336-1016.

To order any of our hardcover Collector's Edition books, please call us at 1-800-327-6388 (Monday through Friday, 7 a.m.— 8 p.m., or Saturday, 7 a.m.— 6 p.m., Central Time).

To enjoy TIME's coverage of scientific discoveries every day, visit: **Time.com**

BETTMANN CORBIS

SOUTH-BOUND *Men, dogs and sleds against the elements: this simple equation drove decades of polar heroics, including this 1930 expedition to the South Pole led by U.S. explorer Admiral Richard Byrd*

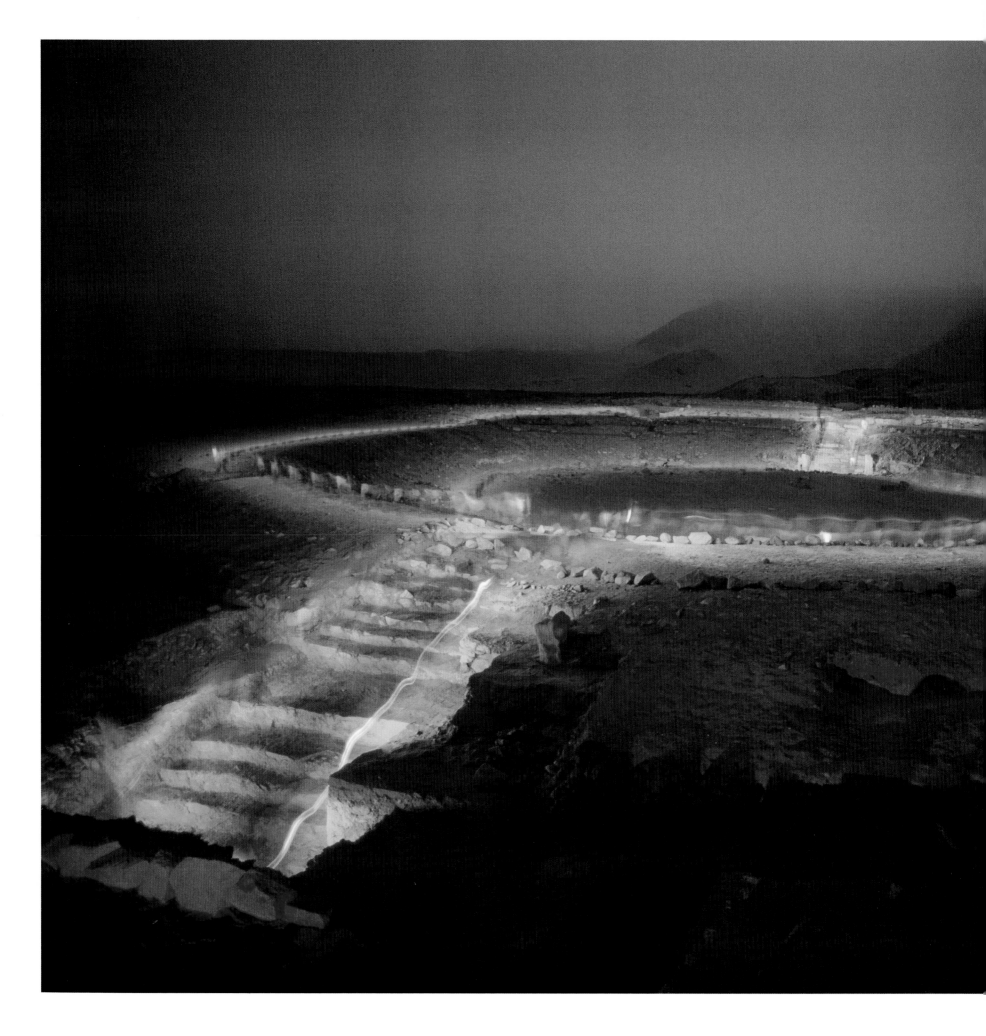

iv

TABLE OF CONTENTS

GATHERING PLACE *This amphitheater in Puerto Supe, Peru, was built by members of the Norte Chico civilization, the oldest known human culture in the Americas. The platform mounds at this coastal site are estimated to have been built between 2800 and 2600 B.C. The culture went into decline around 1800 B.C.*

THE SHOCK OF REVELATION

The book you are holding in your hands is already out of date, even if you bought it on the day it went on sale. At first blush, that statement may seem a poor sales pitch for the volume, but I think of it as a powerful testament to the urgency of its subject matter. The book is likely to be slightly dated because in today's world, the dynamic of discovery moves so quickly that one or another of the facts cited in these pages as accurate is very likely to have been superseded by new findings, or challenged by new arguments, in the weeks it took for the book to be printed after it left our hands.

Consider the female figurine at right. This evocative talisman of sexuality, carved from a mammoth tusk, has been dated to circa 33,000 B.C. It is now considered to be the earliest figurative sculpture ever found, and around the world, scientists are rewriting their accounts of the development of human culture to take note of the new artifact. Yet its existence was known to only a few researchers when our editorial team began working on this book, early in 2009; the figurine was discovered in Germany in September 2008 and was unveiled to the world in May 2009.

The same is true of the fossil of a very early primate, estimated to be 47 million years old, that is pictured on the first page of the book. This specimen was unearthed in 1983 and kept in private hands until its discovery was announced, also in May 2009. The researchers who examined it declared it to be one of the most important fossil finds in history.

That may or may not turn out to be true, but the debate over its significance should prove to be very stimulating for those who relish watching the scientific method in progress.

This book has been written for just such readers: those who love the shock of discovery, enjoy the clash of competing arguments, savor the ingenuity scientists bring to their work and delight in the way new facts and ideas can send lightning bolts of illumination shooting across the mind.

These pages are packed with such Eureka moments. Did you know that major solar storms can make the entire surface of the sun oscillate, in a phenomenon called a "starquake"? Did you know that the Yellowstone Caldera in America's West began percolating late in 2008, one indication that a volcanic eruption may be coming? Did you know that researchers in 2008 suggested that *Titanic* may have sunk primarily because its builders scrimped on costs and bought second-rate rivets? Did you know that scientists are still debating how to classify the miniature hominids, dubbed "hobbits," whose remains were found on an Indonesian island in 2003?

If you didn't know, you're about to find out. I can't predict which of the stories in this book will illuminate your mind with a jagged streak of wonder. But I am convinced that all of them are capable of doing so. So turn the page—and get 'em while they're hot.

—Kelly Knauer

PALEOLITHIC ART *This figurine was unearthed from the Hohle Fels Cave in Germany in 2008. Christened the "Venus of Hohle Fels," it has been dated to 33,000 B.C.*

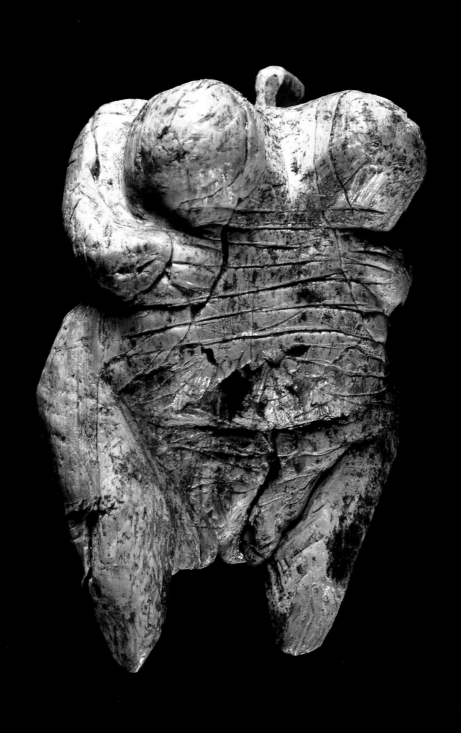

The Geography of Discovery
Sites featured in this book (polar regions distorted)

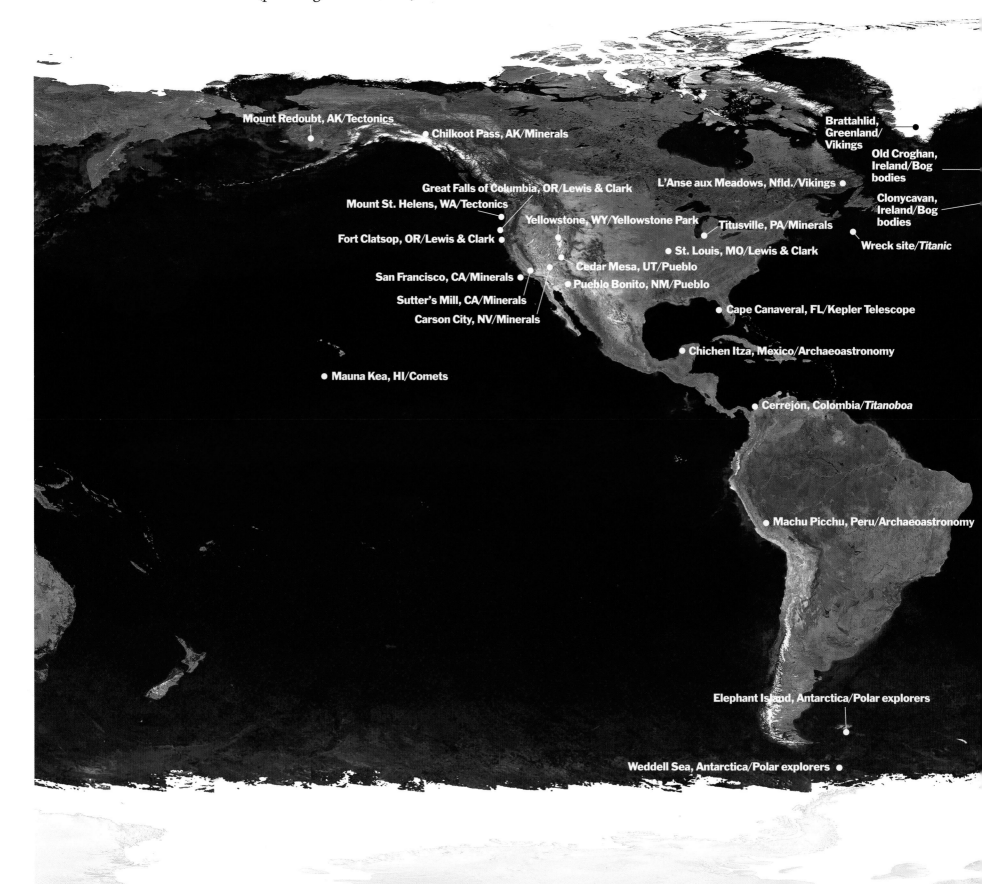

Mount Redoubt, AK/Tectonics

Chilkoot Pass, AK/Minerals

Brattahlid, Greenland/Vikings

Old Croghan, Ireland/Bog bodies

Great Falls of Columbia, OR/Lewis & Clark

L'Anse aux Meadows, Nfld./Vikings

Clonycavan, Ireland/Bog bodies

Mount St. Helens, WA/Tectonics

Yellowstone, WY/Yellowstone Park

Titusville, PA/Minerals

Fort Clatsop, OR/Lewis & Clark

St. Louis, MO/Lewis & Clark

Wreck site/*Titanic*

Cedar Mesa, UT/Pueblo

San Francisco, CA/Minerals

Pueblo Bonito, NM/Pueblo

Sutter's Mill, CA/Minerals

Carson City, NV/Minerals

Cape Canaveral, FL/Kepler Telescope

Chichen Itza, Mexico/Archaeoastronomy

Mauna Kea, HI/Comets

Cerrejón, Colombia/*Titanoboa*

Machu Picchu, Peru/Archaeoastronomy

Elephant Island, Antarctica/Polar explorers

Weddell Sea, Antarctica/Polar explorers

North Pole/Polar explorers ●

Iceland/Tectonics

North Sea, Norway/Minerals

Hammerfest, Norway/Auroras

Yamal Peninsula, Siberia/Mammoth

Spitsbergen, Norway/Pliosaur

Jutland Peninsula, Denmark/Bog bodies

Yde, The Netherlands/Bog bodies

Tonsberg, Norway/Vikings

Skuldelev, Denmark/Vikings

Tollund, Denmark/Bog bodies

Rose Theatre, London/Urban archaeology

Stonehenge, England/Archaeo-astronomy

Sutton Hoo, England/Anglo-Saxon ship

Rome/Urban archaeology

Athens market/Urban archaeology

Liaoning Province, China/Dinosaurs

English Channel/H.M.S. Victory

Abruzzo, Italy/Tectonics

Antikythera, Greece/Mechanism

Xian, China/Terracotta army

Cleopatra site/Egyptology

Bahariya Oasis/Egyptology

Valley of the Kings/Egyptology

Nubian Desert, Sudan/Meteorites

Khartoum, Sudan/Nile

Mogok Valley, Burma/Minerals

Lake Victoria/Nile

Lake Tanganyika/Nile

Pangandaran, Indonesia/Tectonics

Flores Island, Indonesia/"Hobbits"

● Zambezi River/Victoria Falls

● Kimberley, South Africa/Minerals

South Pole/Polar explorers ●

NASA GODDARD SPACE FLIGHT CENTER IMAGE BY RETO STÖCKLI (LAND SURFACE, SHALLOW WATER, CLOUDS); ENHANCEMENTS BY ROBERT SIMMON (OCEAN COLOR, COMPOSITING, 3-D GLOBES, ANIMATION); DATA AND TECHNICAL SUPPORT: MODIS LAND GROUP; MODIS SCIENCE DATA SUPPORT TEAM; MODIS ATMOSPHERE GROUP; MODIS OCEAN GROUP. ADDITIONAL DATA: USGS EROS DATA CENTER (TOPOGRAPHY); USGS TERRESTRIAL REMOTE SENSING, FLAGSTAFF FIELD CENTER (ANTARCTICA); DEFENSE METEOROLOGICAL SATELLITE PROGRAM (CITY LIGHTS)

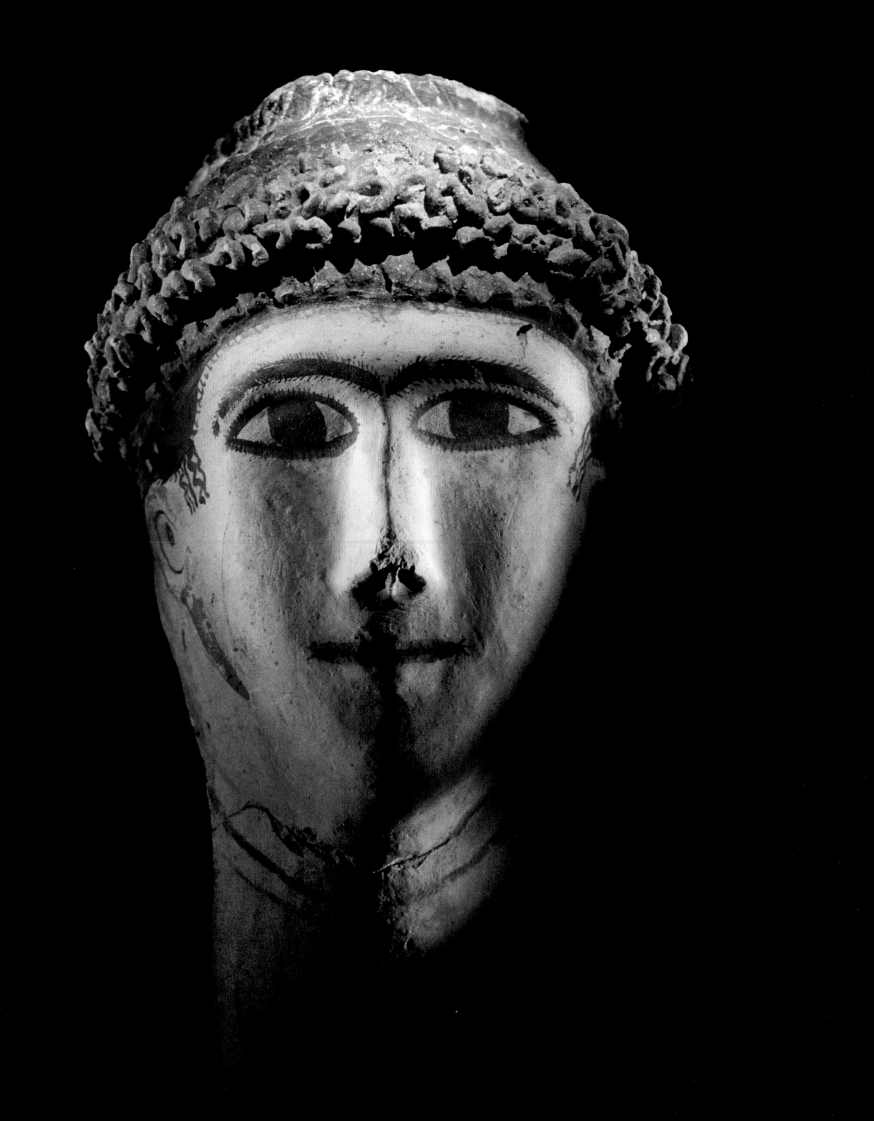

Exploring The Past

"When people ask me which of my discoveries has meant the most to me personally, I often think first of the Valley of the Golden Mummies at Bahariya Oasis. Introducing this amazing site to the world propelled me into an international spotlight. I feel privileged to have been a part of this story, which is so much a part of my own personal history as well as the history of Egyptian archaeology.

"March 2, 1996, is a day that I will never forget. I was working at Giza at the time, supervising the excavation of the Cemetery of the Pyramid Builders. That afternoon, as I sat cleaning the skeleton of a man who had helped to construct the Great Pyramid, my assistant Mansour Boraik came up to me looking very excited. He told me that Ashry Shaker, the director of the Supreme Council of Antiquities office at Bahariya Oasis, had come to tell me about an exciting new discovery. Mansour and I enjoy playing jokes on each other, so I thought at first that he was probably trying to fool me. When I saw Ashry's serious face, however, I knew that something important had happened. Ashry told me that a guard named Abdul Megoud had been chasing after a runaway donkey, when the animal led him to a hole in the ground. When the guard peered inside, he thought that he saw the gleam of gold—surely this was an opening into an ancient tomb!"

—ZAHI HAWASS, SECRETARY-GENERAL
EGYPT'S SUPREME COUNCIL OF ANTIQUITIES
WWW.DRHAWASS.COM

EYES OF THE PAST *This painted burial mask was found at the area at Bahariya Oasis christened the Valley of the Golden Mummies*

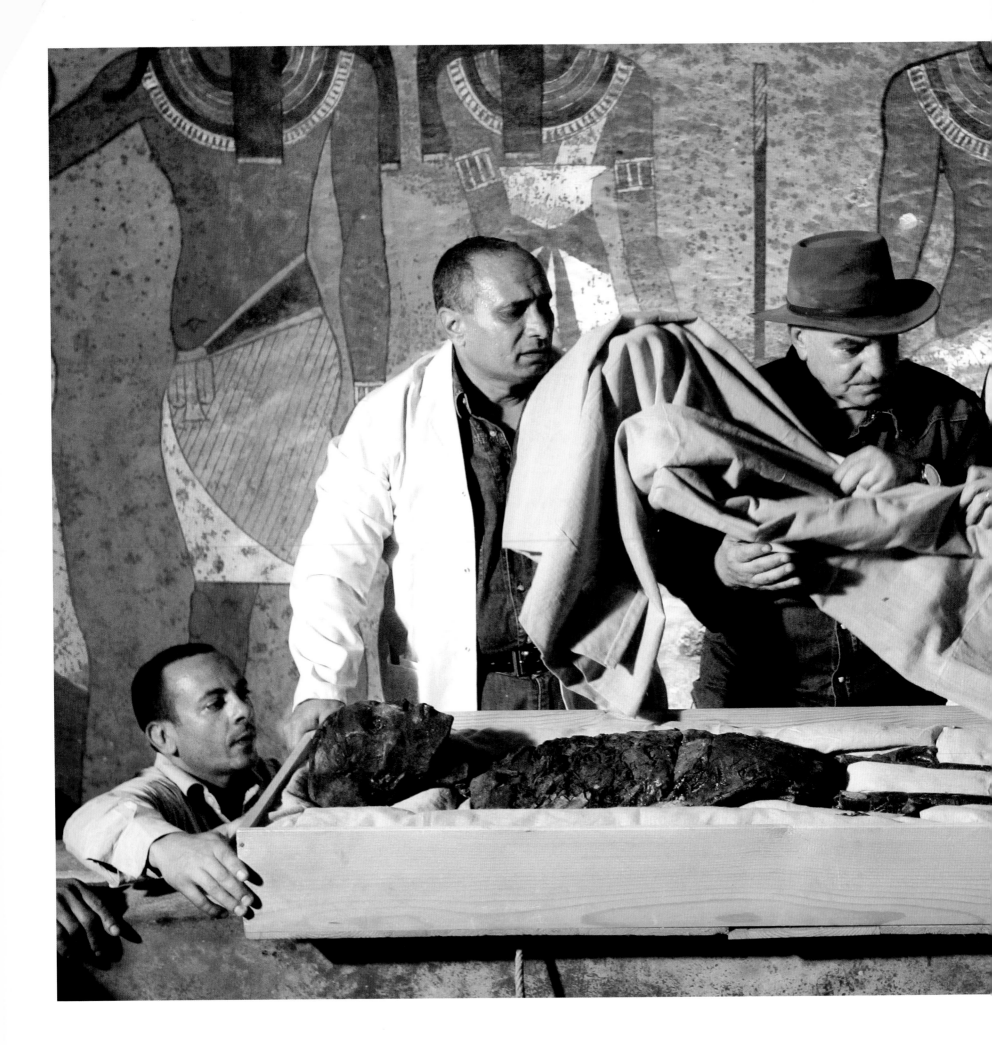

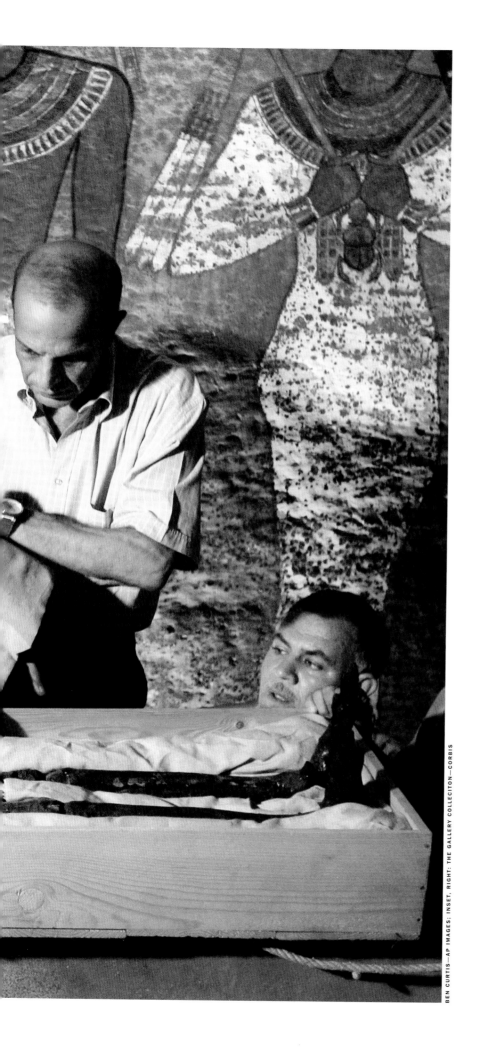

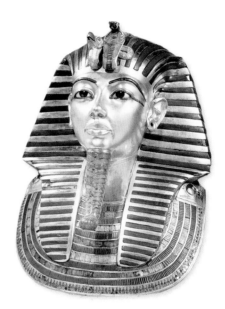

CURRENT EXPLORATIONS

ZAHI HAWASS: EGYPT'S INDIANA JONES

History's most legendary suicide happened more than 2,000 years ago: rather than surrender to the Romans who had captured her Egypt, the lovelorn Queen Cleopatra supposedly exposed herself to the venomous bite of an asp. Ancient historians chronicled the act repeatedly, Shakespeare dramatized it memorably, and HBO added its own spin to the tragedy, lavishly, with the recent TV series *Rome*. Yet while we may believe that Cleopatra died of snake poison, after her consort Mark Antony fell on his sword, archaeologists have yet to pin down where the legendary couple was laid to rest.

That may be about to change, according to the world's most flamboyant archaeologist—a tomb raider who is known for almost always getting his man (or in this case, couple). Zahi Hawass, secretary-general of Egypt's Supreme Council of Antiquities, announced in April 2009 that his team of archaeologists was readying for the final approach toward what could be the tomb of Cleopatra. The site is in Abusir, some 30 miles (48 km) from the port city of Alexandria, among the ruins of an ancient temple to the Egyptian god Osiris. Nearly two

MUCH ADO ABOUT TUTTING *Hawass removes a tarp from the mummy of the boy Pharaoh Tutankhamen. In 2005 Hawass led an effort to reconstruct Tut's face, then promoted a worldwide tour of Tut artifacts, including the gold mask at top, that has proved enormously successful and is still in progress*

7

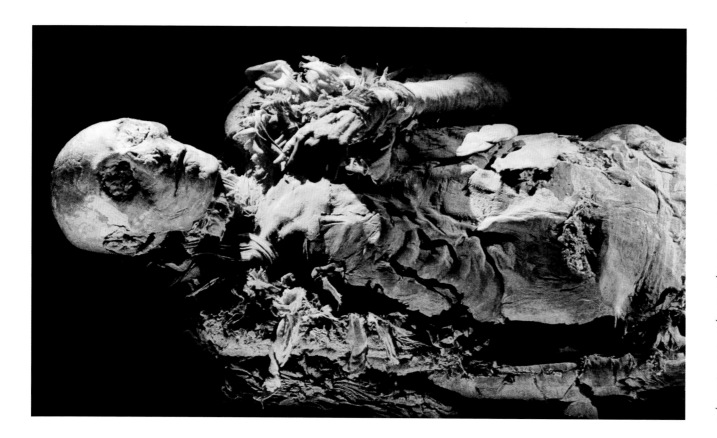

FEMALE PHARAOH? *Hawass declared in 2007 that he had identified the mummy at left as that of the famed Pharaoh Hatshepsut, one of the only women to rule Egypt. Her reign is dated to 1479 to 1458 B.C.*

The key clue: the mummy had a tooth missing, and a tooth found in a small box next to the body of Hatshepsut's wet nurse, Sitire-In, fit the cavity. In addition, DNA testing confirmed a link between the mummy and that of Hatshepsut's grandmother. But some scientists are awaiting further evidence before accepting the claim

dozen coins unearthed there bear Cleopatra's profile and inscription, and carvings in the temple enclosure show two lovers in an embrace. A ceramic fragment supposedly mirrors the cleft chin of the rebel general Antony—leading Hawass to speculate that it is the Roman's own death mask. Archaeologists have dug up the mummies of 10 nobles around the site, a sign, perhaps, that a more regal prize dwells within. Using radar, they have spied three subterranean passageways which they believe could lead to the grave. "If this tomb is found," Hawass told TV reporters as they set about their dig, "it will be one of the most important discoveries of the 21st century."

Hawass is no stranger to hyperbole. Known for sporting an Indiana Jones–style fedora and his habit of ending up in front of cameras, the 62-year-old is the custodian of Egypt's monuments and the greatest promoter of its mysteries. "In Egypt," Hawass writes on his personal website, *www.drhawass. com*, "archaeologists are bigger than movie stars!" His quest for Cleopatra's grave is spawning comparisons with Howard Carter's 1923 discovery of King Tutankhamen's tomb. No one would suggest that Hawass, who is an honorable man, might be fanning the flames of such outsized conjecture.

Few countries in the world sit upon as many layers of history and civilization as does Egypt, from the pyramids of the Pharaohs to the archives of medieval Jewish merchants. And no country in the world boasts a scientist who commands

the power over its past that Hawass brandishes with such authority, pride and zest. Although he is most often photographed in that trademark fedora, he wears many hats. Sometimes he plays the telegenic media darling; any sensational discovery is invariably announced by him. On other occasions he is cast as a bullying tyrant, the King of De Nile, ruling over who will excavate in Egypt—and who will not. But at all times, one thing is certain: Hawass is never boring.

The eminent scientist grew up in a middle-class family in the Nile Delta town of Damietta. "I listened to the tales of *The Arabian Nights* along the shores of the Nile," he told Egypt's *Al-Ahram* newspaper in 2005. After earning a degree in archaeology from Alexandria University and studying Egyptology at Cairo University, he received a Fulbright Scholarship to attend the University of Pennsylvania, graduating with a Ph.D. in archaeology in 1987—and acquiring a knowledge of the U.S. and its media that has served him well. He soon became director of the Giza Plateau, site of Egypt's most significant treasures, and he was named to his present post in 2002. Today he keeps to a whirlwind schedule of lectures, TV appearances and book tours while also publishing a seemingly endless stream of articles. And he doesn't hesitate to use words like *magical, thrilling* and *marvelous* when describing the discoveries that constitute his greatest-hits collection, the first of which was the

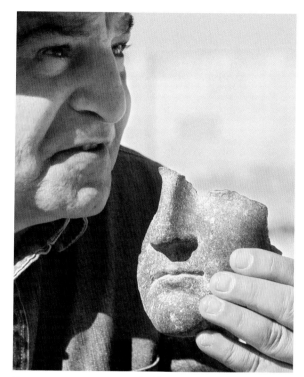

RESEMBLANCE? *Hawass holds the face of a statue he has argued may be that of Roman general Mark Antony*

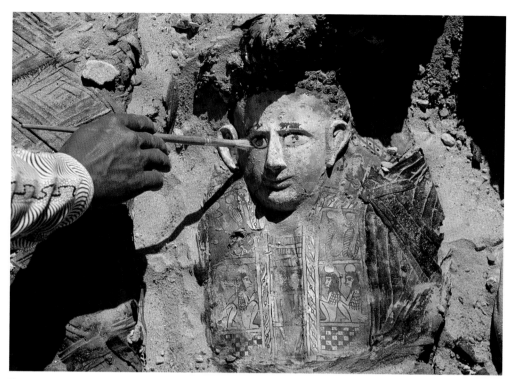

EMERGING FROM THE PAST *An archaeologist brushes dirt from the face of a sarcophagus holding the mummy of a child in Bahariya Oasis, where Hawass explored the Valley of the Golden Mummies*

significant find in the late 1990s that he heavily promoted as the Valley of the Golden Mummies.

AN OUTPOST OF THE EMPIRE

In 1996, while working in Giza, Hawass got wind of a new, unsuspected burial site at the Bahariya Oasis. The sleepy backwater, 230 miles (370 km) southwest of Cairo, had been largely overlooked by archaeologists before 1996. That's when a donkey belonging to an antiquities guard fell into a hole that led directly to an undiscovered tomb that was filled with gold-covered mummies. When he arrived, Hawass told TIME, "one of the tomb ceilings had fallen in and the sun shone through it. I went in and looked at the mummies in the rays of the sun. All I could see was gold."

Astonished by that first glimpse, Hawass returned to lead what he calls the largest expedition ever undertaken in Egypt—and deservedly so. The richness of the find and the tombs' unprecedented state of preservation astounded his peers. While so many ancient tombs, like that of the famed Tut, had been partly looted, these chambers had remained undisturbed since they were sealed some 2,000 years ago, at a time when Egypt and much of the Middle East was part of the Roman Empire.

The bulk of the tombs in Bahariya represent one of two periods: the 26th dynasty (6th century B.C.), when the town first became an important trading and agricultural center; and the 1st and 2nd centuries A.D., during the period when Egypt was ruled by Rome.

The remains were interred in four distinct ways. One type was covered with a thin layer of gold. Another lay under lifelike masks made of plaster-coated linen, or cartonnage, that was painted with scenes of ancient Egyptian gods and goddesses, including Isis, Osiris, Horus and Anubis. Still others were placed in so-called anthropoid coffins—pottery sarcophagi with human faces—and a few were wrapped only in linen. Bracelets, amulets, statues of mourning ladies, pottery vessels and figurines of Bes, whom Hawass described as "the dwarf god of pleasure and fun," were interred with the bodies.

As a lover of the *Arabian Nights,* Hawass can spin a yarn that Scheherazade might envy. During his work in Bahariya, he shared with TIME a dream he said he had during the excavations there, where he was hoping to come upon the remains of Zed-Khonsu-efankh, a powerful governor of the oasis during the 26th dynasty. In the dream, Hawass was trapped in a large room filled with dense smoke. He tried to call for help, but no one heard him. Suddenly, a man's face—looking for all the world like a carving from a sarcophagus—came swimming at him through the haze. Hawass cried out and forced himself awake.

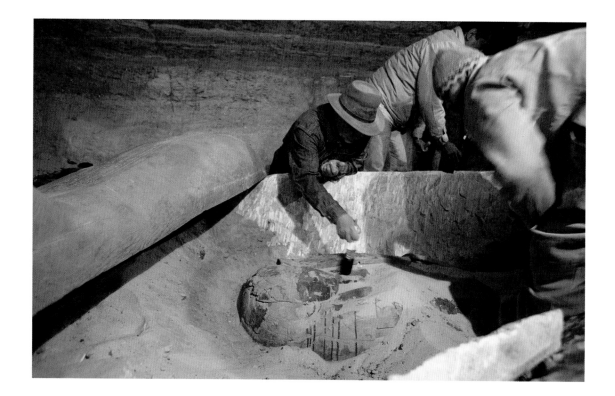

NEW TOMB *Early in 2009, Hawass and his team announced the discovery of a burial chamber from Egypt's 26th dynasty containing eight sarcophagi at the vast necropolis at Saqqara, south of Cairo. Archaeologists continue to find new tombs at this rich site, where the pyramid shown at right was discovered in 2008.*

At left, Hawass brushes dust from one of the sarcophagi, sealed for some 2,600 years. Mummies were retrieved for study when the sarcophagi were opened

Days later, as he was beginning his dig in a tomb from the earlier era that others had already explored, Hawass spied an opening in a chamber wall. When he and his team excavated the rubble that lay beyond, they found anterooms filled with paintings of religious scenes and inscriptions from the Book of the Dead. In the adjacent burial chamber, which swirled with a yellow powder reminiscent of Hawass's dream, they discovered a limestone sarcophagus. When they dusted off the lid and uncovered the famous name Zed-Khonsu-efankh, Hawass recalls, "we all screamed."

At the Bahariya Oasis, Hawass not only found his man; he and his colleagues opened an unprecedented window into Egyptian life in a provincial town under Roman rule. But when you perform on the high wire, as he consistently has, you run the danger of slipping, and Hawass did so in memorable fashion in 2006.

In February of that year, archaeologists announced the discovery of a new tomb in the Valley of the Kings, the first untouched find since Carter entered King Tut's tomb in 1923. Inside the tomb (which Hawass, characteristically, would not permit to be opened until he had arrived at the site) were seven coffins. On the basis of several clues, such as pottery with inscriptions identical to some found with Tut, Hawass whipped up a storm of speculation that Tut's mother Queen Kiya might be inside one of them. With the eyes and cameras of the world press trained upon the scene,

the casket was opened—and Hawass had his Geraldo Rivera moment: Kiya was nowhere to be seen.

THE QUEST FOR CLEOPATRA

If his courtship of publicity rivals Cleopatra's overtures to Antony, Hawass is also a zealous watchdog of his nation's immense treasures. He has made news around the world by demanding the return of important objects he says were "stolen" from Egypt by excavators and museums, including the Rosetta Stone, now in the British Museum; the famed bust of Nefertiti owned by a Berlin museum; the Luxor Temple's obelisk at the Place de la Concorde in Paris; and others. (The charge is accurate in some cases, but not all.)

In November 2008 Hawass announced the discovery of a pyramid at Saqqara, a burial ground near Cairo. It dates to about 2,300 B.C. and is now 16 ft. (5 m) in height, although it originally was 46 ft. (14 m) tall. The entire monument was originally covered in a casing of fine white limestone and commemorates a queen named Sesheshet.

It was a major find, but Hawass soon moved on to his new obsession; after all, a pyramid is a pile of rocks, while Cleopatra is a rock star. "[She] has come to symbolize Egypt for a lot of people," says Joyce Tyldesley, an archaeologist at the University of Liverpool and author of *Cleopatra: Last Queen of Egypt* (Basic Books; 2008). Centuries of Western literature evoked Cleopatra as a lustful seductress, corrupting the stoic Roman men who strayed into her orbit.

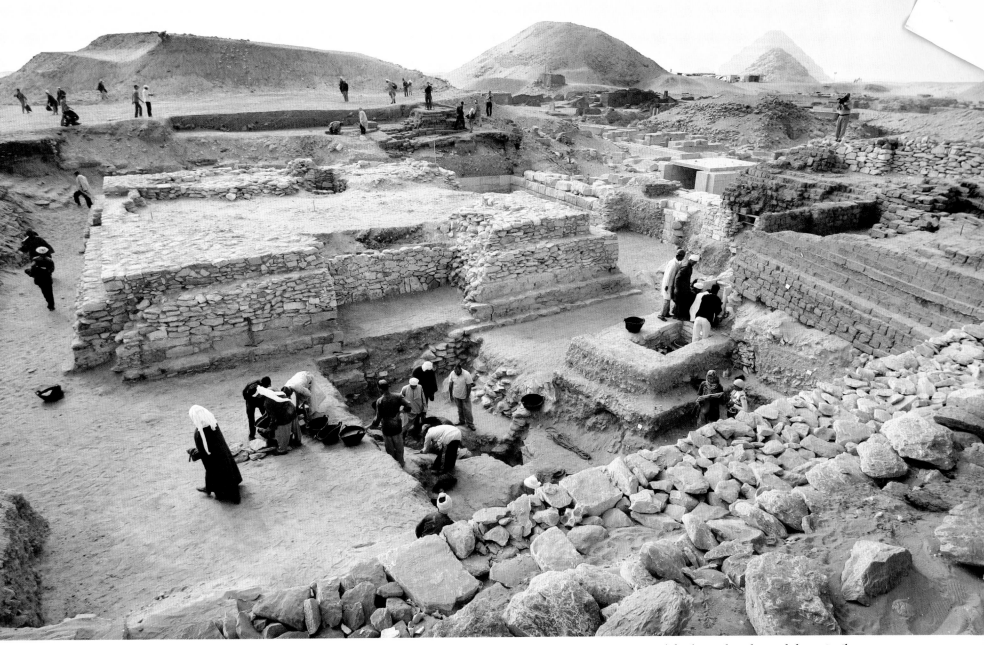

RECENT FIND *Workers toil at the base of the pyramid of Queen Sesheshet in Saqqara late in 2008; its discovery was unexpected, for the vast burial ground about 18 miles (30 km) south of Cairo was thought to have been thoroughly explored. In fact, rubble from prior excavations had been dumped on the site, concealing the ancient edifice*

Debates still rage over everything from her identity—cranial scans of her half-sister's skull in 2009 suggest she may be African, though her known lineage was Greek—to her looks. Close scrutiny of coin portraits have led some to believe that she was rather plain; indeed, the Roman historian Plutarch wrote that "her beauty was in itself not altogether incomparable, nor such as to strike those who saw her."

Even more questions linger surrounding her death, which signaled the dawn of the Roman Empire under Julius Caesar's nephew Octavian, who was waging a bitter civil war with Antony. "She definitely died at a very convenient time for Octavian," says Tyldesley. "There is no absolute proof that she committed suicide, and so it is possible that she was either forced to do so, or that she was killed … [and] there is no proof that she died by snakebite either."

As this book went to press, Hawass had his audience right where he wanted it—eagerly awaiting further developments, thrilled by the possibility of seeing a legend turn real. It's hard to divine what could be buried by Cleopatra's side, let alone how the storied queen's body itself may be preserved. Could there be treasures? The coiled skin of a snake? "A diary," offers Tyldesley, "would be fantastic."

Hawass keeps a diary of sorts on his website, where he says he hopes his most lasting legacy will be his focus on conserving his nation's priceless legacy of antiquities. The irony of his career is that his greatest enemy may be himself: with his P.T. Barnum showman's swagger, he has helped encourage the vast influx of tourists, now central to Egypt's economy, that threatens to overwhelm the gateways to the past that he has sworn to protect.

CALENDARS OF STONE

High in the emerald-hued Andes mountains, at an elevation almost 1.5 miles (2.4 km) above sea level, the ancient fortress city of Machu Picchu testifies that the Incas were gifted astronomers well before Europe's modern age of astronomy began. The Incas built Machu Picchu, or "Old Peak," in south-central Peru's cloud-shrouded heights some time around A.D. 1450, at least a half-century before Polish mathematician and astronomer Nicolaus Copernicus shocked Europe with his heretical heliocentric model, which posited that the sun, not Earth, was the center of the universe. The Incas would have approved: the sun was the center of their religion, and members of this advanced civilization methodically planted crops and performed religious ceremonies based on the sun's alignment with other heavenly bodies and constellations.

The wider world has known of the existence of Machu Picchu for less than a century, and its function as an observatory has been understood only since the early 1980s. Indeed, scientists have been regarding ancient structures across the world with fresh eyes in recent decades, as a new branch of science known as archaeoastronomy has emerged. The field has elucidated the Incas' interplanetary insight, revealed the calendrical genius of the builders of Britain's Stonehenge and decoded the serpentine secrets of a Maya pyramid in Mexico. Along the way, we have learned that many ancient cultures were more advanced than we thought and that the structures they created served different purposes than we supposed. The revelations have illuminated the ancient mind, where astronomy, geometry, architecture, religion and art were not separate disciplines but rather different threads woven into a single, sacred tapestry.

SOLAR POWER AND INCAN INGENUITY
Machu Picchu has entranced the world since Yale University professor Hiram Bingham reached the mountaintop enclave—now thought to have been a royal retreat—in 1911, when native scouts led him to the spectacular terraced ruins. Nestled within the 5-sq.-mi. (13 sq km) compound were architectural features that mystified Bingham and the first academics who followed in his footsteps. One of those features is the Temple of the Sun, or Torreón, at Machu

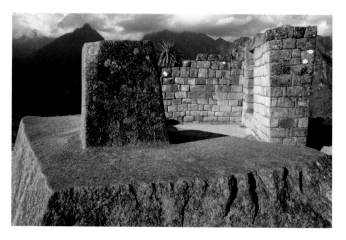

SACRED STONE *The Incas worshipped Viracocha as the supreme deity and creator and his son, Inti, as the god of the sun. The Intihuatana stone at Machu Picchu, above, is referred to as "the hitching post of the sun." At midday on the vernal and autumn equinoxes, the sun appears directly over the stone, thus casting no shadow. Similar "hitching posts" throughout the Incan empire were destroyed by the Spanish as artifacts of pagan culture*

CITY IN THE SKY *Machu Picchu was first opened to scientific investigation by Yale professor Hiram Bingham in 1911, but in 2008 evidence emerged that a German businessman, Augusto Berns, had visited the site and plundered it 44 years earlier, in 1867*

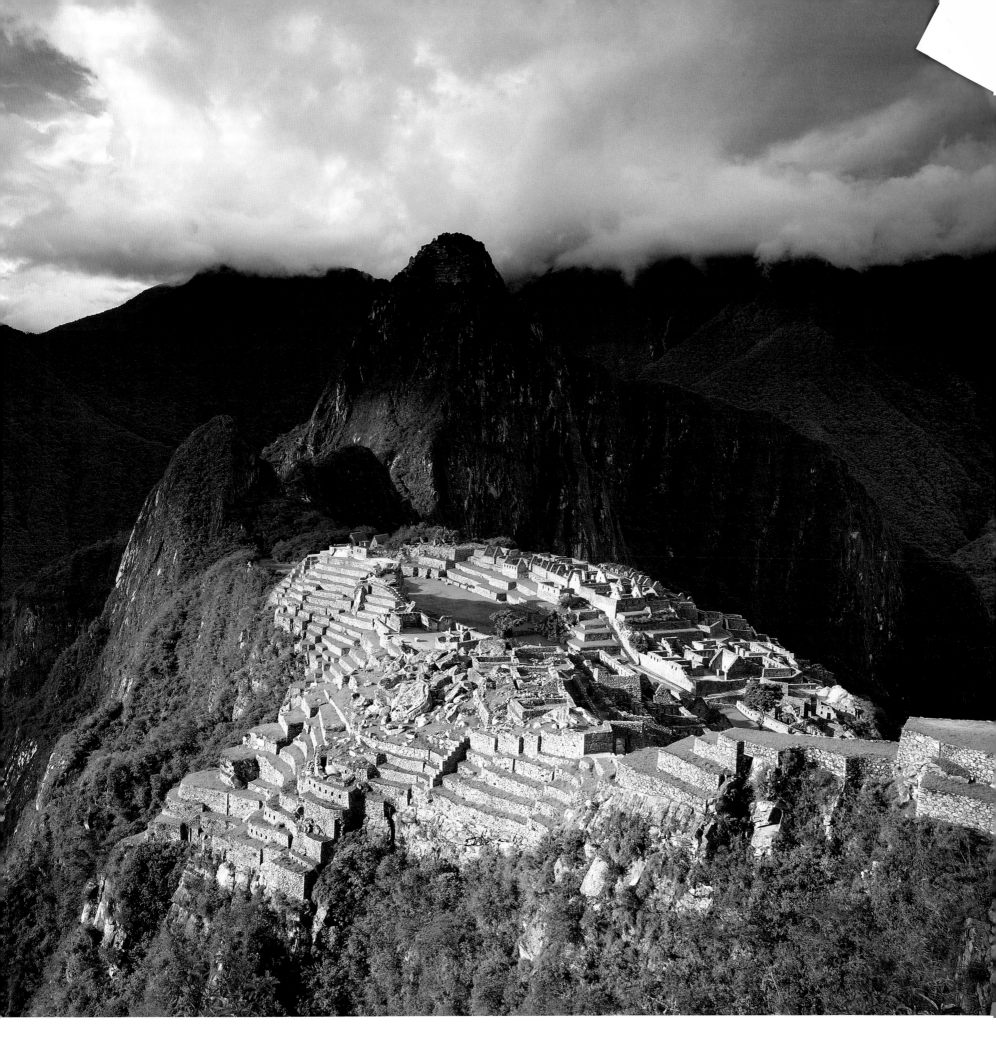

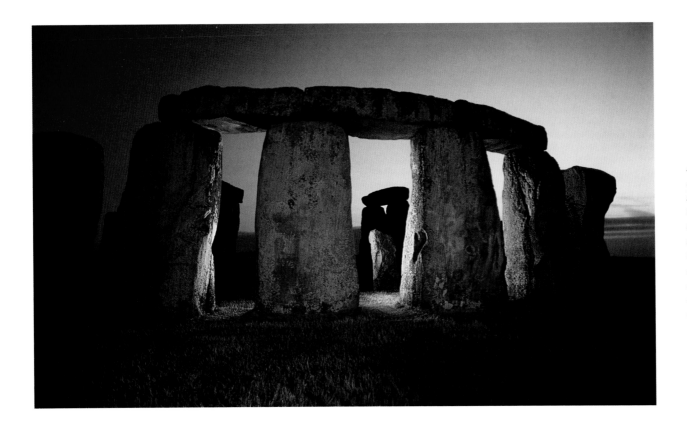

Picchu's southern end. The unique structure consists of a semicircular wall with windows that archaeologists speculated were designed to enable the rulers of this empire of the sun to receive messages from their golden deity.

And they do: but we now know those messages arrived in the form of sunbeams. Two windows within the Torreón's wall are aligned so that the sun's rays first gleam through them during the year's two solstices. The winter solar appearance set the stage for Inti Raymi, or the Festival of the Sun, during which Incan priests made offerings to the sun god Inti and deciphered omens from the innards of ritually slaughtered llamas. The Torreón's solstice alignment, now widely accepted, was first proposed in 1980 by archaeoastronomer David Dearborn, a research astrophysicist at California's Lawrence Livermore National Laboratory.

The Incas also used ceremonial stones such as the Intihuatana stone at Machu Picchu to indicate the vernal and autumnal equinoxes, ceremonially "hitching," or stopping, the sun's course. Scientists believe they also observed the changing position of the Pleiades star cluster; this cosmic farmer's almanac helped them time the planting of crops.

In 2007, scientists discovered another Peruvian site that suggests ancient civilizations in the Americas may have been charting the sun's movement in stone as early as the 4th century B.C. Chankillo, on Peru's coast, has 13 regularly spaced rectangular towers that stretch like vertebrae across a 985-ft. (300 m) ridge. On either side of this stone solar calendar are what's left of observatories. "These towers have been known to exist for a century or so. It seems extraordinary that nobody really recognized them for what they were for so long," Leicester University archaeoastronomer Clive Ruggles told the BBC in March 2007. "I was gobsmacked when I saw them for the first time— the array of towers covers the entire solar arc."

STONEHENGE: A PREHISTORIC CALENDAR

If Copernicus was the father of modern astronomy, then British-born American astronomer Gerald Hawkins is the father of archaeoastronomy. Hawkins' passion was Stonehenge, and his 1965 book, *Stonehenge Decoded*, reshaped the science surrounding the peculiar, upright megaliths that have long delighted—and bewildered— visitors to southwestern England's Salisbury Plain. Hawkins enlisted modern computers to show that the megaliths' huge stone slabs and archways were deliberately positioned in two concentric circles to form a primitive observatory.

The most prominent features of the Stonehenge we know today, which was constructed between 1900 and 1600 B.C., are a 97-ft. (30 m) ring of 25-ton vertical and horizontal slabs known as the Sarsen Circle, which surrounds five huge

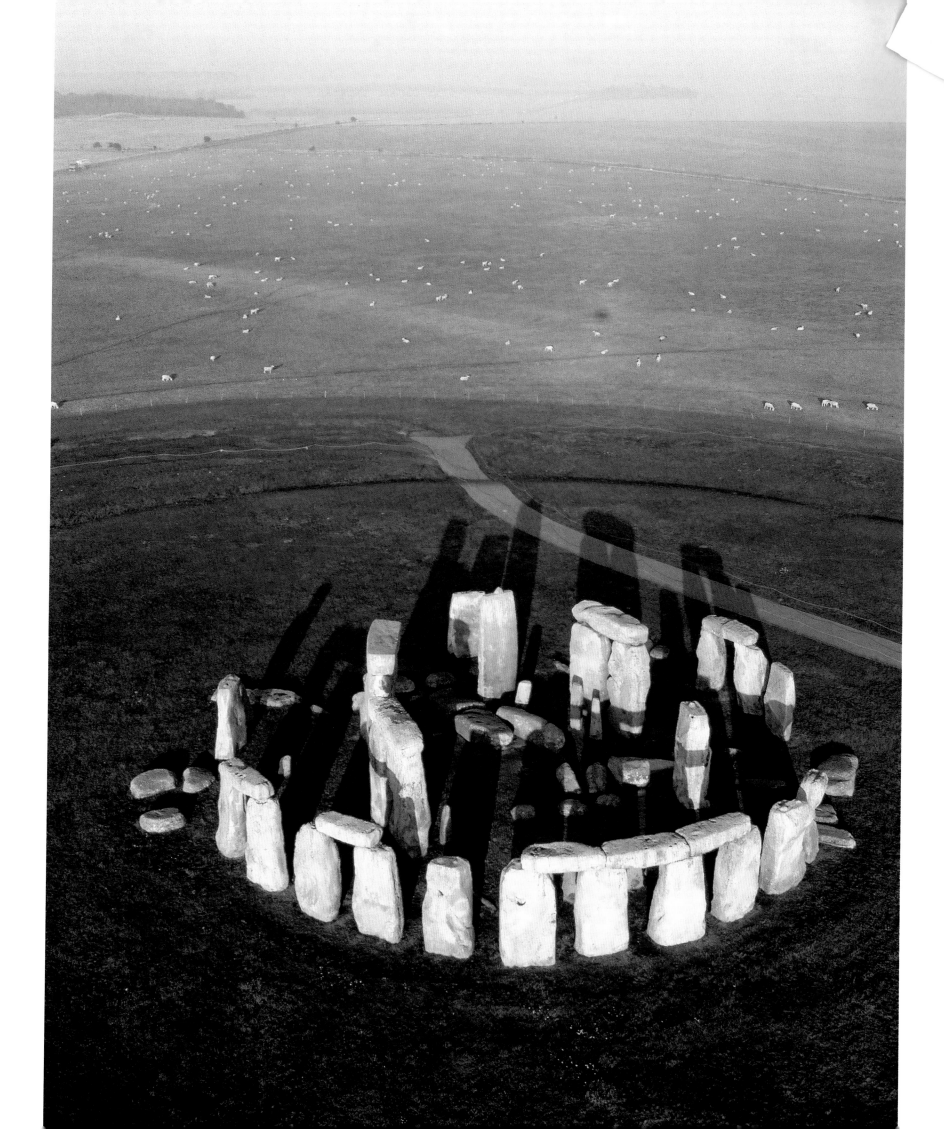

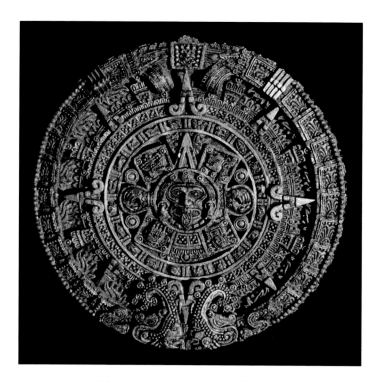

ROCK OF AGES *The Aztec culture of Mexico, like the Maya and Incan, was oriented to the sun. The solar calendar above, known as the Stone of the Fifth Sun, is a carved basalt stone, 3 ft. (1 m) thick and 12 ft. (3.5 m) high. Discovered in Mexico City in 1790, it is believed to represent the Aztec cosmos*

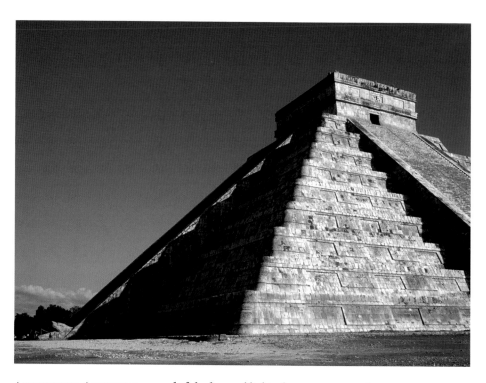

APPARITION *A serpent composed of shadow and light, above, appears on the steps of the stairway of Chichén Itzá's pyramid of Kukulcán on the year's two solstice days. In 2007, voters from 200 countries named the Maya pyramid, shown in an aerial shot at right, one of the Seven New Wonders of the World*

trilithons, or archways. To build them, early Britons hauled stones weighing as much as 50 tons from a quarry 20 miles (6 km) away. More recently, archaeologists have suggested some of the smaller bluestones (named for their bluish-black color) may have been transported more than 150 miles (250 km), from the Preseli Mountains in South Wales.

Stonehenge was long thought by archaeologists to be a crematorium or sacrificial altar because burned bones and teeth were buried there. But Hawkins argued that it was actually a prehistoric, labor-intensive calendar. Stonehenge, he showed, is oriented so that its axis passes through a 35-ton marker stone known as the Heel Stone and points directly to the spot on the northeast horizon where the sun rises at the summer solstice. Further analysis proved that many of the Stonehenge alignments accurately pointed to the summer and winter solstice positions of the rising and setting sun and moon.

Additional plotting revealed that the alignment of other stones pinpointed equinoctial positions of the rising and setting sun and moon, enabling observers to determine accurately the first day of both spring and fall, as well as solar and lunar eclipses. Concluded Hawkins: "Stonehenge was locked to the sun and moon as tightly as the tides. It was an astronomical observatory. And a good one, too."

SLITHERING SCIENCE: CHICHÉN ITZÁ'S SECRET
Like the Incas, the Maya were a Mesoamerican civilization well versed in astronomy. The Maya ruins of Chichén Itzá are a jungle-cloaked jewel on the north-central tip of Mexico's Yucatán Peninsula, about 75 miles (120 km) from the state's capital city of Mérida. Archaeologists believe the UNESCO World Heritage site was first inhabited around the 6th century A.D. and then abandoned for unknown reasons. The Itzá, a Maya-speaking group from southern Guatemala, resettled there in about A.D. 1000.

Chichén Itzá's defining structure is the pyramid of Kukulcán, also known by its Spanish name, El Castillo. The stone temple stands 75 ft. (23 m) tall, and each of its four sides has 91 steps, which, together with the top terrace, equal 365—the number of days in a solar year. On the days of the spring and autumn equinoxes, the pyramid comes alive in a wondrous prayer of sacred geometry: the shadows of its nine terraces cast the wavy illusion of the serpent god Kukulcán slithering down the balustrade of the northern stairway to join its carved reptilian head protruding from the temple's base. At these moments, the works of the astronomer-priest-architects who labored in stone so long ago reach across time to send modern hearts soaring.

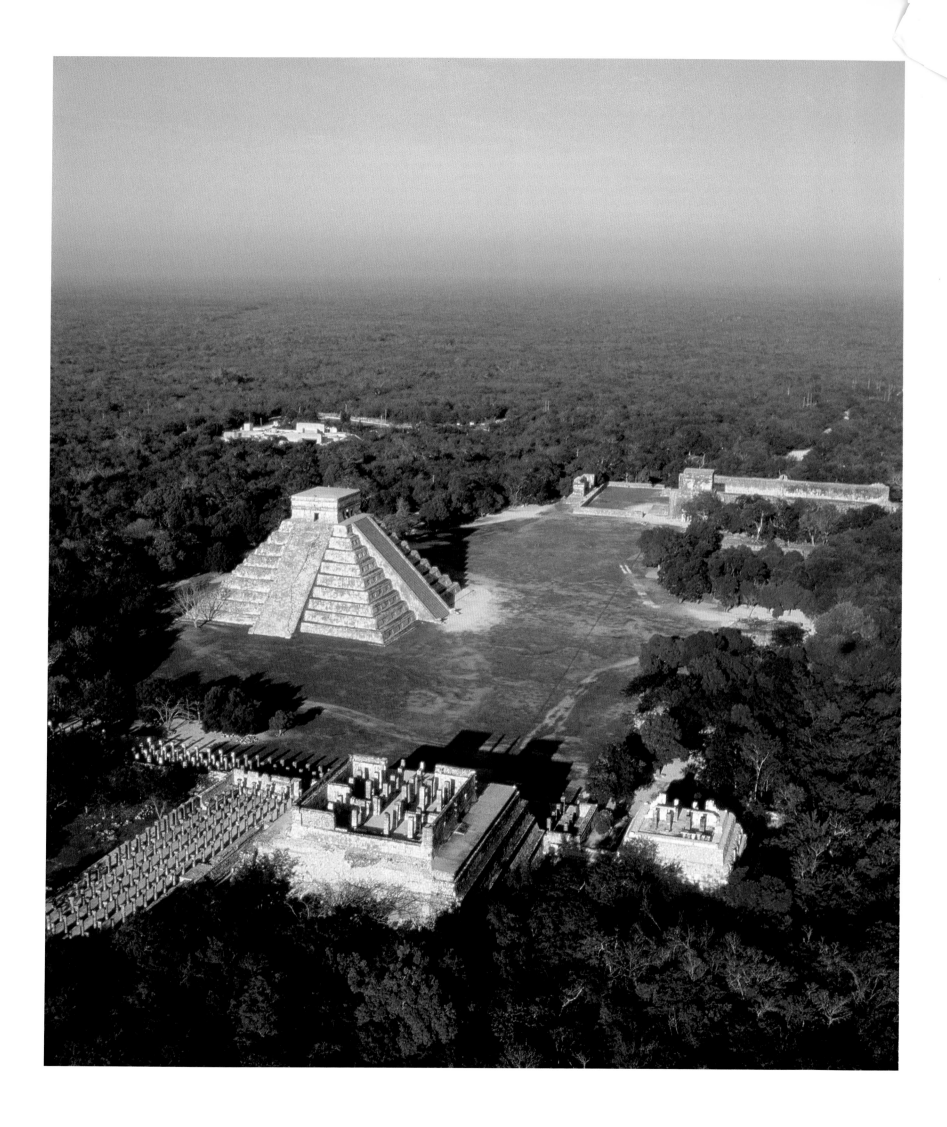

THE ANTIKYTHERA MECHANISM:
A MIRACLE OF RARE DEVICE

Crafted by geniuses some 21 centuries ago, it must have been a wonder of its age. Lost at sea, it was recovered from the ocean floor a little more than 100 years ago, a message written in a code its finders could not crack. And now, examined with the powerful tools of 21st century science, the Antikythera Mechanism has become a sort of mechanical Rosetta Stone that is revolutionizing our understanding of the science and technology of Classical Greece.

Antikythera is a small island in the Mediterranean, where a group of Greek sponge divers in A.D. 1900 stumbled across the remains of an ancient trading vessel that was later determined to have foundered around 70 B.C. Among the artifacts retrieved from the wreck was a mechanism once encased in a wooden box that had mostly disintegrated, revealing sets of badly corroded bronze gears. After an initial fuss, scientists proved unable to explain the purpose of the device, and its shards were stored away in a Greek museum, objects out of time—and soon, out of mind.

Decades later, the damaged artifact struck sparks in one mind, that of Yale historian Derek de Solla Price, who used X rays to discover 30 gears inside the fragments of the device. In a 70-page study of the ancient marvel, *Gears from the Greeks: The Antikythera Mechanism, a Calendar Computer from ca. 80 B.C.* (American Philosophical Society; 1974), De Solla Price argued that the machine was a sort of analog computer, brilliantly geared to track and predict the movements of heavenly bodies. The complex mechanism, he argued, proved that the ancients possessed skills—in engineering, in mathematics, in metallurgy—well in advance of when we had thought they did. It incorporates knowledge and craft that after the decline of the Classical world would be lost to Europe for at least 1,000 years.

The secrets of the device are still being explored. A new X-ray study in the 1990s by Michael Wright, then of the London Science Museum, and Australian computer historian Allan Bromley, led Wright to publish an alternative model in 2005, in which he revived one of De Solla Price's discarded ideas: that the instrument included a Metonic calendar. This system, though named after the Greek astronomer Meton of Athens, was rooted in Babylonian astronomy, long thought to have influenced the Greeks. Wright's new model was eye-opening, yet even so, it left many mysteries unexplained.

Beginning in 2005 new studies were carried out by an Anglo-Greek team, now called the Antikythera Mechanism Research Project, that included U.K. scientists Mike Edmunds and Tony Freeth and Greek scientists John Seiradakis, Xenophon Moussas, Yanis Bitsakis and Agamemnon Tselikas. The team explored the fragments' innards with 3-D X rays and examined the surfaces with digital imaging devices. In 2006 the team published their findings in the science journal *Nature.* By examining 29 of the 30 gears, they showed that the device was able to predict both lunar and solar eclipses many years in the future using the Babylonian Saros cycle. The research also revealed the secrets of an extraordinary set of gears that tracks the variable speed of the moon against the stars, in line with the principles espoused by the noted ancient astronomer Hipparchos.

The team's second *Nature* paper, in 2008, employed X-ray tomography to read formerly illegible inscriptions hidden inside the fragments. The month names on the Metonic calendar were found to be from Corinth in central Greece—a shock, since the device was widely thought to have been made in Rhodes. One intriguing possibility: the device may have been made in the Corinthian colony of Syracuse, home of scientific genius Archimedes. Another revelation: one dial followed the ancient Greek athletic games cycle that included the Olympic Games.

Says researcher Freeth: "The Antikythera Mechanism is a work of genius. The ideas and technologies of the ancient Greeks were far in advance of anything we could have possibly imagined before this device was found. In its complexity, its ingenuity of design and its stunning engineering, it has rewritten the history of technology: it is the world's first computer, and it was created in the 2nd century B.C."

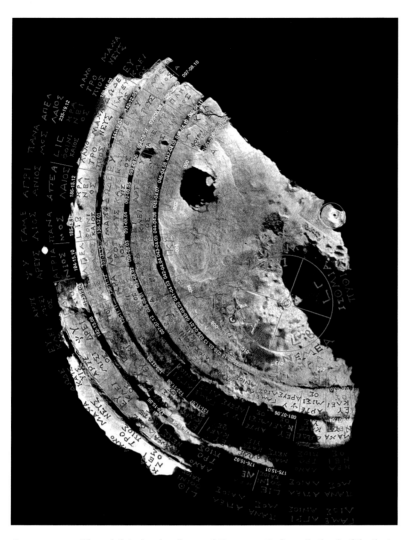

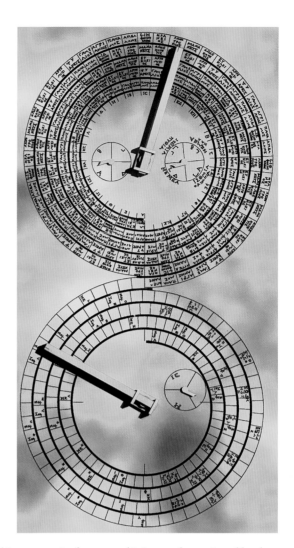

CALENDARS *Above left is the shard termed Fragment B, from the back of the device. In this computerized tomographic image, the text in red has been deciphered from multiple CT slices, revealing the month names of the Metonic calendar. Text in blue is hypothetical, based on the calendar's likely structure. At right is researcher Tony Freeth's model of the back of the device. The main upper dial is a 19-year, 235-month Metonic calendar; the two small dials inside it are an Olympiad dial, which tracks the four-year cycle of the Panhellenic Games and a Callippic dial, a 76-year dial that improves on the Metonic dial. The lower dials predict eclipses according to the 223-month Saros cycle*

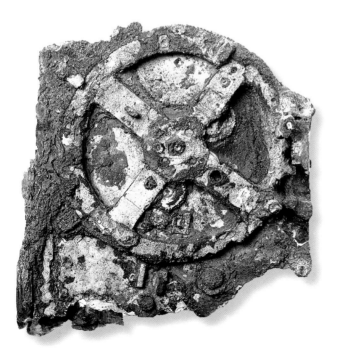

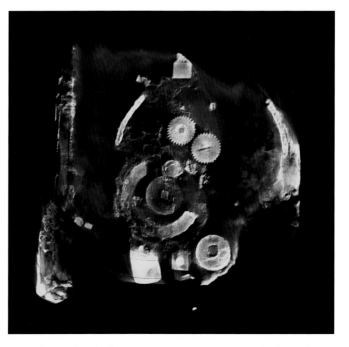

INSIDE OUT *Apparently whole when located, the device later shattered into 82 shards; above left is the largest piece, Fragment A-1. It is the front of the mechanism, which is estimated to have been 12 in. tall, 7 in. wide and 4 in. deep (33 cm x 18 cm x 11 cm). The large gear with four spokes tracked the average movement of the sun. At right is an X-ray tomographic scan of the fragment, revealing details of some of its gears*

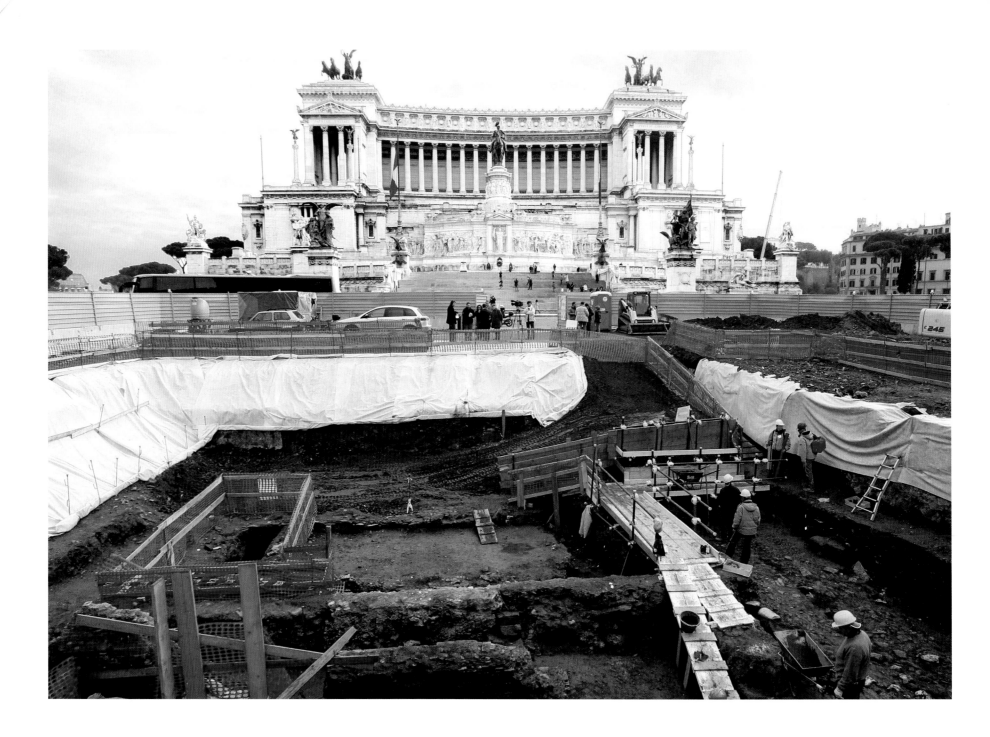

CURRENT EXPLORATIONS

URBAN ARCHAEOLOGY: WHEN TREASURES LURK BENEATH CITY STREETS

When you're building a new subway line smack-dab through the capital city of the ancient Roman Empire, it's more than likely you will turn up an artifact or two … thousand. For example, you might unearth a copper-smelting operation from the 6th century A.D.; or perhaps a kitchen dating to the Middle Ages, complete with saucepans. Those fragments of the past are among those found by construction workers tunneling through Rome's central Piazza Venezia near the ruins

of the Forum in late 2007 and early '08, while building the Eternal City's third subway line. The $4.7 billion underground undertaking is on a tight schedule to start transporting 24,000 time-crunched urbanites an hour in 2015. That goal might be achievable—if only Rome's subterranean strata weren't chock-full of relics that seem to surface with every spade of dirt.

Public- and private-works projects in Rome and throughout Italy are routinely stymied by these urban archae-

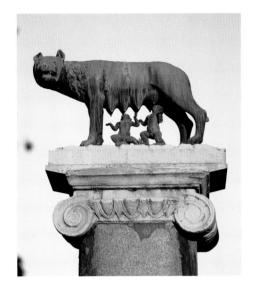

OLD AND NEW *At left, workers digging for a new subway line in Rome turned up a host of artifacts. This site is at Piazza Venezia Square; at rear is the Tomb of the Unknown Soldier*

FOUNDERS *Scientists believe the grotto at right, discovered on the Palatine Hill in 2007, is where ancient Romans believed Romulus and Remus, above, were suckled by a wolf*

ological finds, which legally require a full review by city officials, who either permit crews to keep digging or pull the plug. So rich and various are the finds that oftentimes, interesting artifacts that don't qualify as museum-grade are displayed in "metro-museums" housed right in the subway stations.

In January 2007, archaeologists in Rome announced a major discovery: during an excavation of Emperor Augustus' palace on the Palatine Hill they had turned up a grotto that they believed was the Lupercale, the site of the city's mythical genesis. Abandoned twins Romulus and Remus, who supposedly founded Rome in 753 B.C., are said to have nursed from a female wolf in the cave. The ornate domed ceiling of the underground chamber is decorated with mosaics and seashells.

Rome is hardly the only European city where those seeking to build anew have uncovered that which was built long ago. Archaeologists probing the earth on Athens' southern edge in 2007 found the remains of an all-purpose Greek bazaar, or agora, that once bustled with merchants, politicians and artists—and perhaps a philosopher or two. The agora site likely belonged to the municipality of Aexonides Halai, among the largest settlements surrounding ancient Athens. The main building was a hollow square with a rock-cut reservoir in the center. The building had 12 rooms—probably shops—and

a small temple with an open-air altar. Finds included large quantities of pottery, coins and lead weights that traders would have used to measure commodities in transactions. Only a month before the agora was revealed, the remains of an ancient theater were discovered in the Athens suburb of Menidi.

UNEARTHING AN ELIZABETHAN PLAYHOUSE
Not all urban discoveries carry the whiff of Classical civilization. When construction crews were excavating a site for an office building in London in 1989, they came upon the remnants of an ancient Elizabethan theater. The structure turned out to be the legendary Rose, where the plays of Christopher Marlowe and the earliest of William Shakespeare's comedies and tragedies had come to life 400 years before.

Archaeologists utilized emergency preservation measures when the theater's footings were found: the water-logged chalk foundations and timber drain structures excavated at that time were only exposed long enough to be photographed and accurately mapped. In order to preserve the remains, they were quickly sealed beneath a thick layer of sand under a concrete cap. Today, this is all hidden beneath a large pool of water and English Heritage employees constantly monitor the whole area for signs of degradation. Efforts to preserve the

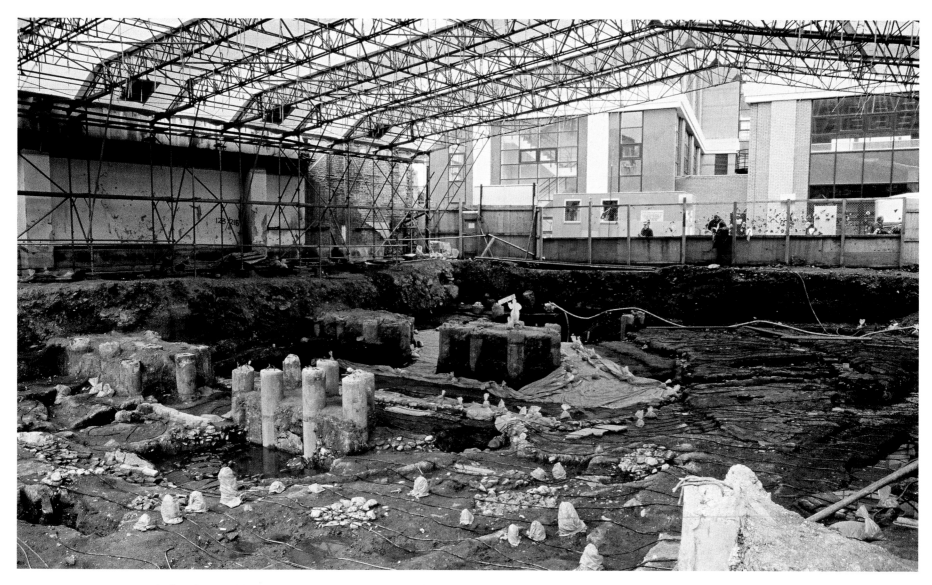

CURTAIN CALL *The foundations of the late-16th century Rose Theatre were exposed, above, during their excavation. The theater was some 70 ft. (21 m) in diameter and could hold about 2,000 people. A number of plays by both Christopher Marlowe and William Shakespeare were first seen here*

remains of the Elizabethan playhouse were successful, and in 2009, a trust intent on excavating the rest of the theater's foundation launched a fund-raising campaign aimed at transforming the site into an educational resource. With the brilliant Shakespearean actor Ian McKellen acting as front man for the appeal, supporters are convinced the effort will succeed.

For British archaeologists, apparently, all the city's a stage. The year after the Rose was discovered, the London Museum of Archaeology unearthed the brick foundation of the simply-named Theatre, which was built 12 years before the Rose. Company manager James Burbage closed the Theatre in 1597 owing to a dispute with his landlord. A year later, he and a group of his colleagues, apparently including Shakespeare, dismantled the playhouse and carried its timbers across the Thames River, where they were used to build the Globe Theatre. In March 2009, London's Tower Theatre Company announced its plans to build a replica of Burbage's Theatre on the site. Such a restored Theater would find itself in competition with the popular replica of Shakespeare's Globe, which opened in 1996. If the discoveries and restorations continue apace, perhaps visitors to London may one day have an opportunity to enjoy an afternoon of bear-baiting.

And why should London command every headline? In 2007 residents of the U.K. coastal village of Meols learned they had been downing pints near a potentially major discovery:

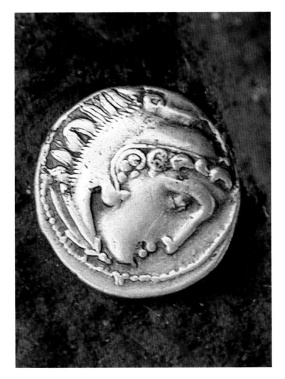 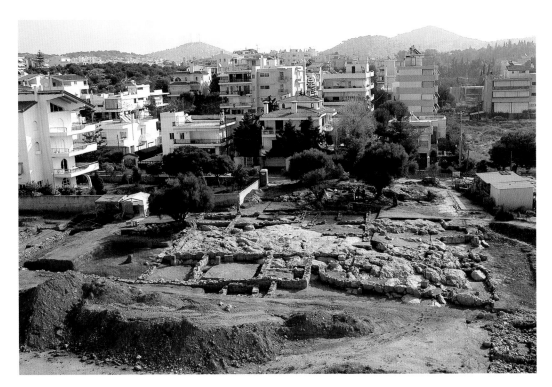

To market, to market *Above is the ancient agora, or marketplace, discovered outside Athens in 2007. The site covers an area of 16,000 sq. ft. (1,500 sq m) and is believed to date from the 5th or 4th century B.C.—the apogee of the civilization of Classical Greece. At left is a magnificently preserved coin unearthed at the site*

ground-penetrating radar equipment had revealed the outline of an entire Norse Viking ship lurking beneath the parking lot of a pub. The vessel measures 30 ft. (9 m) long and 5 ft. (1.5 m) wide, and by some estimates it is 1,000 years old.

Some observers, perhaps including members of the Meols tourist board, suggested the ship might be one of Britain's most significant archaeological finds to date, but skeptics, including those at the nearby Museum of Liverpool, have noted that there's no direct evidence of the boat's age or origin.

"You would have thought that it's an archaeologist's dream to have a major find in front of a pub entrance, but it's actually a bit of a nightmare," Norway's leading expert on Viking ships told Britain's *Telegraph* newspaper. "The dig would take months, and we would need the permission of the brewery and the pub." Indeed, the discovery of such urban treasures often sparks heated disputes between cities and developers eager to create new buildings and scholars and archaeologists intent on preserving and studying such sites.

DISCOVERING OLD MANHATTAN

While European cities, particularly those in the Mediterranean region, will likely continue to be an archaeological jackpot, treasures discovered beneath the streets of considerably younger cities in the U.S. have also grabbed headlines in recent decades. In 1991, a burial ground containing the remains of more than 400 African-American slaves who lived in New York City during the 17th and 18th centuries was discovered during construction of the Foley Square Federal Building and courthouse in downtown Manhattan. Work on the site was halted to allow archaeologists to study the old cemetery and remove the bodies for interment elsewhere. A 25-ft. (7.6 m) black granite sculpture unveiled in 2000 now stands as a memorial at the site.

Close by the African burial ground, additional reminders of New York City's less-than-illustrious past turned up in the same dig: some 850,000 artifacts from Manhattan's infamous Five Points slum, an unsavory industrial district governed by gangs and prostitutes in the 19th century. Charles Dickens visited the site on his visit to America in the 1840s, and it was the setting for Martin Scorsese's 2002 film *Gangs of New York,* based on Herbert Asbury's classic 1928 book.

Today's scientists were delighted to find that time had transformed this onetime center of urban poverty into a site rich with history. Medicinal bottles, clay pipes and dishware were among the items recovered from the dig, but in a chilling clash between past and present, nearly all the artifacts were lost in the Sept. 11, 2001, terrorist attacks. Pending relocation to a permanent repository, the collection was being temporarily stored in the basement of 6 World Trade Center. The building was demolished when the Twin Towers collapsed.

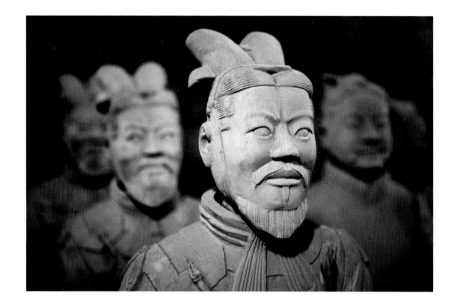

ALL THE KING'S MEN

One of the greatest archaeological discoveries of the 20th century was the product of pure chance. In 1974 a group of Chinese peasants digging a well unearthed the shards of a terra-cotta statue of a human figure that was later found to be 2,200 years old. That find outside the city of Xi'an, capital of China's northwest Shaanxi province, kicked off a process of recovery that is still under way: to date, more than 8,000 life-size figures of both warriors and horses have been recovered from the site, and more figures are recovered and reconstructed each year. Scientists believe there may be hundreds, even thousands, more works to be unearthed. No two of them are alike, leading scholars to believe the statues were modeled after real individuals. The vast array in clay is believed to have been created to honor the life of Qin Shi Huangdi, the first Emperor of China; it has generally been thought to constitute a martial honor guard for the Emperor's nearby mausoleum, which has yet to be excavated.

Even as new figures are unearthed, we are learning more about this magnificent terra-cotta display. In 2007 scientists from Beijing's Chinese Academy of Sciences revealed that they now believe the warriors and horses were constructed in different locations. The evidence: their analysis of the remains of vegetable pollens contained in the clay. Matching the pollens to local vegetation revealed that the horses were fabricated near the site in Xi'an, while the human figures were created at other sites in China not yet identified. The horses, which are more than 6 ft. long and weigh some 440 lbs., rest upon fragile legs, the scientists said, perhaps mandating their construction onsite to prevent accidents during transport.

Meanwhile, some scientists are rethinking the nature of the figures themselves: in April 2009, Liu Jiusheng, an associate professor of history at Shaanxi Normal University, posited that the statues do not represent an army. Rather, he said, they depict imperial court officials and servants. Ancient Chinese traditions and value systems, he argued, would never allow for warriors of humble origin to be placed in such close proximity to the Emperor.

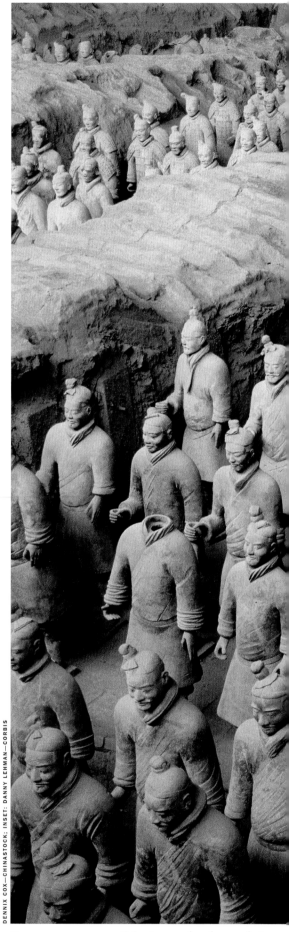

ORGANIC EVIDENCE *Scientists employed an analysis 32 different types of pollen in the figures, mostly from*

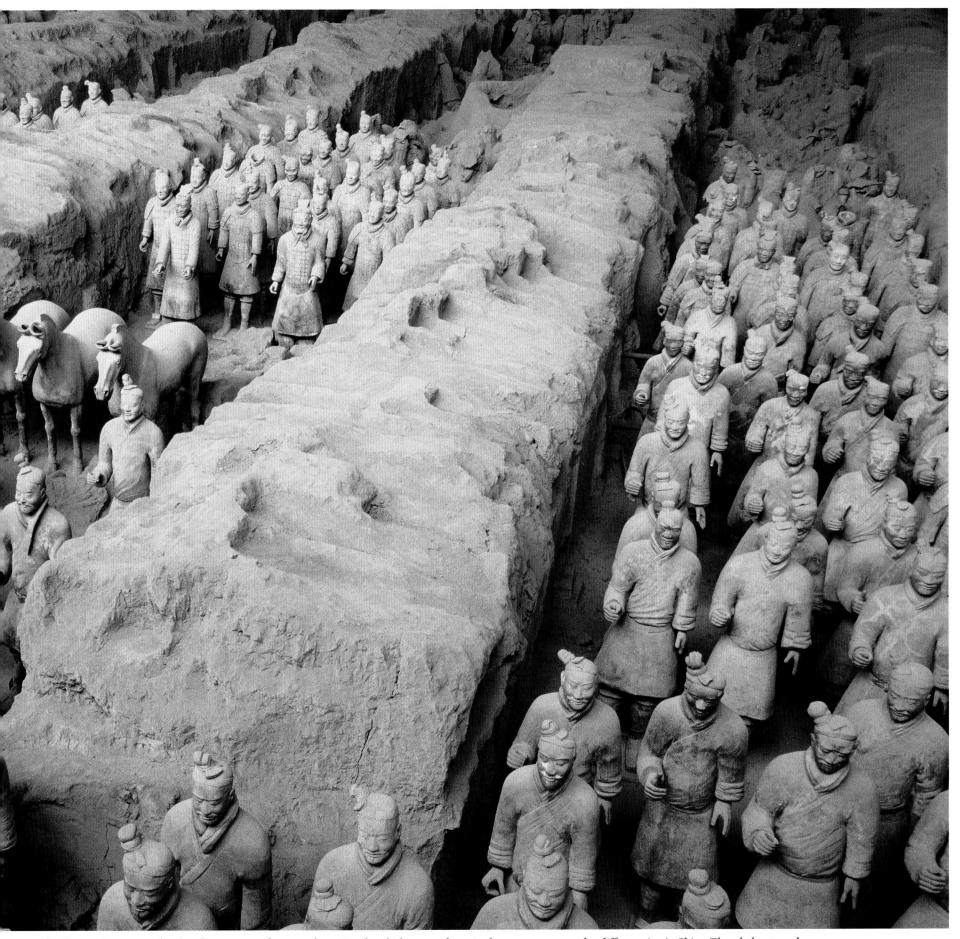

of pollen residue contained within the terra-cotta figures to determine that the horses and men in the group were created at different sites in China. The scholars traced some herbaceous and flowering plants. But the pollen in the clay from which the horses are made came mostly from trees indigenous to the Xi'an region, including pine, kamala and ginkgo

"They streched their beloved lord in his boat,

laid out by the mast, amidships,

the great ring-giver. Far-fetched treasures

were piled upon him, and precious gear."

—Beowulf, *translation by Seamus Heaney*

SUTTON HOO: THE RETURN OF THE KING

At some point in the early 7th century A.D., the followers of a great Anglo-Saxon king delved into the earth to create a suitable monument for their fallen monarch: his burial within a unique mausoleum, a seagoing ship some 90 ft. (27 m) long. To accompany the king on his journey to the afterlife, rich treasures were placed in the tomb, including marvelous goods of silver and gold imported from faraway Byzantium, Rome and northern Africa. The goal was to create a monument that would withstand time itself, as expressed in the Anglo-Saxon epic poem *Beowulf,* another artifact of this vanished, heroic age. That work calls for a hero to be interred in "a mound on a headland high and imposing, a marker that sailors could see from afar … As worthy of him as their workmanship can make it."

For some 13 centuries, this royal death-ship lay hidden beneath its mound on a high and imposing headland called Sutton Hoo in what was once the Kingdom of East Anglia and is now Suffolk, looming over the tidal river of Deben, which flows into the English Channel some seven miles (11 km)away. Other ceremonial graves surrounded this most imposing barrow. Grave robbers had plundered the area, but none had found its most precious riches. Then, in the late 1930s, the owner of the land, aware that the mounds on her property were most likely man-made and possibly contained some sort of remains of the past, decided to investigate. Edith May Pretty asked Basil Brown, a local archaeologist, to explore them. Brown dug into three small mounds, which he quickly identified as Anglo-Saxon graves. They had been plundered of burial treasure, but Brown also found iron ingots from a boat buried in one of the mounds.

In 1939 Brown began excavating the largest mound.

Eureka! A pattern of iron rivets outlined the shape of a mighty ship. Its wooden beams had rotted away, but they had left an imprinted stain in the soil. And the ship's treasure chamber had escaped plunder: within it were magnificent artifacts: weapons, brooches and clasps finely wrought in enamel and silver, elaborate purses filled with gold coins, ceremonial drinking vessels and a minstrel's lyre, as well as ornate objects crafted in distant lands and perhaps treasured as royal tribute.

The Sutton Hoo burial mound illuminated Britain's Dark Ages with a bright shaft of light, offering scientists the most tangible links with the age of the Angles and Saxons yet found in the U.K. Preliminary investigations, now widely accepted, identified the monarch buried in the tomb as King Rædwald of East Anglia, who died around A.D. 624. Rædwald lived at a pivotal time in British history: in the power vacuum created after the Roman legions withdrew from the province of Britannia in A.D. 410, invading groups of Angles and Saxons from Germany, along with Scandinavian tribes, were displacing and enslaving the native Celts and Britons. At the same time, Christianity was coming to the island. In the late 6th century, the missionary Benedictine monk Augustine of Canterbury, dispatched by Pope Gregory the Great to convert the pagans, succeeded in convincing many tribal monarchs to accept baptism. Rædwald was among those baptized by Augustine, yet he seems to have clung to the pagan traditions of his people—one of which, ship-burial, was apparently practiced only in East Anglia and Scandinavia.

Rædwald's age was a time when kings and warriors feasted in ceremonial halls accompanied by lyre-strumming

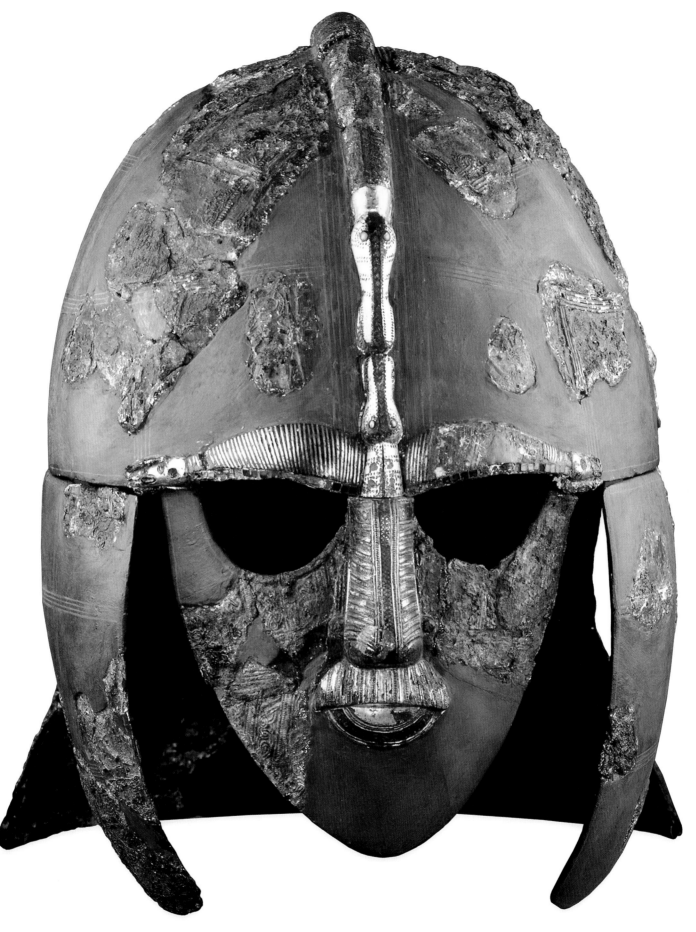

FACE OF WAR *The ceremonial iron helmet with bronze trim found within the burial ship resembles others from this period found in Sweden. It rusted in the grave after the roof of the burial chamber collapsed, was found in hundreds of tiny pieces and has been restored, with the original rusted fragments mounted on smooth modern metal*

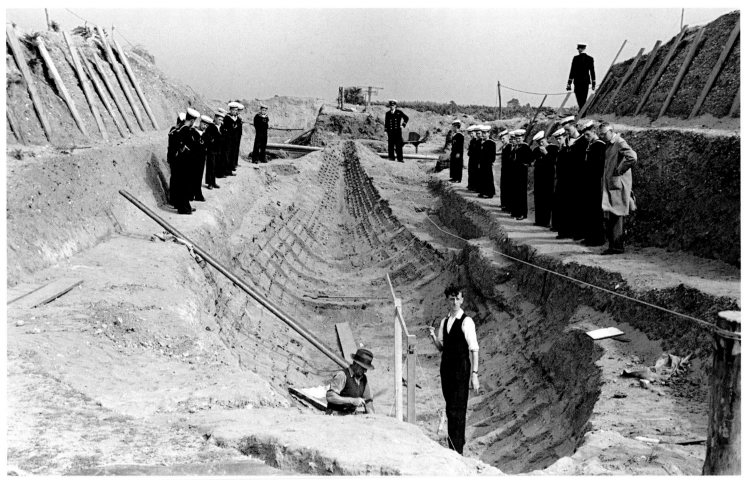

Unearthed *The buried ship was made of oak, and the midship burial chamber was 17 ft. (5 m) long. Scientists believe a royal body was placed in the ship, but no human remains have been found. Above, Royal Marine cadets visit the site in 1939, before the excavation was covered up after the start of World War II*

minstrels. It remains alive in the pages of *Beowulf*—and, for modern audiences, in the works of J.R.R. Tolkien, the Oxford scholar of ancient British tongues whose romances are rooted in this period. The figures of Rædwald's era might have stepped from Tolkien's pages, as warrior kings— Aethelbert of Kent, Sledda of Essex, Aethilfrith of Northumbria and Caewlin of Wessex—vied for supremacy. It was an age of tribal and clan loyalties, valor and treachery, treasure hoards and plunder, marriages of alliance and mighty battles. In one such contest, the Battle of the River Idle in 616, Rædwald's East Angles vanquished the forces of Aethilfrith of Northumbria, who was slain, as was Rædwald's son Rægenhere. Aethilfrith's sons fled, taking refuge with the Scots and Picts of the north. Some eight years later, Rædwald died and was given his royal burial.

Later Excavations

The discovery of the treasures at Sutton Hoo demanded further exploration of this world of ancient warfare—but the work was halted by modern-day warfare. As Britain plunged into World War II in September 1939, the burial mound at

Sutton Hoo was covered up, and during the war the British Army used the Pretty property to train troops against a new threat of German invasion across the Channel. It was not until 1965 that the site was opened again, under the direction of the British Museum, and additional significant objects were found during six years of excavations.

After exploration resumed in the 1980s, scholars found a warrior buried in full armor near the remains of a magnificently harnessed horse in a newly discovered mound. The welcome surprises continue: in 2000, as ground was dug up for the creation of a visitors' center and museum on the site, more burial mounds were revealed. One-third of the site remains unexplored, promising further revelations to come.

At the dedication of Sutton Hoo as a National Trust property in 2002, the Nobel-prizewinning Irish poet Seamus Heaney read from his acclaimed translation of *Beowulf*. Of the $5 million new museum that displays the Sutton Hoo treasures, he said, "This is what the burial sites described in the poem [*Beowulf*] were—a lavish expenditure of wealth for a purpose other than utilitarian, spent for its cultural and spiritual value. It has been well done."

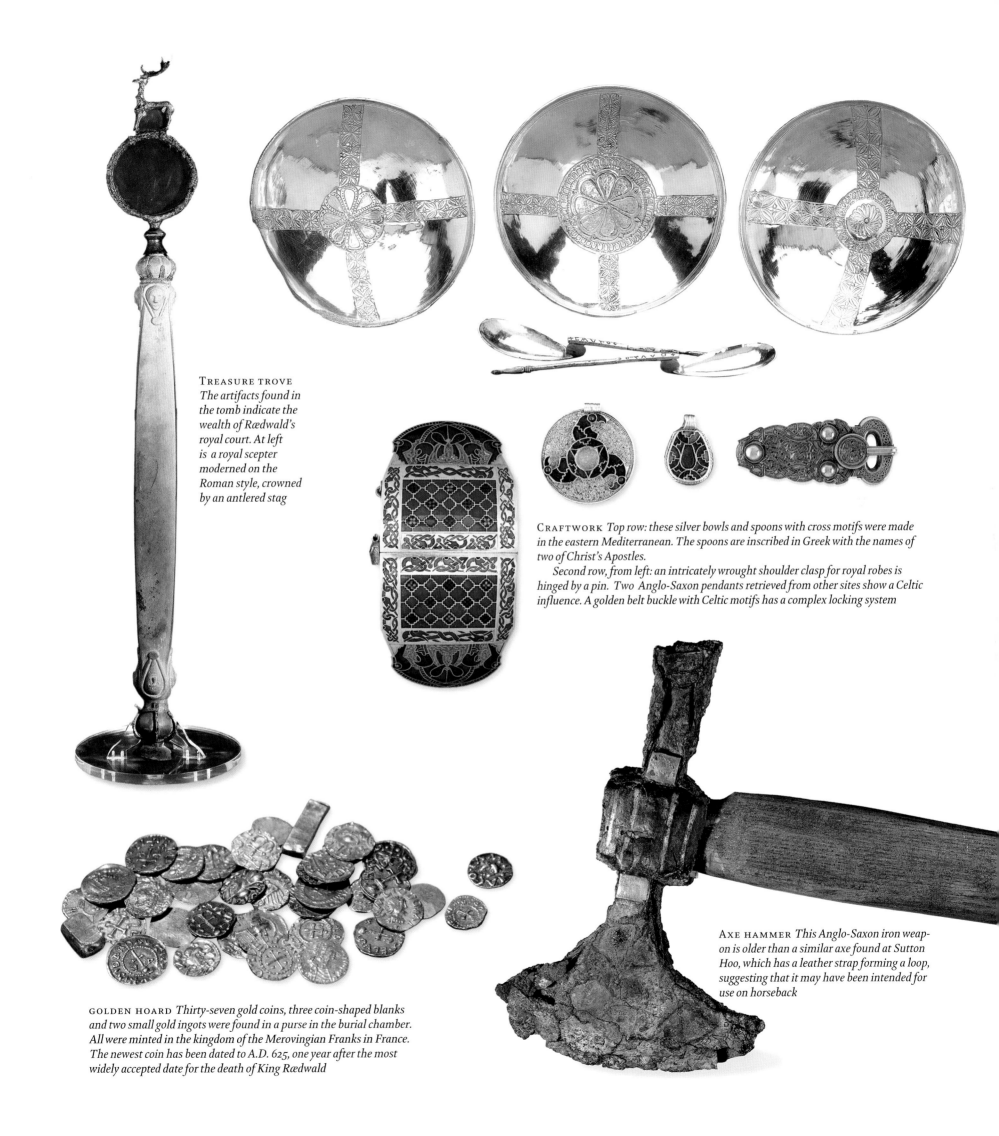

TREASURE TROVE *The artifacts found in the tomb indicate the wealth of Rædwald's royal court. At left is a royal scepter moderned on the Roman style, crowned by an antlered stag*

CRAFTWORK *Top row: these silver bowls and spoons with cross motifs were made in the eastern Mediterranean. The spoons are inscribed in Greek with the names of two of Christ's Apostles.*

Second row, from left: an intricately wrought shoulder clasp for royal robes is hinged by a pin. Two Anglo-Saxon pendants retrieved from other sites show a Celtic influence. A golden belt buckle with Celtic motifs has a complex locking system

GOLDEN HOARD *Thirty-seven gold coins, three coin-shaped blanks and two small gold ingots were found in a purse in the burial chamber. All were minted in the kingdom of the Merovingian Franks in France. The newest coin has been dated to A.D. 625, one year after the most widely accepted date for the death of King Rædwald*

AXE HAMMER *This Anglo-Saxon iron weapon is older than a similar axe found at Sutton Hoo, which has a leather strap forming a loop, suggesting that it may have been intended for use on horseback*

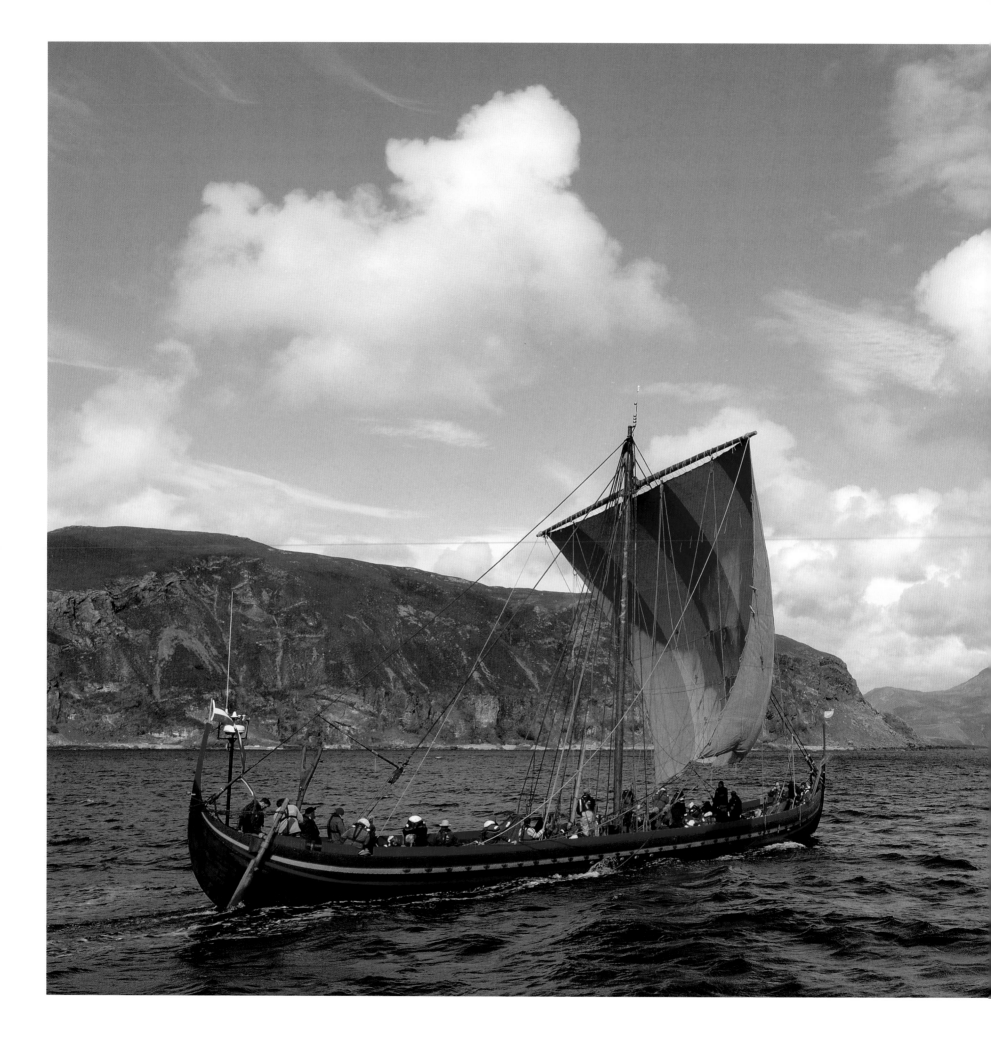

ON THE TRAIL OF VIKING NAVIGATORS

Ravagers, despoilers, pagans, heathens—such epithets pretty well summed up the Vikings for those who lived in the British Isles during medieval times. For hundreds of years after their sudden, bloody appearance at the end of the 8th century A.D., these ruthless raiders would periodically sweep in from the sea to kill, plunder and destroy, essentially at will. "From the fury of the Northmen, deliver us, O Lord" was a prayer uttered frequently and fervently at the close of the 1st millennium. Small wonder we think of these seafaring Scandinavians as little more than violent brutes.

But that view is wildly skewed. The Vikings were indeed raiders, but they were also traders whose economic network stretched from today's Iraq all the way to the Canadian Arctic. They were democrats who founded the world's oldest surviving parliament. They were master metalworkers, fashioning exquisite jewelry from silver, gold and bronze. Above all, they were intrepid explorers, whose restless hearts brought them to North America some 500 years before Columbus. In recent decades a spate of new scholarship, based largely on archaeological excavations in Europe, Iceland, Greenland and Canada, has begun to fill in the elusive details of their westward expansion and the persistent mysteries of how extensively the Vikings explored North America and why they abandoned their outpost in today's Newfoundland.

The term Viking (possibly from the Old Norse *vik,* meaning bay) refers properly only to men who went on raids. All Vikings were Norse, but not all Norse were Vikings—and those who were did their viking only part time. And while rape and pillage were part of the agenda, they were a small part of Norse life.

A FOLLOWING WIND *The* Sea Stallion from Glendalough, *a modern-day reconstruction of* Skuldelev 2, *one of the five Viking ships unearthed from a Danish fjord in the 1960s, sailed from Denmark to Dublin in 2007. The original ship was built near Dublin in A.D. 1042. The longship is 98 ft. (30 m) in length*

31

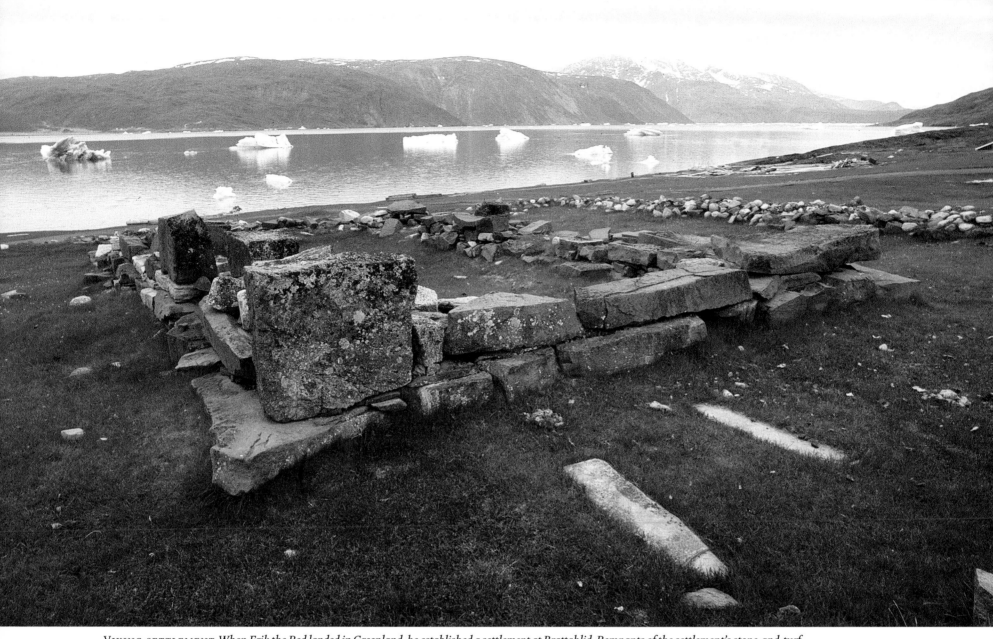

VIKING SETTLEMENT *When Erik the Red landed in Greenland, he established a settlement at Brattahlid. Remnants of the settlement's stone-and-turf buildings were discovered in 1961. Erick built his Christian wife a tiny church on the site, measuring about 12 ft. (3.6 m) long by 8 ft. (2.8 m) wide*

In fact, this mostly blue-eyed, blond or reddish-haired people who originated in what is now Scandinavia were primarily farmers and herdsmen. Like the ancient Greeks and Romans, they worshiped a pantheon of deities, three of whom—Odin, Thor and Freya—we recall every week, as Wednesday, Thursday and Friday. Their oral literature—epic poems known as *Eddas* as well as their sagas—was Homeric in drama and scope. And some of the sagas tell the story of Leif Eriksson and the Viking discovery of North America.

Most important, though, they made the finest ships of the age. Thanks to several Viking boats disinterred from burial mounds and fjords in Norway, archaeologists know beyond a doubt that the wooden craft were by far the finest craft then extant in the world. Sleek and streamlined, powered by both sails and oars, quick and maneuverable,

the boats operated equally well in shallow waterways and on the open seas. With these fine craft, the Norse searched far and wide for goods they couldn't get at home: silk, glass, sword-quality steel and silver coins that they could melt down and rework. In return they offered furs, grindstones, Baltic amber, iron, and walrus hides and ivory.

At first, the Norse traded locally around the Baltic Sea. But their explorations soon included the British Isles and the rivers of Russia. They reached Rome, Baghdad, the Caspian Sea, probably Africa too. The Hagia Sophia basilica in Istanbul has a Viking inscription in its floor. A Mycenaean lion in Venice is covered with runes of the Norse alphabet.

At a point in the late 8th century, however, the Vikings realized there was a much easier way to acquire luxury goods. The monasteries they traded with in Brit-

ain, Ireland and mainland Europe were not only extremely wealthy but also situated on isolated coastlines and poorly defended—sitting ducks for men with agile ships. With the raid on England's Lindisfarne monastery in 793, the reign of Viking terror officially began. But the Vikings didn't just pillage and run; sometimes they came to stay. Dublin became a Viking town; so did Lincoln and York, along with much of the surrounding territory in northern and eastern England.

LEIF ERIKSSON'S VOYAGE OF DISCOVERY

Given their hugely profitable forays into Europe, it's not entirely clear why the Vikings chose to strike out across the forbidding Atlantic. One reason might have been a growing population; another might have been political turmoil. The search for such exotic trade goods as furs and walrus ivory might have also been a factor. So westward the Vikings went. Their first stop, in about 860, was the Faeroe Islands, northwest of Scotland. Then, about a decade later, the Norse reached Iceland. Experts believe as many as 12,000 Viking immigrants ultimately settled there. In 930 Iceland's ruling families founded a general assembly, known as the Althing, at which representatives met annually to discuss matters of importance and settle legal disputes. The institution is still in operation today, more than a thousand years later.

In 982 the Althing considered the case of an ill-tempered immigrant named Erik the Red. Erik, a contemporary saga says, had arrived in Iceland several years earlier after being expelled from Norway for murder. He settled down on a farm, married a Christian woman named Thjodhild and had three sons, Leif, Thorvald and Thorstein, and one daughter, Freydis. It wasn't long, though, before Erik began feuding with a neighbor and ended up killing again.

The Althing decided to exile him for three years, so Erik sailed west to explore a land he had heard about from sailors who had been blown off course. Making his way around a desolate coast, he came upon magnificent fjords flanked by lush meadows and forests of dwarf willow and birch. This "green land," he decided (in what might have been a clever bit of salesmanship), would be a perfect place to live. In 985 Erik returned to Iceland and enlisted a group of followers to help him found the first Norse outposts on Greenland.

Erik the Red established his base at Brattahlid, a verdant spot at the neck of a fjord on the island's southwestern tip. The remains of the main stone-and-turf building he erected there were found in 1961. The most spectacular discovery from the Greenland colonies, however, was made in 1990, when two Inuit hunters searching for caribou about

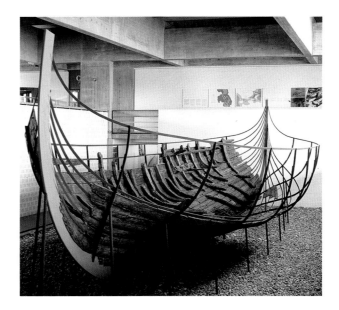

THE FLEET SHIPS OF MASTER NAVIGATORS

Scholars don't simply surmise that the Vikings built the most advanced ships in the world in their heyday—they have actually touched the timbers of these impressive craft, thanks to two major finds. The first was the discovery and retrieval of a fully intact Viking ship from a royal burial mound located at the Oseberg Farm in Tonsberg, a coastal town in Southern Norway. The ship was excavated in 1904-05. The mound has been dated to A.D. 834, very close to the date assigned to the Anglo-Saxon ship found at Sutton Hoo, U.K., but the Norse ship itself is even older. Although it is large, at 72 ft. (22 m) long and 16 ft. (5 m) broad, it is relatively fragile, has oar holes for 30 rowers and is covered with rich carvings, suggesting it was a regal craft used for coastal trips rather than open-sea navigation.

The second major discovery was the retrieval of five 11th century ships that had been deliberately sunk to form a barrier across Roskilde Fjord near Skuldelev, Denmark. The site was long known to locals, who liked to believe the remains were of the royal ship of Queen Margaret, who reigned around

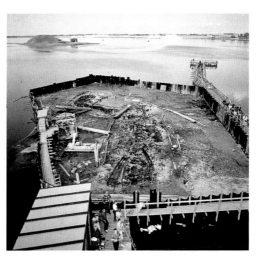

A.D. 1400. Archaeologists built a cofferdam, left, and unearthed the ships in the early 1960s. Above is the ship designated *Skuldelev 1*. The sturdy vessel is 52 ft. (16 m) long and 15 ft. (4.8 m) wide, and would have carried a crew of six to eight Norsemen.

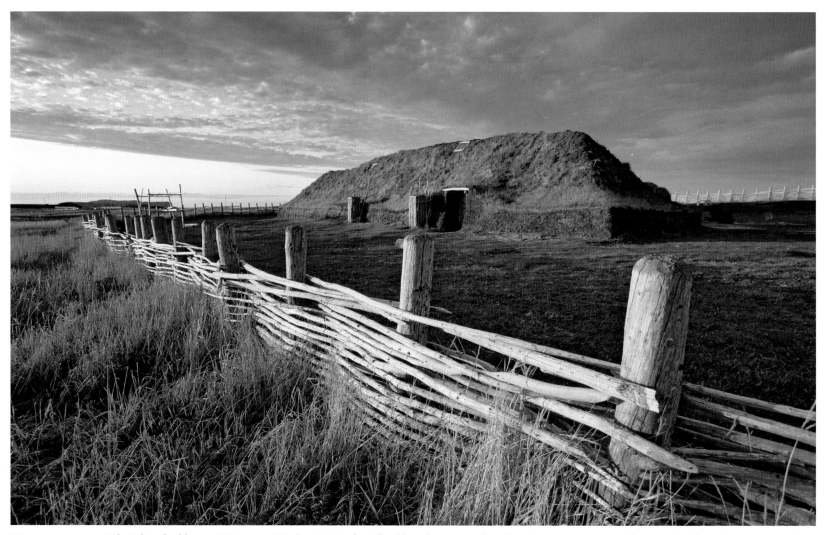

HOME OF THE BRAVE *The Viking buildings at L'Anse aux Meadows in Newfoundland have been restored, and modern reconstructions of surrounding fences have been installed. Remains of eight structures were found, composed of wooden frames covered with sod. The site is now a Canadian national historic park*

55 mi. (88km) east of Nuuk (the modern capital) noticed several large pieces of wood sticking out of a bluff. Because trees never grew in the area, they reported their discovery to the national museum. The wood turned out to be part of an enormous Norse building, completed after Erik's death, perfectly sealed in permafrost and covered by 5 ft. of sand. Occupied from the mid-11th century to the end of the 13th century, this structure in its final form was a huge, multi-function building with more than 30 rooms housing perhaps 15 or 20 people, plus sheep, goats, cows and horses.

Sometime between 997 and 1003, Erik's eldest son Leif decided to sail westward to find a new, timber-rich land supposedly seen by a local captain. First, say the sagas, the crew came to a forbidding land of rocks and glaciers. Then they briefly dropped anchor in a tree-lined bay. Eventually they continued south to a place he called Vinland ("Wineland," probably for the wild grapes that grew there). Leif and his

party made camp for the winter, then sailed home. Members of his family returned in later years, but Leif never did. Erik died shortly after his son returned, and Leif took over the Greenland colony and ceased his explorations.

THE VIKING SETTLEMENT IN NEWFOUNDLAND

This much had long been known from the Icelandic sagas, but until 1960 there was no proof of Leif's North American sojourns. That year, after a long search of eastern coasts, noted Norwegian explorer Helge Ingstad and his wife, archaeologist Anne Stine Ingstad, went to explore a place in Newfoundland identified on an Icelandic map from the 1670s as "Promontorium Winlandiae," near the small fishing village of L'Anse aux Meadows, in the province's northern reaches. They hoped that it marked an ancient Norse settlement.

Once at the site, finding the settlement turned out to be absurdly easy. When the Ingstads asked the locals

if there were any old ruins in the area, they were taken to a place known as "the Indian camp." They immediately recognized the grass-covered ridges as Viking-era ruins like those in Iceland and Greenland. During the next seven years, the Ingstads and an international team of archaeologists exposed the foundations of eight separate buildings. Sitting on a narrow terrace between two bogs, the buildings had sod walls and peaked sod roofs laid over a (now decayed) wooden frame; they were evidently meant to be used year-round.

The team also unearthed a Celtic-style bronze pin with a ring-shaped head similar to ones the Norse used to fasten their cloaks, a soapstone spindle whorl, a bit of bone needle, a small whetstone for sharpening metal, lumps of worked iron and iron boat nails. All these items helped win over detractors, since the artifacts were clearly not native to America.

Further excavations in the mid-1970s under the auspices of Parks Canada, the site's custodian, turned up loom weights, another spindle whorl, a bone needle, jasper fire starters, pollen, seeds and about 2,000 scraps of worked wood that were subsequently radiocarbon dated to between 980 and 1020—just when Leif visited Vinland.

The siting of the ruined buildings, the paucity of artifacts and garbage compared with those found at other sites and the absence of a cemetery, stables and holding pens for animals convinced archaeologists that L'Anse aux Meadows was used for perhaps less than 10 years. Instead, they believe, it served as a base camp for exploratory expeditions along the coast, perhaps as far south as the Gulf of St. Lawrence.

The Norse did not secure their footholds in the New World. While digs at ancient Inuit sites in the eastern Canadian Arctic and western Greenland have turned up a wealth of Norse artifacts, indicating that the Europeans and Arctic natives interacted long after Leif Eriksson and his mates left, the Vikings departed Greenland by 1450. One reason was climate change. Starting about 1350, global temperatures entered a 500-year slump known as the Little Ice Age. Another factor was the rapacious overuse of scant local resources. And plagues and poverty in Europe lessened demand for trade goods from the Vikings' outposts in North America.

Back in their Scandinavian homeland, the Vikings' descendants united into kingdoms that became Norway, Sweden and Denmark. The Norse scattered around Britain and Europe, intermarried with the locals and disappeared as a distinct people. Unlike Columbus, the Vikings did not establish a permanent presence in North America. But given the millions of Americans who share at least a bit of Viking blood, they are still with us in spirit.

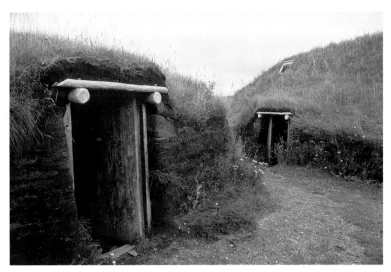

ENTER! *The original post-and-lintel wooden door frames had long rotted away at L'Anse aux Meadows. The name is a corruption of the French for "jellyfish bay"*

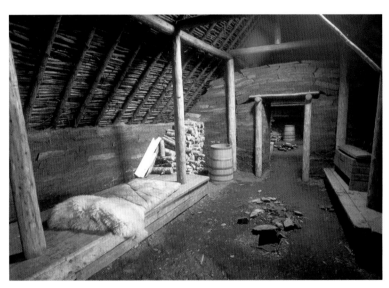

EVER SO HUMBLE *The long, bitterly cold Canadian winters would have kept the Norse settlers in their sod homes, warmed by stone hearths in the center of the floor*

ON LEIF'S TRAIL *L'Anse aux Meadows discoverer Helge Ingstad, right, is one of the great romantic figures of 20th century exploration. The Norwegian left a law practice in his youth to live with Inuit natives of the Arctic and also studied pre-Columbian tribes in Mexico. He found Leif Eriksson's Newfoundland settlement after searching along the coastlines of Canada and the U.S. for some 10 years. Ingstad died in 2001, at age 101*

HUMAN TIME CAPSULES: THE BOG BODIES

The year was 1835. The place was the Haraldskær Estate on Denmark's Jutland Peninsula. Laborers were engaged in routine daily toil, carving out bricks of peat from a dismal bog on the estate, to be burned for warmth. As they cut through the mossy turf, they unearthed the limbs, then the entire body, of a human being. The corpse was in a strange state of suspended animation, partially decayed yet partially preserved: its bones had become soft, but its skin, hair and features were lifelike, as though it had been placed in the bog only recently. Yet we now know that the corpse was that of a woman who had died more than 2,300 years earlier and whose body had been preserved by the unique chemistry of the bog. This was the first recorded discovery of a "bog body," though no doubt others had come before.

In the decades that followed, more and more "bog people" have come to light, offering scientists a rare window into the past. These eerily preserved time capsules in human form allow us to examine what our ancestors ate and what clothes they wore, even how they styled their hair. But this cadre of the dead raises as many questions as it answers: Were these bodies—many of which bear the record of acts of extreme violence—deliberately placed in the bogs? And if so, why? The attempt to answer such questions has helped illuminate the broader practices of ancient societies, cultures and religions.

Scientists do know the reason why the bodies are so well preserved: the answer is in the peat. Peat bogs are unique ecosystems that form in low-lying land covered by sphagnum moss. Such land-

HANGED UNTIL DEAD *Tollund Man's skin, like that of all bog people, has been preserved and transformed into a sort of human leather by the chemistry of the peat bog in which it was found. At top left is a sprig of sphagnum moss, the substance that forms peat bogs*

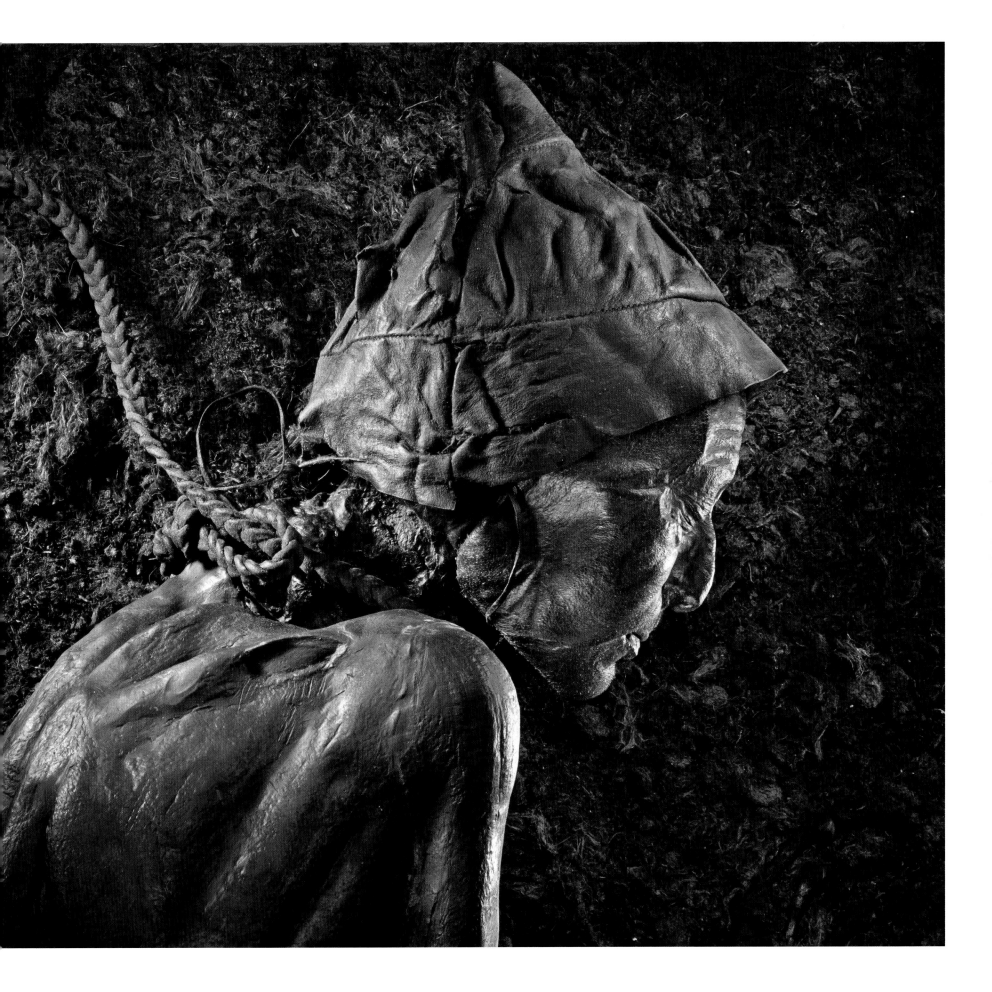

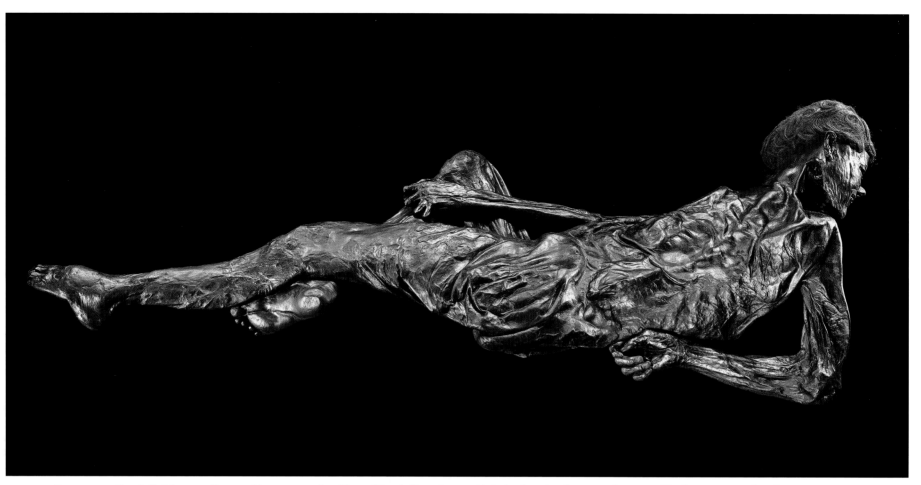

EXECUTED *Grauballe Man was discovered in 1952 near the village of Grauballe on Denmark's Jutland Peninsula. His neck is twisted back at an unusual angle, as a result of his death from a very deep slash into the throat. But some of the additional damage to the corpse, once viewed as deliberate, may have been accidental*

scapes often become waterlogged and acidic, shutting out both oxygen and bacteria. And absent those substances, normal processes of decomposition are halted. Meanwhile, the moss accumulates in layers, forming peat. Nourished by minerals contained in ocean spray, such peat bogs near saltwater shores can be more than 12 ft. (3 m) deep. This recipe for a peat bog is also the recipe for the preservation of dead bodies, for the marsh water is filled with humic acid, or bog acid, a natural tannin that forms a sort of brine that preserves skin and turns it into a brownish, human leather. Bog bodies are, essentially, pickled. Their bones, meanwhile, are leached of minerals by bog acid, and become soft.

After the 1835 discovery of the female bog body—soon dubbed Haraldskær Woman—intrigued scientists began investigating the phenomenon of bog preservation. With the development of modern machinery for the harvesting of peat, the discoveries have come faster. As of 2009, more than 1,000 bog bodies have been retrieved. Thanks to modern radiocarbon-dating technology, we now know that most of the bodies date to a period ranging from the 5th century B.C. to the 5th century A.D.—although bodies have been found dating from 8,000 B.C. to well into the Middle Ages.

The bodies have been unearthed over a wide swath of northern Europe, including lower Scandinavia, the Netherlands, Britain and Ireland. The Jutland Peninsula remains the most active region for the discovery and study of these remains, while much of Ireland also is conducive to peat bogs and the unique specimens of the past they preserve.

UNHALLOWED GROUND

It's the location of the bodies that sends shivers quivering up modern spines, for scientists believe many of the bodies were deliberately placed in the bogs as a sign of disrespect. Before the advent of Christianity in northern Europe, bodies were either cremated or buried in reserved ground. In contrast, burial in a peat bog—eerie in feel and appearance, a form of terrain midway between water and land—might clearly bear the onus of a curse. Indeed, scientists believe that many of the bog people were executed, either as criminals, social deviants or outcasts, or as ritual victims of pagan sacrifice, then placed in the bogs as a form of eternal damnation. And the record of their manner of execution is written on their bodies and preserved by the peat.

One such victim is the bog body known as Tollund

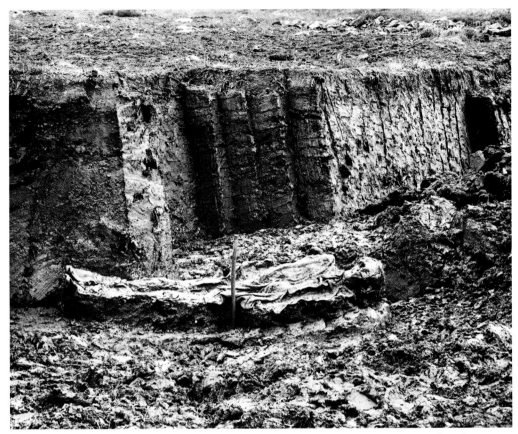

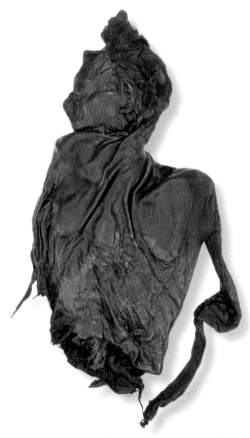

PRESERVED BY PEAT *The first photograph of a bog body taken at the location where it was found was made in 1898 in Nederfrederiksmose in Denmark. Although few artifacts have been recovered along with the bodies, samples of clothing, ranging from cloaks to shoes and undergarments, have been preserved*

NOBLE SACRIFICE? *Clonycavan Man, a recently discovered Irish bog body, had his tall hairdo held in place by pomade, perhaps an indication of high status*

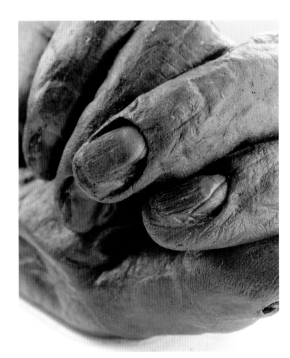

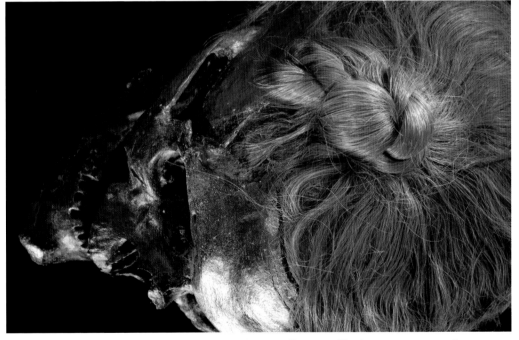

EVIDENCE *The hands of Old Croghan Man were so well preserved that investigators took high-quality fingerprints from the Irish corpse. Manicured fingernails suggest a person of high status unused to manual labor*

KINGDOM OF THE REDHEADS *Like human skin, hair is well preserved by the tannins contained in bog acid, but after long centuries in the peat, the hair is dyed red. The hair of this body, Osterby Man, was wound into a style called a Swabian knot, typical of the Suebi tribe of Germany, where the body was found*

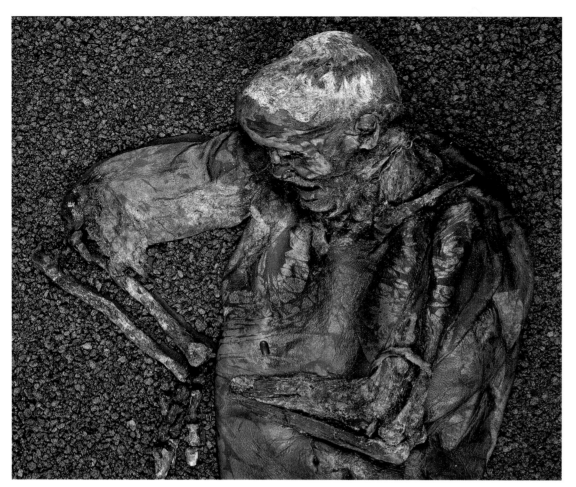

LINDOW MAN *The body was discovered in 1984 at the Lindow Moss bog in northwest England. The remains were dated to between 20 and 90 A.D. He was about 25 years of age. The corpse shows signs of torture and ritual killing*

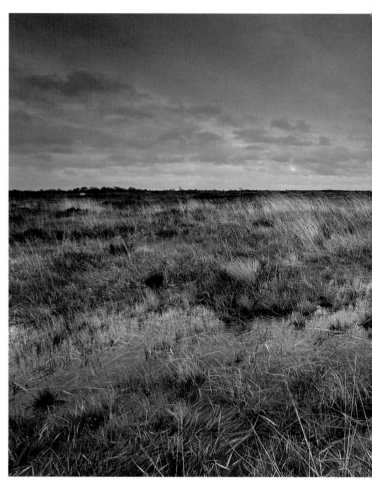

PRESERVED *The Danish bog where Tollund Man was found suggests the Neither land nor sea, these environs may have been looked upon by the*

Man. His full corpse was found in 1950 by two brothers digging peat outside the village of Tollund on the Jutland Peninsula. The body lay some 7 ft. (2 m) beneath the surface of the bog. His face was so lifelike that the brothers believed he was a murder victim, and the police were called in. And indeed, Tollund Man probably was deliberately killed—but around 2,400 years ago, in 400 B.C. Around his neck, the leather cord with which he was hanged remained intact. His corpse was also intact, although scientists in 1950 chose to sever his head and let the body decay. Tollund Man is currently displayed at the Silkeborg Museum in Denmark, near Tollund, although only the head is original.

Why was this man executed? An autopsy conducted in 1950, and a second in 2002, indicated that he was a hanging victim; his distended tongue was a clear sign of such an end. His age was estimated at 30 years. Scientists analyzed the contents of his stomach and found that his last meal, eaten perhaps a day before his death, consisted of a porridge that contained a large quantity of ergot fungus found on rotted rye. This natural hallucinogenic, a relative of LSD, may be a sign that Tollund Man was participating in pagan religious rites, in which his mental state was deliberately altered

before he was hanged. Perhaps he constituted a ritual sacrifice, whether voluntary or not. Danish archaeologist P.V. Glob, who studied the body in 1950, posited that Tollund Man was the victim of ancient fertility rites.

Or perhaps he wasn't. What we do know is that the residents of northern Europe at this time indeed engaged in human sacrifice as a means of soliciting the favor of the gods for a host of reasons: for victory in times of war, for calm in times of upheaval, for fertility and abundance at all times. Nor were executions entirely sacrificial: social outcasts such as homosexuals or alleged witches, even the physically disabled, may also have been targeted for death.

Yde Girl, a 16-year-old female discovered in 1897 in the Netherlands, may have been one such victim. A band of fabric was wound around her neck, suggesting that she had been strangled. Carbon dating has revealed that she lived and died around the period 100 B.C. to A.D. 50. More than 100 years after her discovery, Richard Neave of Britain's Manchester University, a specialist in facial reconstruction, took a CT scan of the skull of Yde Girl and determined that she suffered from a physical deformity, the spine-twisting disease scoliosis. Perhaps she had been strangled as an

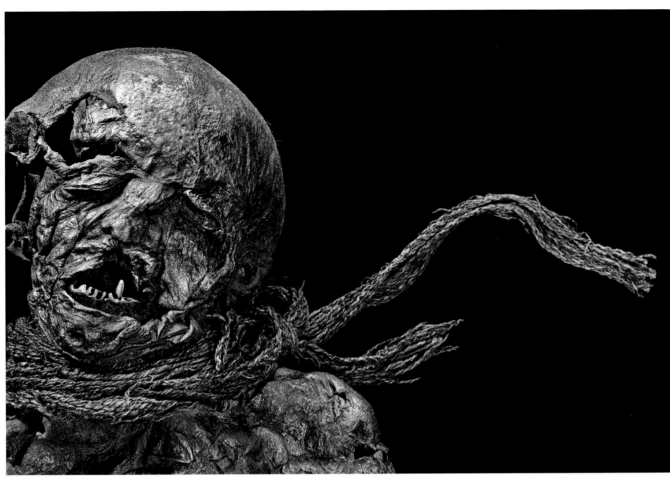

appeal of such landscapes as a form of netherworld.
ancients as fitting repositories for unworthy souls

STRANGLED *The fabric belt around the neck of Yde Girl is believed to be the instrument used in her execution. The body was discovered in the Netherlands in 1897 near the village of Yde. In addition to the fabric around the neck, a woolen cloak was found with the body*

outcast or as a sacrifice to prevent such maladies from striking in the future. And such misfits, of course, could not be buried next to one's family or, more likely at this time, cremated; instead, they were bog fodder.

ROYAL SACRIFICES?

Yet it's easy to overreach as we attempt to reconstruct the past based on fragmentary knowledge. For every positive identification of the fate of a bog person, there are examples of false conclusions, too easily drawn. One such cautionary tale involves the fate of Grauballe Man, found in Jutland in 1952. There was little doubt about the manner of his death: his throat had been slashed so deeply by a blade that it nicked a vertebra. But scientists also noted that his skull had been fractured and his leg broken, leading them to suspect that he had been tortured, then executed. But a team of forensic investigators later concluded that these violations of the corpse were more likely the result of the excavation process, during which a boy wearing clogs accidentally stepped on the fragile corpse. As for the Windeby Girl, unearthed in Germany in 1952, whose close-cropped hair was once thought to have been shaved as a sign of adultery: recent DNA tests suggest that this bog body should more properly bear the name Windeby Boy.

In some cases, the fate of a bog body opens vistas on a world that is so foreign to us as to be unfathomable. Consider the bodies of two young men found 25 miles (40 km) apart in Ireland, in 2003. Old Croghan Man and Clonycavan Man both showed the signs of violence. Old Croghan Man's nipples had been sliced—a sign of torture, some scientists believe, or perhaps a gesture negating nurturing and fertility, others suggest. His arms had been pierced and small bands of twisted hazel had been passed through them. Clonycavan Man's hair bore traces of a pomade that included resin imported from France, perhaps a sign he was of noble birth. Eamonn Kelly, Keeper of Irish Antiquities at the National Museum of Ireland, believes he was likely a royal sacrifice to the gods. But whatever the reason for the young man's untimely demise, Kelly reminded Britain's *Daily Mirror* newspaper, "These are our ancestors and we should treat them with the greatest of respect. They died in a particularly horrific and terrifying manner. We owe it to them to ensure that their terrible end isn't trivialised or sensationalised. They give us an insight into the dark side of human nature."

THE PUEBLO: EXODUS OF THE CLIFF DWELLERS

Visitors to the Four Corners area of the U.S. Southwest—the quadrant where Utah, Arizona, Colorado and New Mexico meet—marvel at the magnificent, complex cliff dwellings created by ancient Pueblo tribes in the centuries before Europeans came to the Americas. But these imposing ruins are as mysterious as they are marvelous, for scientists are still probing the history of these sites, which were first inhabited around A.D. 1150, only to be abandoned, seemingly in haste, some 150 years later. Why the sudden exodus? The long-accepted explanation blames an unexpected change in climate, but some scholars suspect other factors may have led to the virtual abandonment of these sites.

The Pueblo Indians who built the cliff houses are often called the Anasazi, but that term is increasingly rejected by today's Pueblo and scholars: it was coined by the Navajo, their foes, and it means "ancient enemies." Modern-day Pueblo are the direct descendants of these ancient tribes, who around A.D. 500 to 900 primarily lived along rivers in the desert landscape of the Four Corners region and built "pit houses"—chambers dug into the ground and roofed over with wooden beams, thatch and mud—for homes. Beginning around 700, these tribes began to enjoy a population boom, perhaps as a result of an improved climate that provided additional water for agriculture. The Pueblo, once hunters and gatherers, had learned to capture water in irrigation canals, growing crops in the silt that collected along their banks.

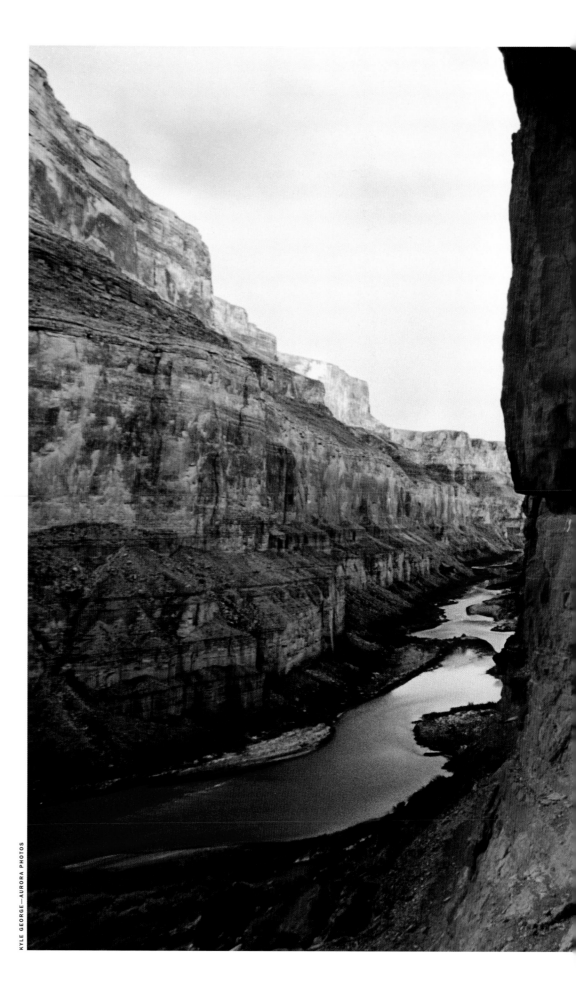

KYLE GEORGE—AURORA PHOTOS

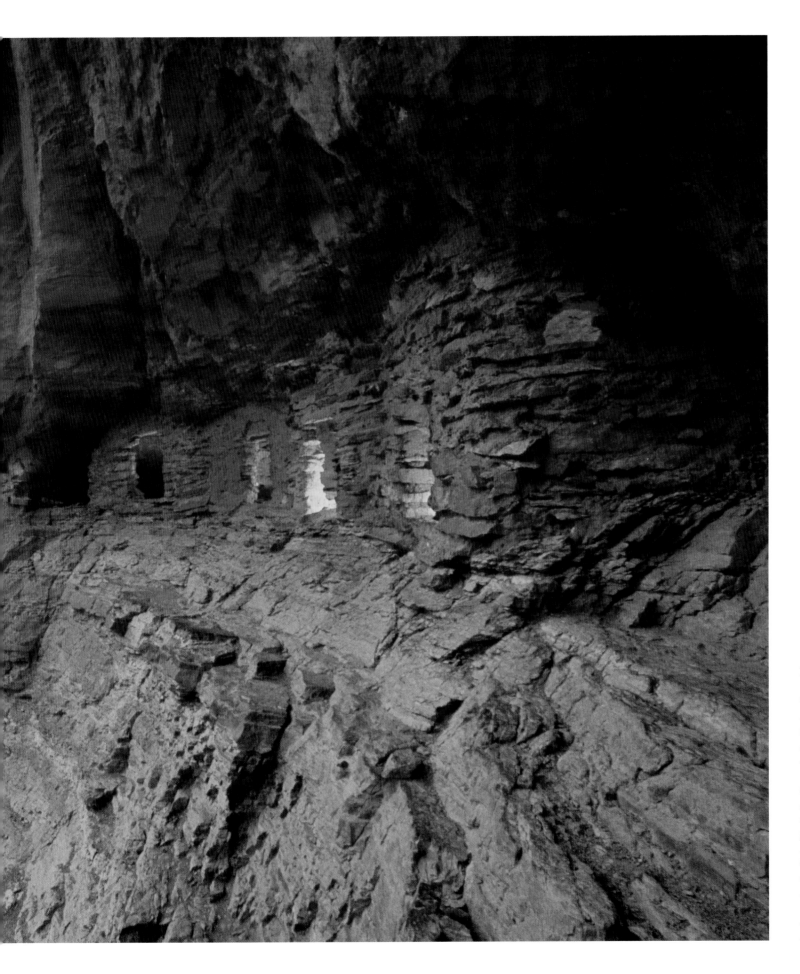

ILLUMINATIONS
Glowing from within, windows in an ancient Pueblo cliff dwelling overlook the Colorado River in Grand Canyon National Park, Arizona. The cliff complexes and Pueblo Great Houses are preserved in a number of federally protected areas in the Four Corners region, including Mesa Verde and Chaco Culture National Parks and, Canyon de Chelly and Hovenweep National Monuments

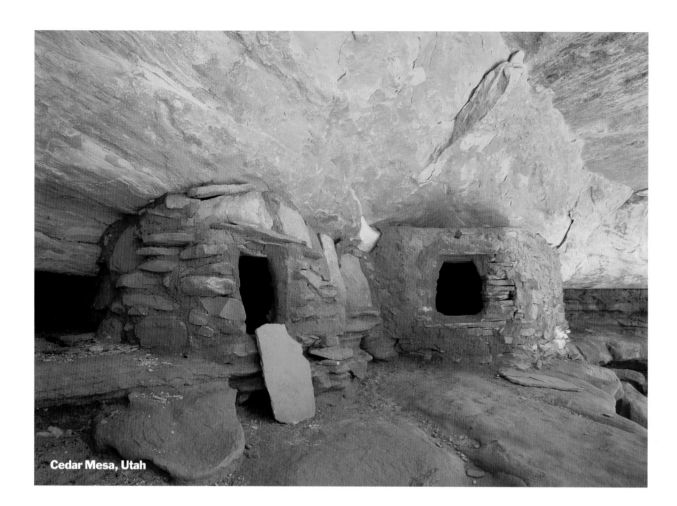

Cedar Mesa, Utah

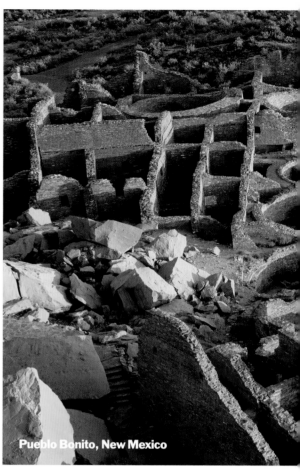

Pueblo Bonito, New Mexico

Up until 1100 or so, the population boomed, most likely as a result of a long period of good weather and adequate water supplies. Agriculture, trade and the arts, especially pottery, advanced. And some of the Pueblo began creating the cliff dwellings that are a testament to their advanced culture. These adobe structures were elaborate, multichambered labyrinths that were generally located under a projecting overhang, providing shelter from the elements. The siting also conferred a martial advantage: any adversaries could attack only head on—and uphill. Some of these cliff towns were accessible only by rope or rock climbing. Many of the small rooms of the cliff dwellings were used to store food, while others were sleeping chambers. Some rooms held dead bodies, while others were circular religious rooms, or kivas; daily life took place in open-air plazas. Some Pueblo chose to live in "Great Houses," elaborate adobe complexes not completely sheltered by cliffs.

Then, seemingly abruptly, the Pueblo began migrating from the Four Corners, abandoning their cliff homes as well as their Great Houses in favor of locations farther south—even though the weather there was not substantially superior. By the year 1350 they were largely gone. The first travelers of European descent to visit these sites arrived more than 500 years later, in the 1860s and '70s: they were mountain men,

explorers and U.S. Army scouts, followed by federal surveying parties and a few scholars, including the Finn Gustaf Nordenskiöld, the first to recognize the significance of such sites as Mesa Verde's famed Cliff House. Sadly, in the decades that followed, the sites were vandalized and pillaged by white settlers who sold invaluable artifacts as souvenirs and burned ancient roof beams for firewood. It was not until the mid-20th century that the U.S. government stepped in to begin protecting the sites as national parks.

The mystery remains: What led to the sudden decline of the ancient Pueblo civilization? Scientists long believed the cause was a pair of droughts that began around 1130, which also led to the collapse of several other pre-Columbian civilizations in the Americas. And there is little doubt that climate change played a role in the Pueblo exodus. But some scientists now believe that other factors may also have hastened the migration south. These scholars point to signs of social and religious turmoil: the shape of the kivas changed, suggesting the appearance of new religious practices, and incursions by antagonistic tribes may have led to a new emphasis on building defensive fortifications. The raiders who left behind Pueblo dead whose bodies showed signs of violence, even cannibalization, moved on—and so, ultimately, did the cliff dwellers.

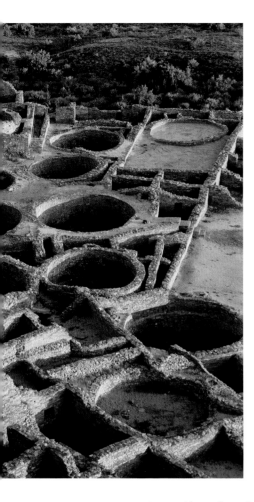

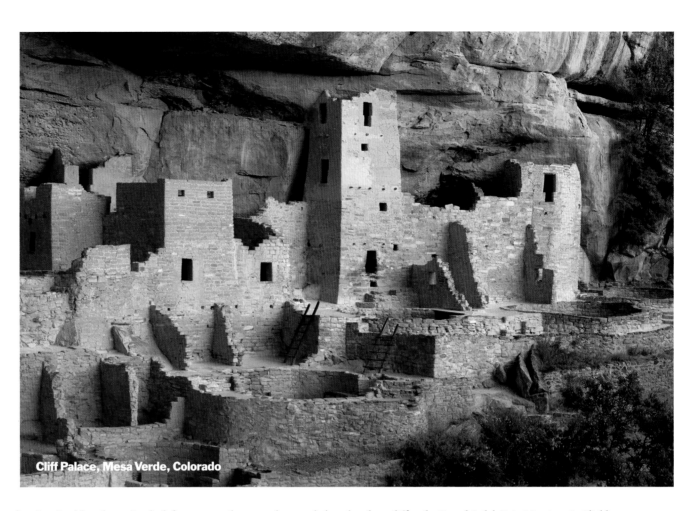

Cliff Palace, Mesa Verde, Colorado

RUINS *Above, three sites of ancient Pueblo culture. On the left are two early rooms that are sheltered under a cliff at the Grand Gulch Primitive Area in Slickhorn Canyon in Cedar Mesa, Utah. At center is the Pueblo Bonito, a vast complex of rooms and kivas (circular rooms used for religious ceremonies) at the Chaco Culture National Historical Park in New Mexico. The structure is the largest remaining example of a Pueblo Great House. At far right is the most famed of the Pueblo dwellings, the Cliff Palace in Mesa Verde National Park in Colorado. The structure was built around A.D. 1190 to 1280 and probably sheltered some 100 people*

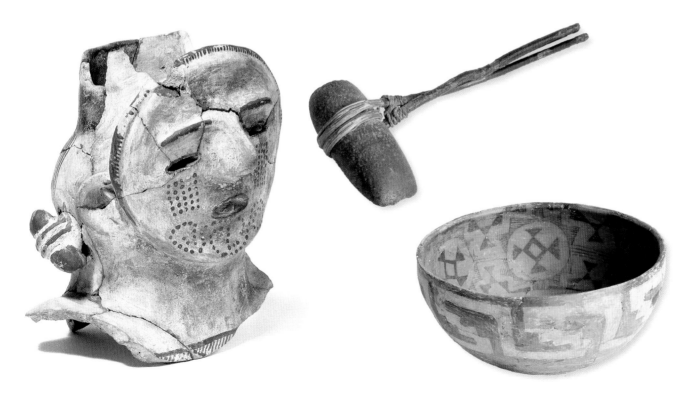

ARTIFACTS *Products of the ancient Pueblo culture show a high degree of craftsmanship in arts such as pottery, but a more primitive approach to basic tools.*

At far left is an elaborate pottery vessel in the shape of a human head, dated to A.D. 919 to 1050. At the center is a stone axe bound with willow twine.

On the right is a pottery bowl dated to 1300, during the exodus period. Like other tribes of the U.S. Southwest, the Pueblo excelled at pottery making, covering bowls and jars with colorful geometric motifs

45

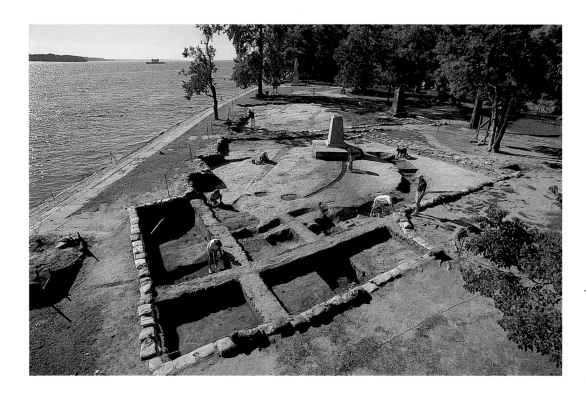

UNEARTHING THE PAST
Archaeologists work on exposing the stone foundations of buildings located within the wooden palisades of the fort. The James Fort complex was long presumed to have been covered by the waters of Chesapeake Bay, but most of it has now been located on land. A sea wall built in 1900 helped preserve the site

CURRENT EXPLORATIONS

JAMESTOWN: REDISCOVERING BRITAIN'S FIRST ENDURING SETTLEMENT IN AMERICA

On May 14, 1607, three ships hired by the London Co., a group of British merchants awarded a royal charter to launch a colony in the New World, landed on an island in Chesapeake Bay. The 144 passengers and crew of the *Susan Constant,* the *Godspeed* and the *Discovery* had endured a miserable Atlantic crossing after embarking from Britain on Dec. 20, 1606. They selected Jamestown Island—named to honor their King—as the site of their outpost because of its strategic location, which guarded against attack from the sea by Spanish foes. But it was the local Powhatan Indians, rather than envious Europeans, who soon launched an assault on the settlers.

Within a month of their landing, the colonists realized they needed a log palisade to protect them from Indian arrows. So they went to work: in 19 days and in a June swelter they cut and split more than 600 trees weighing 400 to 800 lbs. each and set them in a triangular trench three football fields long per side and 2½ ft. (0.75 m) deep. In 2004 New Line Cinema built a replica of the fort for its film *The New World* and did it in about the same amount of time—using modern power tools.

When archaeologists first started digging in Jamestown in the 1930s, they turned up more than half a million artifacts—but not a trace of the original fort. In fact, nobody expected to find it. According to a handful of written eyewitness accounts and two maps, the James Fort was widely believed to have been built at the west end of Jamestown Island, close to the deepwater channel where the colonists presumably moored their ships. The river had washed away some 25 acres of that part of the island long ago, however, and most archaeologists figured the fort site had ended up on the river bottom.

William M. Kelso disagreed. Unlike his colleagues, Kelso, a specialist in colonial American archaeology who began working for the Association for the Preservation of Virginia Antiquities in 1993, was convinced that the fort lay instead somewhere close to the brick church tower built in 1690, the only surviving structure from the colony's first century. So on April 4, 1994, he put his shovel in the ground. In less than an hour he turned up fragments of early-17th century ceramics. Kelso and a team of volunteers next uncov-

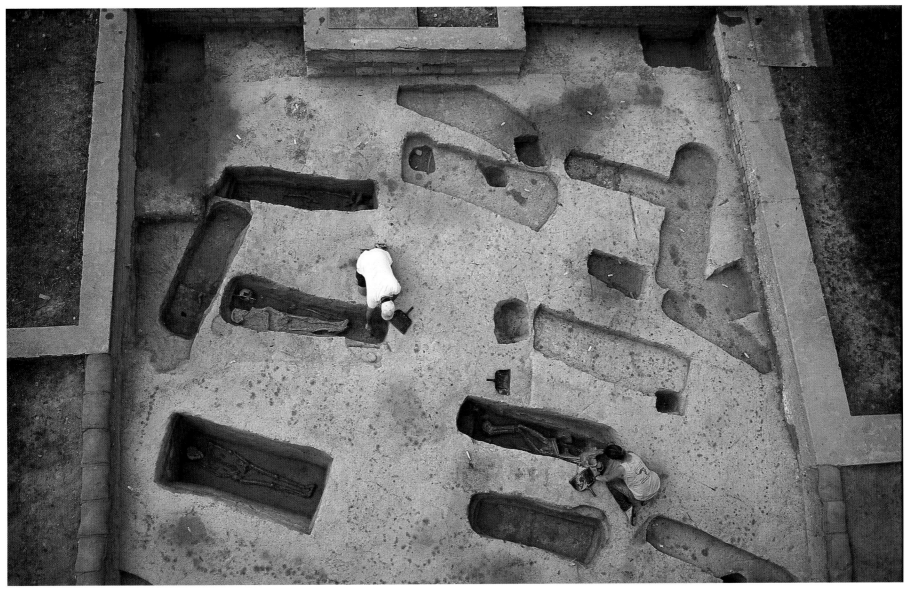

BURIAL GROUND *A cemetery unearthed within the fort held the remains of 23 people. A grave located just outside the fort contained a ceremonial staff 5 ft. (1.5 m) long, topped with an iron cruciform finial. Some scholars suspect the deceased may have been a leader of the colony, Bartholomew Gosnold, but that identification remains a matter of conjecture*

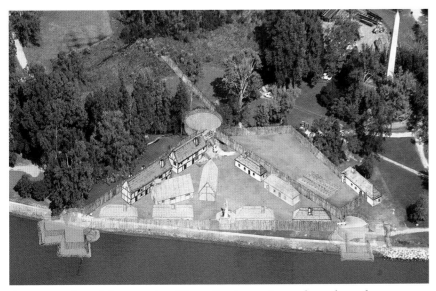

OVERVIEW *An artist's conception of James Fort is superimposed over the modern landscape. Buildings sketched in detail are those whose remnants have been located*

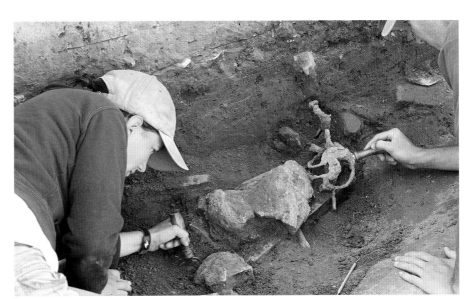

17TH CENTURY BLADES *Archaeologists Mary Anna Richardson and Luke Pecoraro excavate the hilts of a broadsword, left, and rapier, right, inside James Fort in 2007*

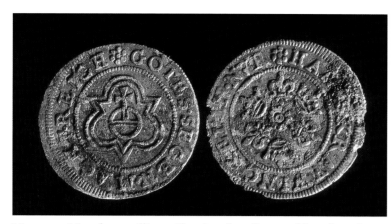

MARKERS *More than 1 million artifacts have been discovered from the early Jamestown settlement, including these two examples of late-16th or early-17th century jetton, metal markers used in card games, much like today's poker chips*

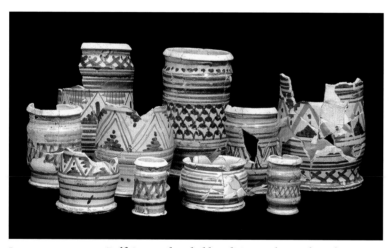

IMPORTED GOODS *Delft jars made to hold medicines, salves and similar substances are the form of pottery most widely found at Jamestown. In its early years the colonists relied on trade with Europe for such high-quality products*

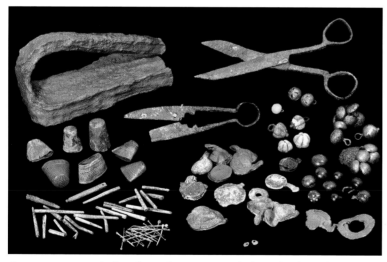

SEWING BASKET *Archaeologists have uncovered a host of tools used in specific trades at Jamestown. The tailoring tools above include, from left to right and top to bottom: an iron, thimbles, decorative copper aglets for laces, straight pins, scissors and shears, lead cloth seals, and glass and copper buttons*

ered a series of circular stains in the soil—the marks of logs that had once stood upright but had long since rotted away.

Although it took him another 10 years of slow, patient work, Kelso eventually managed to map out the triangular shape of the fort along with the foundations of at least five buildings, several wells and a burial ground. His team also dug up more than 1 million artifacts, about twice the number found over the previous half-century, including arms and armor, pottery, clay pipes, clothing and shoes, iron tools, jewelry, animal bones, trade beads, sheets of copper and hundreds of stone points. Individually, these objects seem trivial. Taken together, however, they create an extraordinary picture of colonial life.

Perhaps the most unexpected discovery is evidence that the local Powhatan, whom the settlers assumed would be uniformly hostile, actually lived in the fort for some period of time. Trash pits, for example, yielded fragments of an Indian reed mat as well as shell beads favored by the Indians and the type of stone tool that they would have used to drill them. The Indian artifacts were found mixed in with English ones in an undisturbed layer of soil and in greater concentrations than have ever been found in Virginia Indian villages. That, and the fact that the Indians bothered to carry tools like the stone drills into the fort, has led archaeologists to think the Indians spent significant amounts of time there. "It must have been a very close relationship," says Kelso.

Additional evidence of the Indians' presence in the fort comes from one of the buildings Kelso's team excavated. Known as "the quarter," it was at least 30 ft. long by 18 ft. wide (9 m by 5 m) and appears to have been built using a mud-and-stud technique that was popular in Lincolnshire, England, during the early 17th century. In one corner of its cellar the archaeologists found a butchered turtle shell and pig bones, as well as an Indian cooking pot with traces of turtle bone inside. Nearby were a Venetian trade bead, a sheathed dagger and a musketeer's kit bag. As a result, Kelso surmises that an Indian woman may have cooked for the inhabitants.

Kelso's team also uncovered a modest cemetery within the fort. The plot, which dates to the colony's earliest years, holds at least 23 individuals: 19 single burials and two double burials (most likely people who died on the same day). One of the single graves contained the remains of a boy with a stone arrowhead in his leg, a broken collarbone and a jawbone that had been partially excised due to an abscess. The position of the bones, the lack of coffin nails and the abundance of straight pins scattered in the graves indicate that some of the bodies were interred in simple shrouds without coffins.

Another burial ground, outside the walls of the fort and dating from 1610 to 1630, holds some 80 individuals. From them, forensic anthropologists at the National Museum of

Natural History in Washington determined that the average male inhabitant of Jamestown died at age 25, with women living slightly longer. (At the time, Kelso notes, life expectancy for lower-class residents of London was about 20 years; for the upper class, it was about 40.) To the scientists' surprise, hardly any of the graves contained infants.

But perhaps the most significant discovery was a lone grave with the remains of a ceremonial staff inside. Kelso believes it may be the resting place of Bartholomew Gosnold, one of the driving forces behind the foundation of the colony, who died on Aug. 22, 1607, after a "three-week illness." DNA tests on the skeleton have so far been inconclusive.

The colonists were ill-prepared for life in Virginia and, at least initially, had no crops to harvest. So Kelso was not surprised to dig up the goods they offered the Indians in exchange for food. Among them: Venetian glass beads (blue ones were preferred), sheet copper (a commodity prized by the Powhatan), European coins (useless in Virginia) and metal tools (the Indians had ones made only from stone, wood, bone and shell). In the decades that followed, the embattled, struggling Jamestown colonists were joined by a host of other new settlements. The English were in the New World to stay. As for Jamestown, Americans celebrated its 400th anniversary in 2007. And as scholars continue to unearth its secrets, the colony promises to retain its firm grip on our national memory.

Ætatis suæ 21. Aᵒ. 1616.

POCAHONTAS, UNVARNISHED

Poor Pocahontas! To Americans, she lives on as a caricature, as imagined in legends of her acquaintance with a British captain and as depicted in cartoon form in a Walt Disney Co. film. She deserves better.

She was named Matoaka upon her birth, around 1596, but her father, Chief Powhatan, called her Pocahontas ("Little Capricious One"). Captain John Smith of Jamestown was smitten by her, and though they were not lovers, she appears to have saved his life twice, once by pleading for clemency with her father and a second time by warning Smith of an imminent ambush. She led a party of Indians who bore meat to the starving colonists in the harsh winter of 1608. Five years later she was kidnapped by a British sailor, and a wealthy planter, the widower John Rolfe, fell in love with her. They wed—it was the first known marriage between an Englishman and a Native American woman—and had a son, and at the request of the company that financed the Virginia colonies, she traveled with her husband to England, a living advertisement for the rewards of colonization. She and Smith had one brief reunion in England before she died in 1617, while preparing to return to Virginia.

ADAPTING *The metal breastplate at left has been dated to the 15th century, more than 100 years before it was brought to Jamestown. Such war gear may have become obsolete; above is a similar breastplate that has been converted into a vessel*

MISPLACED PRINCESS *Top right, a British portrait of Pocahontas from 1616. Inset: shell earrings she is said to have worn*

BRITAIN'S EXPERIMENT IN AMERICA BEGINS

After a miserable Atlantic crossing, the colony of British greenhorns at Jamestown had been on land barely two weeks, living in tents behind a crescent fence of brush, when the attack started. About 200 Indians "came up allmost into the fort [and] shott through the tentes," wrote settler Gabriel Archer. With the help of a ship's cannon, the outnumbered settlers won the hourlong battle, but two died and 11 were wounded.

After 19 days of furious labor the colonists were safer but utterly exhausted. Under frequent arrow attack from Indians in the surrounding grass, they had dug more than 900 ft. of trenches, cut down and hauled hundreds of trees and upended them to form a triangular enclosure of about an acre. Once inside, "scarce 10 among us could either go or well stand, such extreme weakness and sickness oppressed us," John Smith reported.

Built, burned, rebuilt, expanded, abandoned, revived: James Fort never stayed the same for very long. Inside its walls a new world was being born, one that foreshadowed America's future in nurturing both representative government and human slavery. Outside, a prosperous Indian empire was dying.

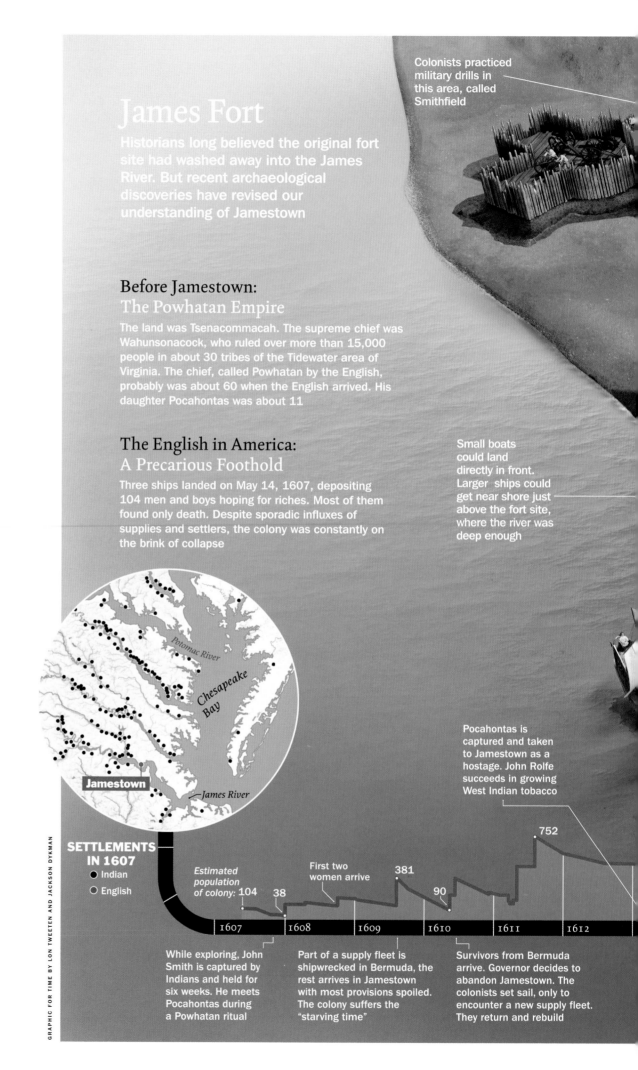

James Fort

Historians long believed the original fort site had washed away into the James River. But recent archaeological discoveries have revised our understanding of Jamestown

Colonists practiced military drills in this area, called Smithfield

Before Jamestown:
The Powhatan Empire

The land was Tsenacommacah. The supreme chief was Wahunsonacock, who ruled over more than 15,000 people in about 30 tribes of the Tidewater area of Virginia. The chief, called Powhatan by the English, probably was about 60 when the English arrived. His daughter Pocahontas was about 11

The English in America:
A Precarious Foothold

Three ships landed on May 14, 1607, depositing 104 men and boys hoping for riches. Most of them found only death. Despite sporadic influxes of supplies and settlers, the colony was constantly on the brink of collapse

Small boats could land directly in front. Larger ships could get near shore just above the fort site, where the river was deep enough

Pocahontas is captured and taken to Jamestown as a hostage. John Rolfe succeeds in growing West Indian tobacco

Potomac River

Chesapeake Bay

Jamestown

James River

SETTLEMENTS IN 1607
- ● Indian
- ○ English

GRAPHIC FOR TIME BY LON TWEETEN AND JACKSON DYKMAN

	Estimated population of colony: 104	38	First two women arrive	381	90		752
1607	1608	1609	1610	1611	1612		

While exploring, John Smith is captured by Indians and held for six weeks. He meets Pocahontas during a Powhatan ritual

Part of a supply fleet is shipwrecked in Bermuda, the rest arrives in Jamestown with most provisions spoiled. The colony suffers the "starving time"

Survivors from Bermuda arrive. Governor decides to abandon Jamestown. The colonists set sail, only to encounter a new supply fleet. They return and rebuild

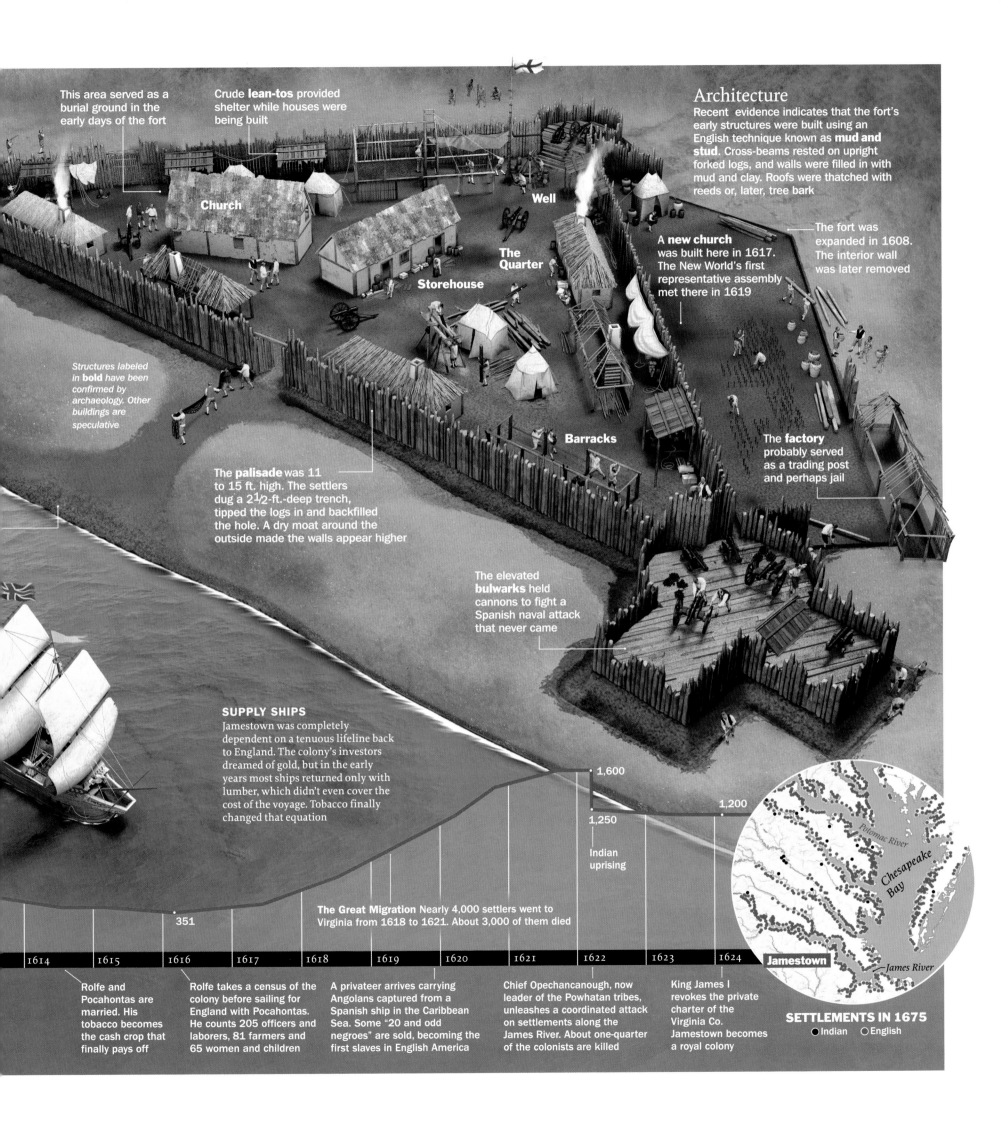

This area served as a burial ground in the early days of the fort

Crude **lean-tos** provided shelter while houses were being built

Architecture
Recent evidence indicates that the fort's early structures were built using an English technique known as **mud and stud**. Cross-beams rested on upright forked logs, and walls were filled in with mud and clay. Roofs were thatched with reeds or, later, tree bark

Well

Church

The Quarter

Storehouse

A **new church** was built here in 1617. The New World's first representative assembly met there in 1619

The fort was expanded in 1608. The interior wall was later removed

Structures labeled in **bold** *have been confirmed by archaeology. Other buildings are speculative*

The **palisade** was 11 to 15 ft. high. The settlers dug a 2 1/2-ft.-deep trench, tipped the logs in and backfilled the hole. A dry moat around the outside made the walls appear higher

Barracks

The **factory** probably served as a trading post and perhaps jail

The elevated **bulwarks** held cannons to fight a Spanish naval attack that never came

SUPPLY SHIPS
Jamestown was completely dependent on a tenuous lifeline back to England. The colony's investors dreamed of gold, but in the early years most ships returned only with lumber, which didn't even cover the cost of the voyage. Tobacco finally changed that equation

1,600

1,200

1,250

Indian uprising

The Great Migration Nearly 4,000 settlers went to Virginia from 1618 to 1621. About 3,000 of them died

351

1614	1615	1616	1617	1618	1619	1620	1621	1622	1623	1624

Rolfe and Pocahontas are married. His tobacco becomes the cash crop that finally pays off

Rolfe takes a census of the colony before sailing for England with Pocahontas. He counts 205 officers and laborers, 81 farmers and 65 women and children

A privateer arrives carrying Angolans captured from a Spanish ship in the Caribbean Sea. Some "20 and odd negroes" are sold, becoming the first slaves in English America

Chief Opechancanough, now leader of the Powhatan tribes, unleashes a coordinated attack on settlements along the James River. About one-quarter of the colonists are killed

King James I revokes the private charter of the Virginia Co. Jamestown becomes a royal colony

Potomac River

Chesapeake Bay

Jamestown

James River

SETTLEMENTS IN 1675
● Indian ○ English

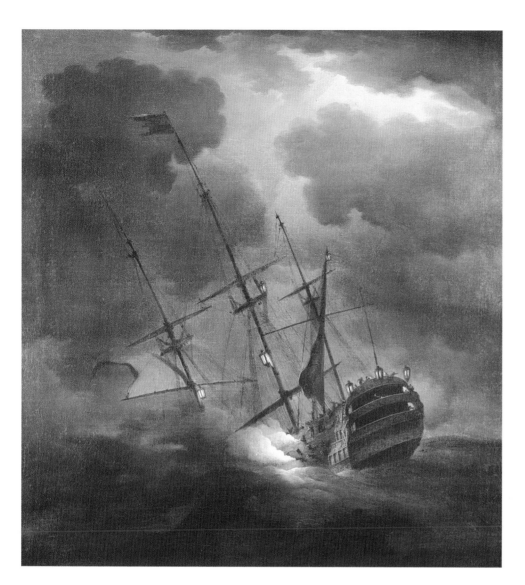

FACE OF WAR *H.M.S.* Victory *was immortalized in her final moments—lanterns lit and guns desperately firing a distress signal as she went down in the Channel—by contemporary marine painter Peter Monamy.*

The ship's captain, Sir John Balchin, above, had served the Royal Navy with distinction for nearly 60 years, sailing the waters of the Baltic, English Channel, Mediterranean and West Indies on 13 different warships

CURRENT EXPLORATIONS

A BRITISH WARSHIP'S WRECK IS FOUND AT LAST— BUT WHO OWNS ITS REMAINS?

Under swirling clouds, its four-story hull illuminated by lanterns tied to its masts, the massive warship sinks beneath the waves. For more than two centuries, Peter Monamy's dramatic painting was one of the few images available of the tragic end of H.M.S. *Victory*, which mysteriously disappeared, along with its crew of 1,100 men, one stormy night in 1744. But on Feb. 2, 2009, the Florida-based shipwreck salvage company Odyssey Marine Exploration Inc. announced it had recovered *Victory's* remains.

"This is the most significant shipwreck discovery in history," says Odyssey president Greg Stemm. "It's the solution to one of the most intriguing naval mysteries in history. It went down with the most famous admiral of his time, it has the largest collection of bronze cannon in the world onboard,

and research suggests that it has one of the largest shipments of gold and silver that will likely ever be found on a shipwreck." There's the rub. As Odyssey has discovered before, where there is gold and silver, there is likely to be controversy as well. The publicly traded firm has repeatedly provoked the ire of archaeologists who complain that it is more interested in profit than in protecting historically valuable artifacts. In June 2009, the company lost a court battle with the country of Spain over ownership of the cargo of a ship that experts believe to be the 17th century *Nuestra Señora de las Mercedes*. Odyssey retrieved some 17 tons of silver coins from the wreck site: that booty's estimated value is $404 million. The company vowed to continue fighting the case on appeal.

Built in 1737, H.M.S. *Victory* (a later version would be

WAR MACHINE *This 42-lb. cannon bears the crest of King George I; it was his son and heir, George II, who dispatched H.M.S.* Victory *on its mission to relieve a British fleet blockaded in Lisbon. The maker's mark on the cannon indicates it was built by Andrew Schalch of the Royal Brass Foundry, Woolwich*

commanded by Admiral Nelson) was, in its day, the most powerful warship in the Royal Navy. In 1744, it was part of the fleet, commanded by war hero Admiral John Balchin, that broke through a French blockade of the Tagus river at Lisbon. Returning to England, a fierce storm hit the fleet, first separating the *Victory* from the other ships, and then sinking it, reportedly near the Channel Islands.

After years of exploration, Odyssey located the wreckage about 62 miles (100 km) from the rocky site where the *Victory* had long been thought to have sunk. That location, notes Stemm, clarifies that bad design sank her. "It was almost certainly the construction of the ship that caused the loss."

For Admiral Balchin's descendants, the discovery came as both a wonderful surprise—and vindication. "For 12 generations we have wondered what really happened," says Sir Robert Balchin. "This astonishing find has brought it all back to life for us." Not everyone was so enthusiastic, however. Dr. Jon Adams, director of the Center for Maritime Archaeology at the University of Southampton, worries that site preservation and scientific knowledge will be sacrificed in Odyssey's quest to unearth valuables. "I don't think they're the best people to be conducting this retrieval," he says. "They're in business to make money from what they find beneath the sea. They're basically treasure hunters."

Odyssey defends itself against those charges by noting that it hires experienced archaeologists for its expeditions, and observing that only commercial archeology has the resources to carry out expensive, time-consuming exploration. As for treasure, well, thus far the only booty recovered from the *Victory* are two cannon, including a historically valuable 42-pounder etched with the crest of George I. But according to one contemporary newspaper account, there was $657,000 of gold on board, not an unusual amount in a time when

warships acted as the Brinks armored trucks of their day.

That gold could prove controversial. In 2002, Odyssey negotiated an agreement with the British government to share the value of any retrieved artifacts from a shipwreck believed to be H.M.S. *Sussex.* At the time, historians and archaeologists were outraged that the "spoils" from the historically significant site would be divided and put in private hands, an outrage only increased by Odyssey's practice of selling artifacts individually in order to fund its expeditions. Noting that every coin is carefully cataloged so that no information is lost, Stemm defends the practice. "Selling these coins to pay for the archaeology and to save these shipwrecks from destruction is much better than asking taxpayers to foot the bill."

This time around, Odyssey again expects the British government to see things the same way and is currently negotiating with the country's Ministry of Defense on the salvaged treasures. But because Britain in 2005 adopted UNESCO's patrimony guidelines, which include ensuring that any cultural heritage site is maintained intact, a *Sussex*-style agreement would come loaded with inherent conflict.

That may be why Odyssey is hedging its bets this time around; it declared that the U.K. would retain the right to maintain intact any collection of artifacts, and may compensate the finders not with actual booty, but with payment for their value. Still, even if the gold controversy is resolved, *Victory* presents one more twist that *Mercedes,* at least so far, has not: Odyssey has discovered human remains at the site. In compliance with UNESCO guidelines, the company says its robotic diver Zeus was directed to rebury the unearthed bones. Yet Sir Robert hopes they don't stay that way. "My own view is that the human remains should be brought up and properly buried on land," the admiral's descendant says. "I think it's what John Balchin would have wanted."

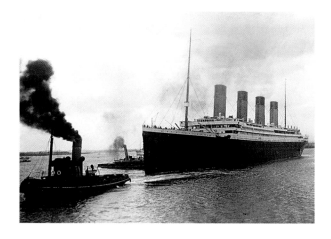

PROBING *TITANIC'S* DEMISE

The sinking of the White Star ocean liner R.M.S. *Titanic* in the early-morning hours of April 15, 1912, after it collided with an iceberg in the North Atlantic Ocean has never lost its hold on our imaginations. The tragedy left 1,517 dead of the 2,223 aboard, and the dramatic details of the sinking of the heralded ship on its maiden voyage have intrigued generations and inspired a host of books, films, TV documentaries and even a Broadway musical. Just as compelling is the story of the search for the remains of the ship on the ocean bottom, which achieved success in 1985 under a team led by veteran oceanographer Robert Ballard.

Yet no matter how often it has been told, the tale of *Titanic* remains a work in progress: scholars, historians and engineers are still arguing over the most basic facts of the tragedy. Why did the big ship founder so quickly after the collision with the iceberg, which seems to have struck only a glancing blow on the liner? What was the sequence of events as *Titanic* broke apart and sank? And for how long did portions of the ship remain buoyant? Meanwhile, new revelations are emerging about the manner in which the remains of the liner were found—and the question of who owns the rights

to items salvaged from *Titanic's* watery grave was being addressed in a U.S. courtroom in 2009.

The finding of the ship's remains 73 years after the tragedy easily qualifies as one of the great discoveries of the 20th century. The climax of that story occurred on Sept. 1, 1985, for the team led by Ballard of the Woods Hole Oceanographic Institution. Earlier that summer the French vessel *Le Surôit* had "mowed the lawn" in the North Atlantic, roaming over a 150-sq.-mi. target area with a sonar device that provided high-resolution maps of the seabed. But after surveying 80% of the expanse where Ballard's team believed *Titanic* lay, *Le Surôit* had found no trace of its prey. Then the U.S. Navy research vessel *Knorr* began combing the rest of the target area with a sonar-and-video platform called *Argo,* towed behind the ship at a depth of 12,500 ft.

Around 1 a.m. on Sept. 1, the *Argo* detected a shape on the seabed. Was it the remains of a steam boiler? "That's it!" cried Ballard. *Titanic* had been found, but it was not until 9 months later that Ballard's team returned to explore the ship with the manned submersible *Alvin* and the remotely operated vehicle *Jason Jr.* The two craft toured the wreckage, wandering across the decks, past corroded bollards, peering into the officers' quarters and through still-curtained portholes where doomed passengers once stood. Ballard found no trace of the rumored 300-ft. (91 m) tear supposedly left in the ship's hull by the iceberg, leading him to believe only a small rip sank the ship. This conclusion was confirmed by a 1996 exploration that found no large gash but rather six slits where the ship's bow hull plates had come apart after the collision. The ship rested on the seabed in two widely separated parts, confirming eyewitness reports that *Titanic* broke apart on the surface before she sank.

It was not until 2008 that a more complete narrative of *Titanic's* discovery began to emerge. It turned out that Ballard's team had an unseen partner in developing the submersible technol-

BEFORE AND AFTER *Above,* Titanic *embarked from Southampton, U.K., to cross the North Atlantic on its maiden voyage. At right, the rusted prow of the ship was photographed in 1985 by the Ballard expedition that first discovered Titanic's remains. The ship lies some 13,000 ft. (3,962 m) beneath the waves, about 380 miles (611 km) southeast of the southern tip of Newfoundland*

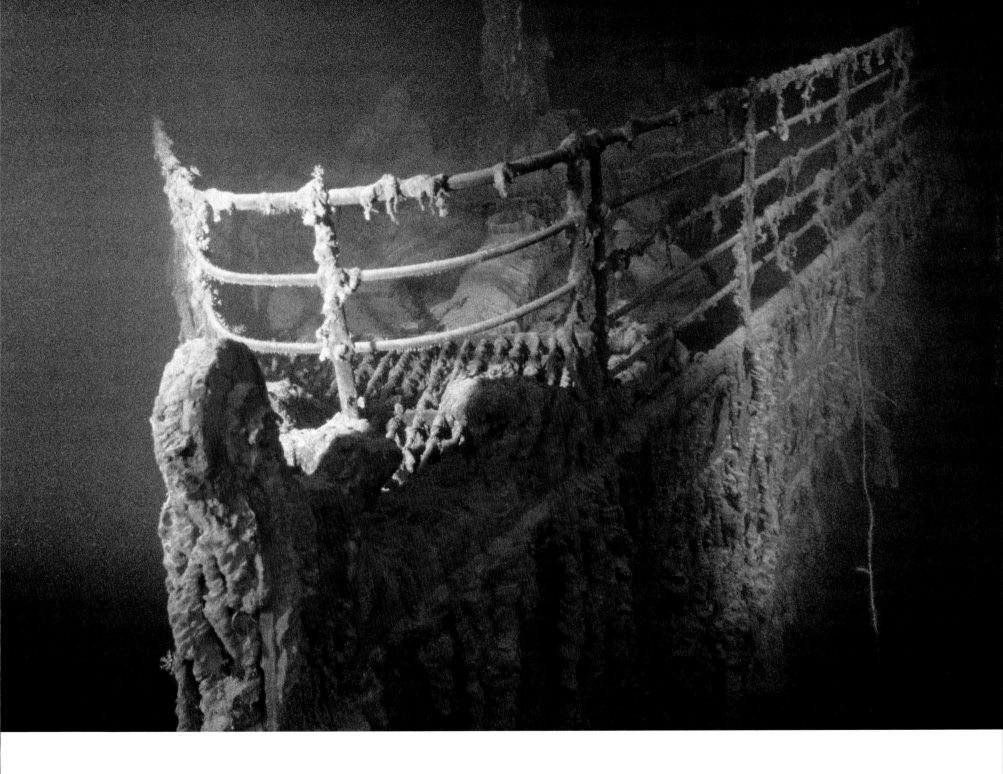

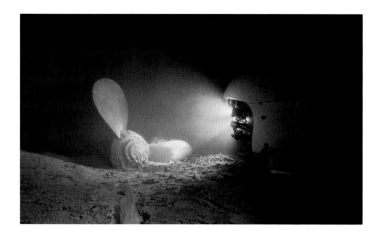

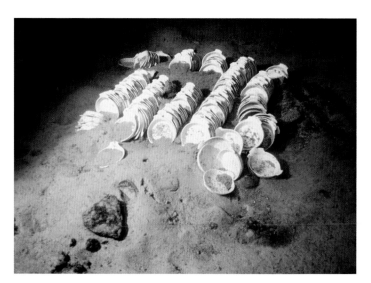

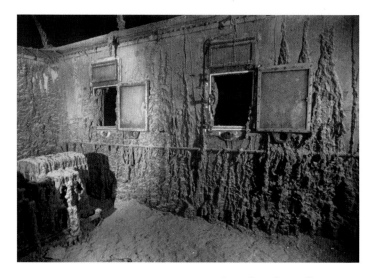

VISIONS FROM THE DEPTHS *At top,* Titanic's *starboard propeller was photographed in 1991 by renowned underwater photographer Emory Kristof in 1991, using two Russian-built submersible craft. The propeller is illuminated by the lights of* Mir 1, *while Kristof, in* Mir 2, *recorded the scene. The bottom two photos were taken in 1985. A rack of dishes came to rest in orderly fashion, with few items broken, after descending more than two miles (3.2 km) to the ocean floor. And at bottom, two windows in a first-class stateroom remain open where no breezes blow*

ogy used in the search: the U.S. Navy. When Ballard met with Navy officials to request money to develop the craft, they agreed to help fund the project—on the condition that it would first be used to explore the remains of two nuclear-powered submarines that had sunk during the cold war: U.S.S. *Thresher* in 1963 and U.S.S. *Scorpion* in 1968. The Navy was particularly interested in the fate of the two ships' nuclear reactors and the fuel they carried. Ballard agreed—on condition that he could search for *Titanic* in any time remaining from his sub search. The Navy signed on, and the rest is history, if only recently revealed history.

WEAK LINKS: THE IRON RIVETS?

Meanwhile, two books published in 2008 offer compelling evidence to support new accounts of why the minor collision sank the ship and the sequence of its destruction. In *What Really Sank the Titanic: New Forensic Discoveries* (Citadel Press), authors Jennifer Hooper McCarty, a materials scientist at Oregon Health and Science University, and Tim Foecke, a scientist at the National Institute of Standards and Technology, identify the weak link in the ship as its iron rivets, the metal pins that held the hull together. Previous accounts had identified the steel hull plates as the culprits. The team gleaned clues from 48 rivets recovered from the hull of *Titanic,* which they compared with other metals from the same era. Their conclusion: White Star Line executives, faced with a shortage of high-quality rivets and rushing to get the ship launched, chose to use rivets of inferior quality to hold the ship's hull plates together, at a tragic cost. In addition, a shortage of experienced workers to perform the complex job of installing hot rivets may have further contributed to *Titanic's* weakness. The company that built the ship, Harland & Wolff, is still in operation; its executives have emphatically dismissed the book's findings.

In Brad Matsen's book *Titanic's Last Secrets* (Thorndike Press), veteran divers Richie Kohler and John Chatterton, who have visited the site, argue that the ship's stern did not rise high in the air before it plunged to the bottom, as many experts, including Ballard, had believed. This scenario had provided a memorably vertiginous climax to James Cameron's hit 1997 film. Based on their examination of two recently discovered large pieces of *Titanic's* hull, they argue that the ship broke apart at a much more shallow angle to the ocean surface.

Even as the story of *Titanic's* fate was being revised, a U.S. federal judge in Norfolk, Va., was preparing to rule over the legal ownership of some 5,900 artifacts retrieved from the undersea wreck beginning in 1987 by Premier Exhibitions, Inc., a company that has sent touring displays of the relics around the world. The court has declared that the artifacts cannot be sold on the free market. The company said it has tried and failed to sell them to museums, but none have offered the company's notion of a fair price for the items. Their estimated value: $100 million—further proof that, when it comes to *Titanic,* the term "treasures of the deep" is, for once, more than a shopworn metaphor.

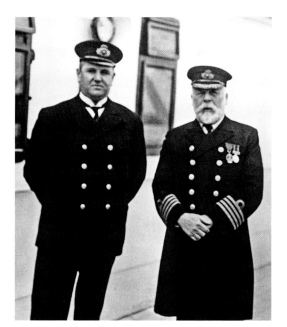

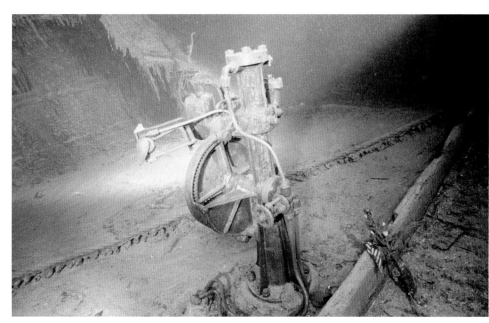

CALL OF DUTY *Captain Edward John Smith, 62, on right, posed with purser Purser Hugh McElroy days before* Titanic *sank; the 32-year veteran of the White Star Line went down with his ship. He also served as captain of* Titanic's *sister ship,* Olympic. *At right, a steering motor from* Titanic's *bridge remains upright*

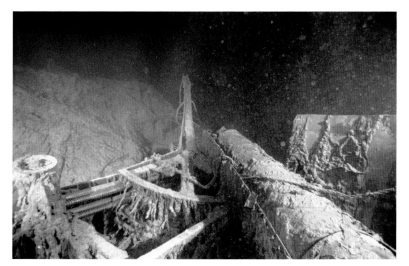

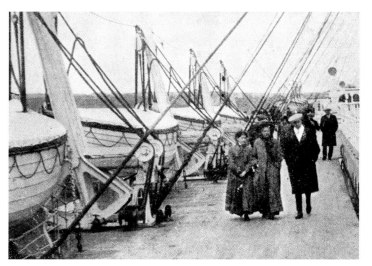

INSUFFICIENT PRECAUTIONS *At left, a view of the wreckage of the forward port deck of the ship, with a toppled mast lying atop a lifeboat davit. At right, maiden-voyage passengers stroll the deck next to the lifeboats. There were too few of the craft to save all the passengers and crew, causing hundreds of unnecessary deaths*

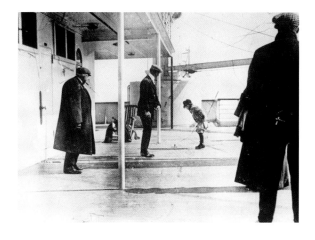

AN IRONIC FATE *The boy at play on the deck is Douglas Spedden, who survived the sinking of the ship only to be killed in a car accident two years later. At right, the metal frame of a deck bench. Some 1,517 people died when the ship sank, and another 706 survived. The ship remained afloat for more than two hours after it collided with the iceberg, and those aboard generally followed the nautical protocol of allowing women and children to board lifeboats first*

Diary of the weather &c. October 1805 (Beginning the 21st October &c.)

№ 2.

Great Falls of Columbia River

laid down by a scale of 200 yards to the inch

Eneeshur Nation

River

rock

rock

rock

rock

Portage 457 yds

Canoe

Black rock

clifts of 200 to 300 foot perpindicular

a clear chanel

Portage of 1200 yards

Island

37 feet 8 In. fall

Exploring Planet Earth

"About ½ a mile lower passed 6 more [Indian] Lodges on the Same Side and 6 miles below the upper mouth of Towarnehiooks River the comencement of the pitch of the Great falls, opposit on the Stard. [starboard] Side is 17 Lodges of the nativs. we landed and walked down accompanied by an old man to view the falls, and the best rout for to make a portage which we Soon discovered was much nearest on the Stard. Side, and the distance 1200 yards one third of the way on a rock, about 200 yards over a loose Sand collected in a hollar blown by the winds from the bottoms below which was disagreeable to pass, as it was Steep and loose. At the lower part of those rapids we arrived at 5 Large Lodges of nativs drying and prepareing fish for market, they gave us Philburts, and berries to eate, we returned droped down to the head of the rapids and took every article except the Canoes across the portag where I had formed a camp on ellegable Situation for the protection of our Stores from Thieft, which we were more fearfull of, than their arrows.

"We despatched two men to examine the river on the opposit Side, and reported that the Canoes could be taken down a narrow Chanel on the opposit Side after a Short portage at the head of the falls, at which place the Indians take over their Canoes. Indians assisted us over the portage with our heavy articles on their horses, the waters is divided into Several narrow chanels which pass through a hard black rock forming Islands of rocks at this Stage of the water …"

—CAPTAIN WILLIAM CLARK, U.S. ARMY
JOURNAL ENTRY, OCT. 5, 1805

CASCADES *This hand-drawn map of the Great Falls of the Columbia River in the Journals is most likely the work of Clark*

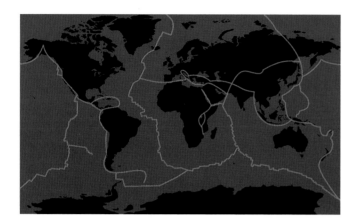

Planet in Progress: Can We Learn to Predict Natural Disasters?

The 20th century is just beginning to recede in history's rear-view mirror, but already it is clear that the discovery of plate tectonics will rank as one of the greatest scientific achievements of the era. Plate tectonics is the notion that the continents and oceans of the planet are borne upon gigantic layers of the earth's crust, which are in a state of constant slow motion; that the boundaries where such plates meet constitute a network of geologic fault lines that are particularly prone to upheaval in the form of volcanic eruptions and earthquakes; and that soaring mountain ranges as well as miles-deep trenches in the ocean are formed by this process.

The theory is both absurdly obvious and defiantly counterintuitive. Any schoolboy can look at a globe or map—or the diagram of continental plates above—and notice that the bump on the eastern edge of the South American continent would fit snugly into the notch on the western edge of the African continent. But imagining how such a process of continental union and division might occur demands that we accept the improbable notion that the solid ground beneath our feet is malleable, and that entire continents and oceans are slowly moving across the surface of the planet.

Small wonder, then, that when German meteorologist Alfred Wegener proposed his theory of "continental drift" in 1912, it was met with bewilder-ment. It was not until the 1940s and '50s that new seismographic studies of ocean seabeds gradually revealed that the outline of Wegener's theory was correct: the sea floors of the ocean were spreading in some places and contracting in others, while new land was being created as hot magma formed below the crust was ejected from undersea vents. In the 1960s and '70s, tectonic theory was firmly accepted.

Plate tectonics is what scientists call a "grand theory"—a unifying vision that explains countless phenomena that otherwise might seem unrelated. The movement and collision of tectonic plates explain the source of earthquakes on land and beneath the oceans, creating tsunamis that can send monster waves thundering onto shores thousands of miles apart to wreak havoc. The constant formation of new land in the form of sizzling magma ejected from the planet's interior explains both volcanoes and the fascinating hydrothermal vents discovered on the ocean floor in the 1960s.

Now it falls to 21st century scientists to take the descriptive science of the last century and turn it into predictive science. Can we learn to anticipate earthquakes, tsunamis and volcanic eruptions—and save hundreds of thousands of lives? Around the globe, experts are developing new ways to take the earth's temperature, check its pulse—and warn us in advance of impending turmoil.

On the brink
The fissure between tectonic plates called the Mid-Atlantic Ridge runs directly through the island of Iceland, as shown on the tectonic map at top left.

At right, the ridge can be seen running through a residential district in Thingvellir. It marks the boundary between two huge tectonic plates, the Eurasian Plate and the North American Plate.

Iceland was entirely created by volcanic activity along the ridge, and it is one of the few places where the Mid-Atlantic Ridge may be seen above sea level

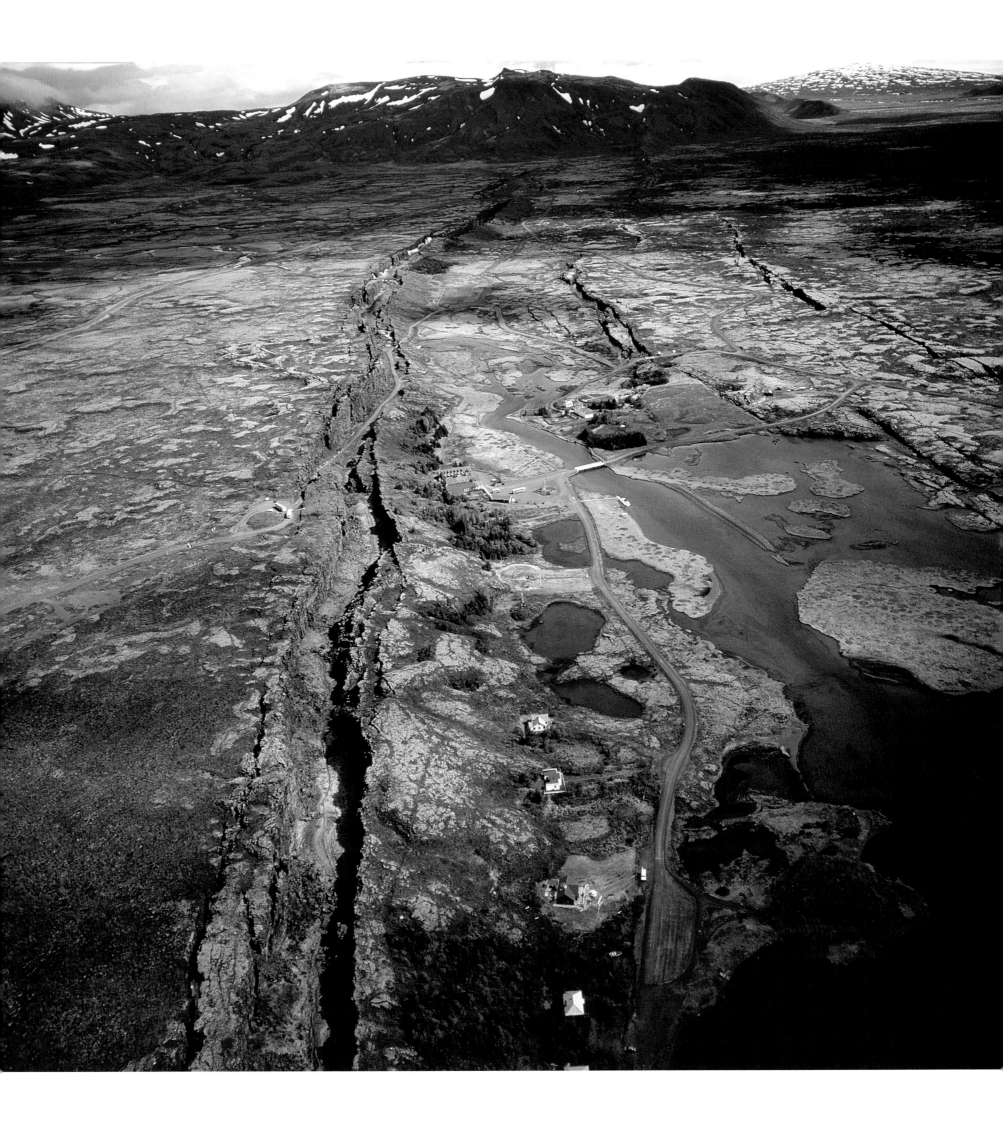

A Warning Ignored, a Region Shattered

In March 2009, a man drove through the streets of L'Aquila, a town in the mountainous Abruzzo region of central Italy, in a van equipped with loudspeakers, warning residents to flee their homes, for an earthquake was coming. The man was Giampaolo Giuliani, a technician at the Institute of Nuclear Physics in Gran Sasso. When Giuliani, an enthusiast of seismology, posted a warning on his website predicting the quake would hit on March 29, local officials berated him as a Cassandra, an alarmist who was spreading fear. On the appointed date, only a small tremor registered on seismographs. Then, in the early-morning hours of April 6, the ground in Abruzzo rumbled and Italy's worst earthquake in nearly three decades struck. The 6.3-magnitude quake devastated L'Aquila, killed nearly 300 people and left tens of thousands homeless, just as Giuliani had said it would, though it occurred eight days after his predicted date. He called for a public apology, and newspaper headlines around the world blasted officials for failing to heed his warning.

Can we learn to predict earthquakes and save thousands of lives? That is the holy grail of seismologists, who have been attempting to do so for decades. But no one has yet found a system that works. Giuliani was partially correct in this case, but most seismologists declared that the amateur's prediction, using a method that measures radon gas emitted by small tremors along the tectonic fault line that runs beneath Abruzzo— was a lucky fluke. Enzo Boschi, Italy's leading volcanologist and earthquake expert, said, "There is no way that anyone can predict a tremor." And, writing in the New York *Times,* seismologist Susan Hough of the U.S. Geological Survey, said, "Scientists have yet to be able to accurately predict coming earthquakes. Investigating precursors like radon is a legitimate avenue of research, but until and unless the track record of a method is shown to be statistically significant, making public predictions is irresponsible." In the meantime, as the search for ways to predict quakes continues, an equally important quest goes on: to create more buildings strong enough to survive them.

SIGN OF LIFE *The earthquake that struck Italy's Abruzzo region on April 6, 2009, did not stop one household in the village of Onna from performing washday chores. Italy's boot-shaped peninsula is crossed by two tectonic fault lines; an earthquake in 1980 killed some 2,500 people*

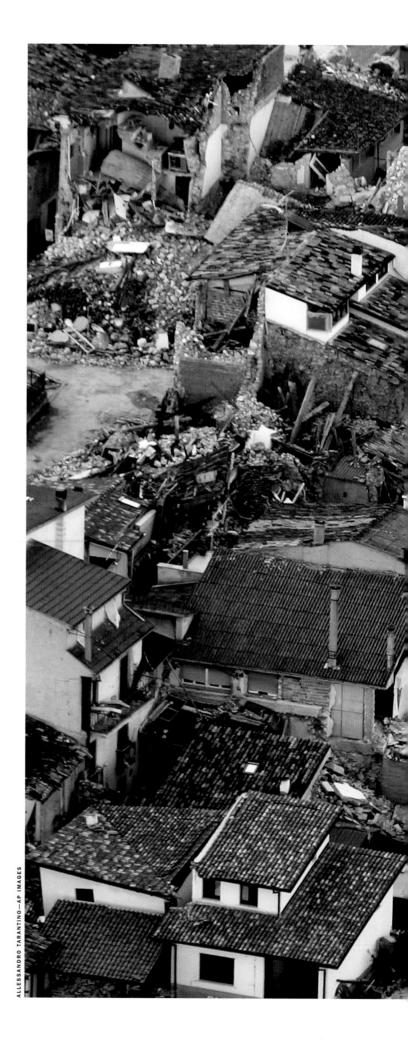

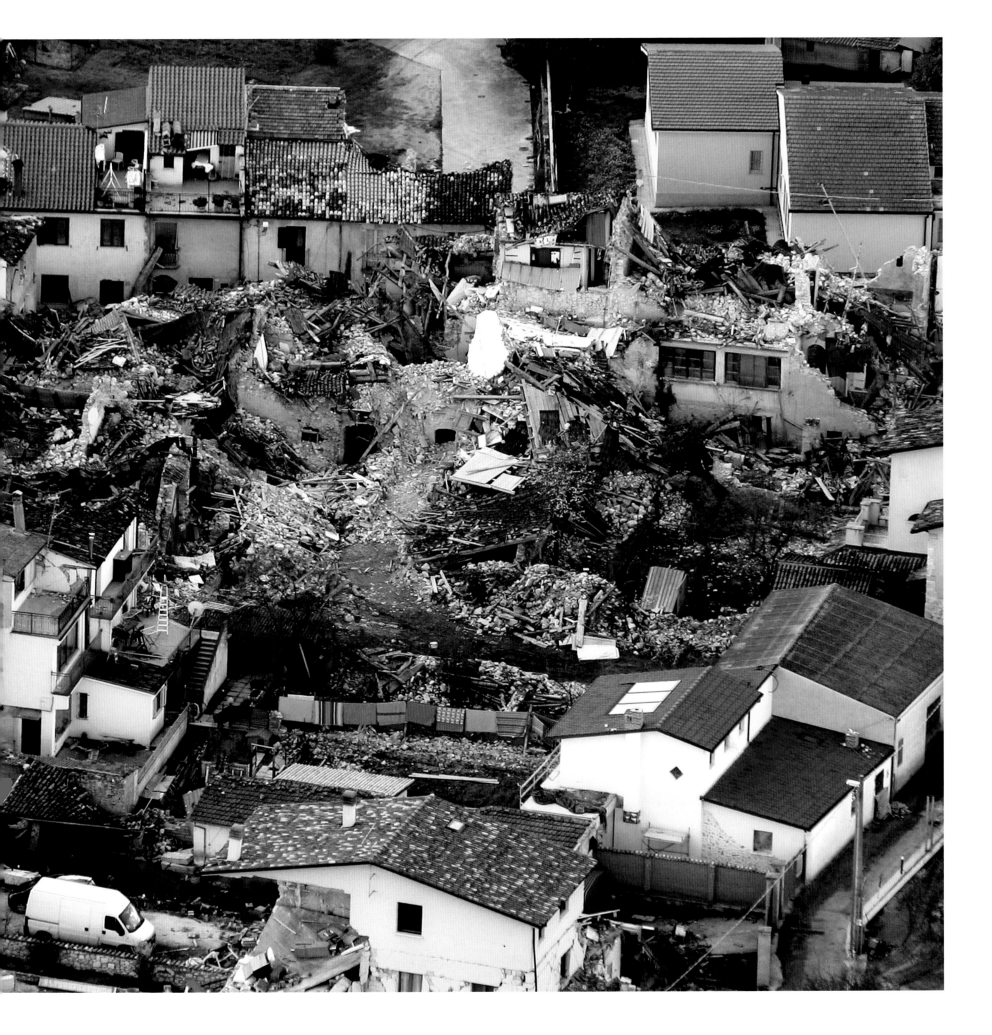

Volcano Monitoring: Doubts and Redoubts

Perched on one border of the famed Ring of Fire, the vast circle of volcanoes seated atop tectonic fault lines that borders the Pacific Ocean, Alaska is home to roughly 1 in 10 of the world's active volcanoes. One of them is Mount Redoubt, a 10,197 ft. (3,108 m) peak located some 103 miles (166 km) southwest of Anchorage. During its last cycle of major activity, from December 1989 to early June 1990, the big cone erupted in a series of explosions, mudslides and ash clouds that caused damage estimated at $160 million. Unlike the famed eruption of Mount St. Helens in Washington State in 1980, which claimed 57 lives, Redoubt's last period of eruptions did not cause fatalities. But it came close: during the 1989-90 activity, a KLM Boeing 747 jetliner flying through Alaskan airspace sucked volcanic ash and debris into its engines, lost power in all four of them and fell 2 miles (3.2 km) through the sky. The pilots were able to restart the engines with only seconds left to spare and landed safely in Anchorage, despite windshields rendered almost opaque by the sandblasting power of volcanic ash.

Small wonder the U.S. Geological Survey and the state of Alaska maintain a major facility, the Alaska Volcano Observatory (AVO), to keep a watchful eye on the state's cones. Indeed, the science of volcano prediction achieved its first success here, when Swiss-American volcanologist Bernard Chouet successfully predicted the 1989 eruption of Redoubt. Chouet and others have identified a number of signs of an impending eruption: the sizzling hot magma moving beneath a volcano often generates earthquakes, and the bulk of the liquid magma can cause the surface of the volcano to swell. At the same time, the volcano begins to emit an increased amount of gases from its cone. Scientists use a network of seismometers positioned around the mountain to measure earthquake activity. At some volcanoes, low-frequency earthquakes and a continuous seismic disturbance called a tremor will occur shortly before an eruption. Deformations in the volcano's surface are measured through an array of high-tech tools. Electronic distance meters are used to bounce infrared light off of targets placed on the peak's slopes and measure any displacement. Global positioning systems linked to satellites also measure shifts in the surface structure. And instruments called tiltmeters—essentially a digital-age version of a carpenter's level—also are placed on the peak to register deformation. Meanwhile, spectrometers located on the ground and on helicopters monitor gas levels.

When the signals are right, the AVO staff goes on high alert, as it did in January 2009, when instruments registered fresh activity beneath Mount Redoubt, and the AVO advised that an eruption could come soon. On March 22-23 Redoubt erupted five times in a 12-hour period, sending a pillar of smoke 9 miles (14 km) into the stratosphere. Airlines heeded AVO warnings and canceled scores of flights into the state. After almost 20 years of silence, Redoubt again belched fire, gas and ashes for weeks.

The volcano's timing was interesting: it came alive only a few weeks after a politician had denounced "something called volcano monitoring" as a frivolous use of federal funds in a nationally televised address. One interested resident of the Ring of Fire, Seattle newspaper columnist Joel Connelly, was not amused. His headline advice to Americans: "DON'T SNEER AT SCIENCE." The last word in this episode belonged to U.S. Secretary of the Interior Ken Salazar, who announced in April 2009 that the U.S. would increase by $15 million the funding devoted to the monitoring of volcanoes and would also spend an additional $29 million to double the number of stations devoted to earthquake monitoring.

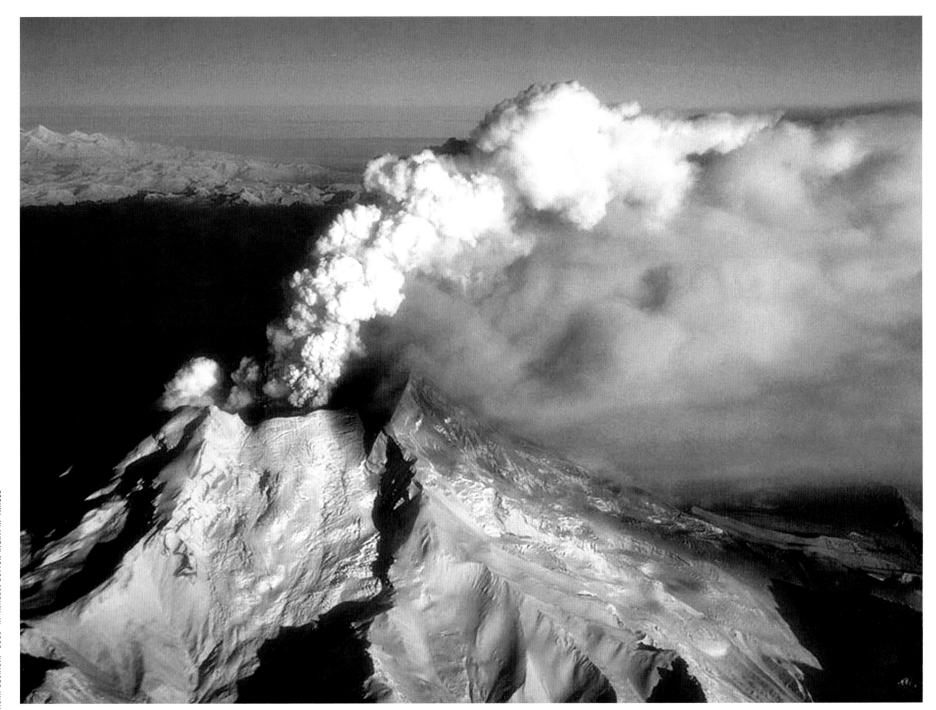

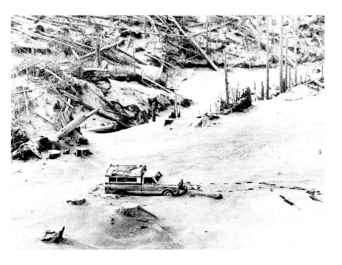

WATCHFUL WAITING *At top, Mount Redoubt in Alaska emits a stream of smoke and ash on Dec. 18, 1989. When a passing jetliner's engines were clogged with ash, it came close to crashing. At far left, a seismologist places a GPS station on the slope of Mount St. Helens in Washington State in 2004. At near left, the 1980 eruption of Mount St. Helens cloaked the surrounding area in a thick layer of ash and dust*

A Tsunami Is Predicted, Yet Lives Are Lost

On July 17, 2006, Aesih Irawan was drinking iced tea at a friend's house near the beach in Pangandaran, a resort town on the Indonesian island of Java, when the ocean crashed through the living room. The 27-year-old homemaker was seized by the churning water and carried far down the beach before she became tangled in cable, which prevented her being swept out to sea. Irawan survived, but almost 700 people were killed, nearly 1,000 were injured and some 20,000 families were left homeless by the tsunami that hit a 109-mile (177 km) stretch of Java. Triggered by a 7.7-magnitude undersea earthquake about 124 mi. (200 km) offshore, the 7-ft. (2 m) waves that slammed ashore in Pangandaran were a frightening flashback to the December 2004 tsunami that claimed the lives of 230,000 around the Indian Ocean. Now, as then, the victims were taken by surprise. "There was no warning," Irawan says. "We didn't even feel the earthquake."

It wasn't supposed to be a surprise this time. Soon after the 2004 disaster, the international community began work on a regional tsunami-alert system for the Indian Ocean, similar to the one already operating in the Pacific Ocean. Germany, Japan, the U.S. and other nations helped upgrade the region's shore-based tide-gauge stations, which can measure the sea-level changes caused by a tsunami, and planned to install sophisticated deep-ocean buoys off Indonesia to detect tsunamis when they're still out to sea. By June 2006, the United Nations Education, Scientific and Cultural Organization (UNESCO), the body leading the international effort, declared that an interim alert system was up and running. Warnings would be relayed to Indian Ocean nations from existing tsunami-monitoring centers in Hawaii and Japan.

And they did. The tragedy in this case came in the "last mile" of the warning network, for the sophistication of the monitoring system far outpaced Indonesia's communication system, and due to gaps in the way a tsunami alert is broadcast to the public, no warning reached the people on the Javanese beaches. "Let's not kid ourselves and think we solved the warning problem because we can detect a tsunami and say, 'It's coming,'" Laura Kong, head of the International Tsunami Information Center in Honolulu, told TIME. "We have to make sure that the information gets out to the last person, and that they know what to do. We're not there yet." Though Indonesia's national geological agency received an e-mail message warning of the impending catastrophe roughly 30 minutes before the waves hit the shore, there were no alarm bells to ring on the beach, no emergency broadcasts to transmit over the radio or TV, no way to alert the people on the coast. Tragically, the 2006 tsunami illustrated how a triumph of science can be undermined by a failure to communicate.

WAVE OF DEATH *Swimmers are caught by the first of six tsunami-generated waves that struck Hat Rai Lay Beach in southern Thailand on Dec. 26, 2004. Some 230,000 people were killed in the catastrophe. The grainy image was snapped by an amateur photographer*

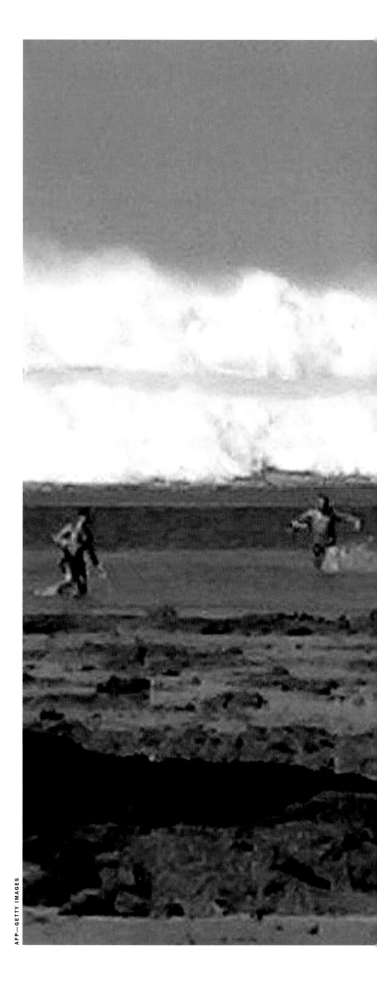

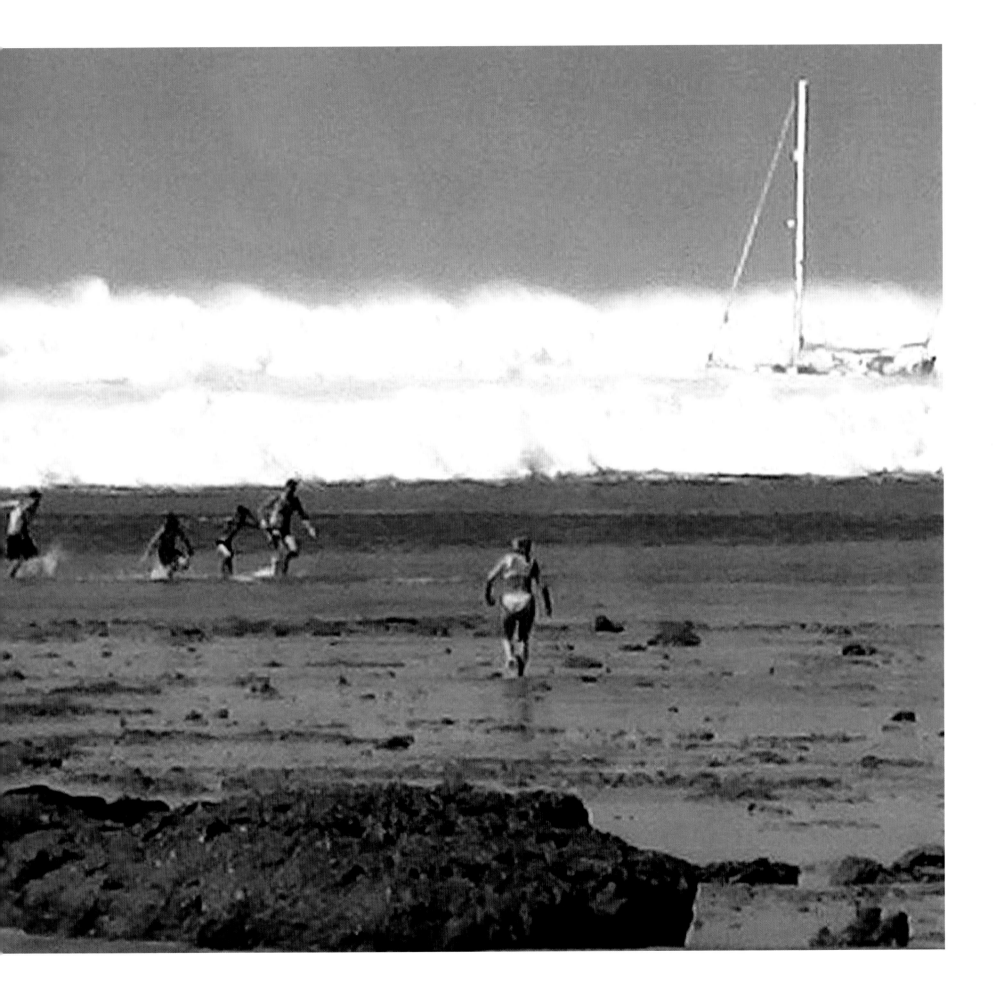

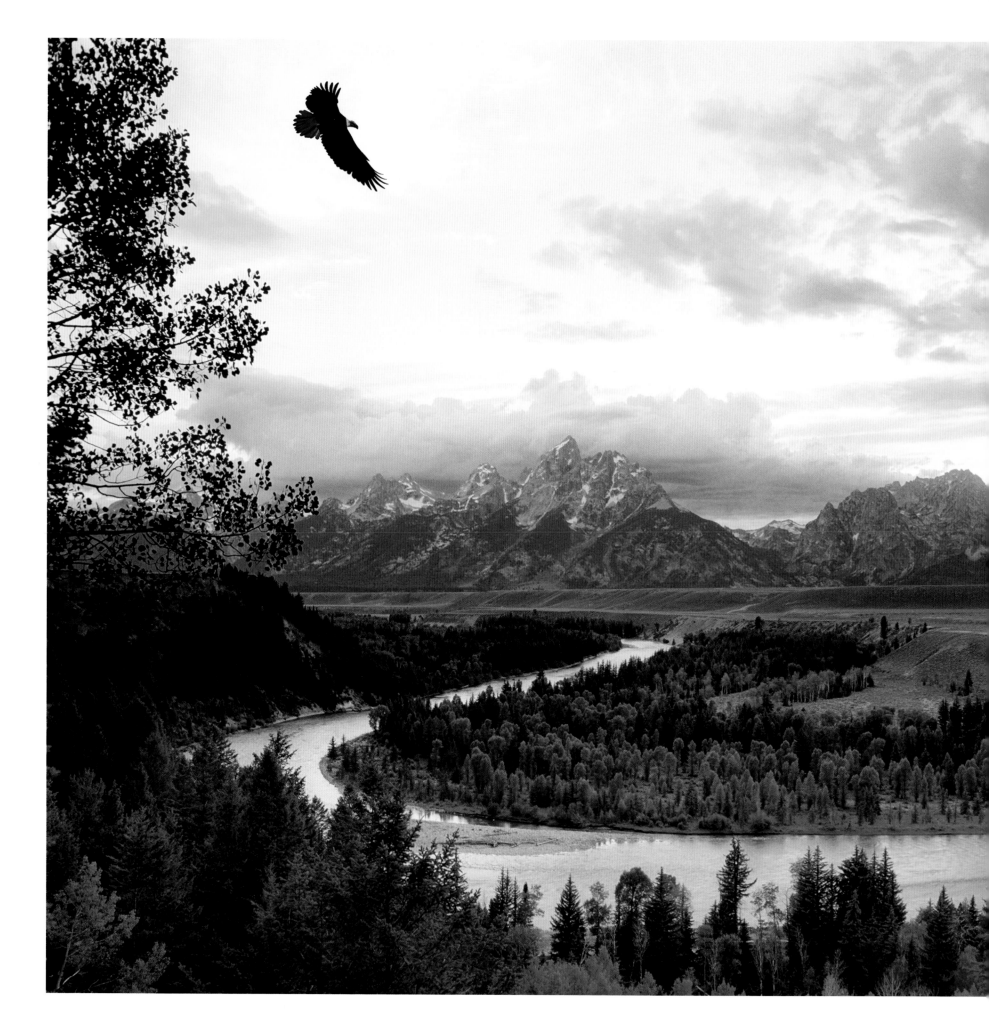

CLASSIC DISCOVERIES

Brave New World: Lewis and Clark's Adventures

Two hundred years and counting after the members of the Lewis and Clark Expedition pointed their canoes toward the sunset, their achievement retains its wonder and allure for Americans. Part of the tale's appeal, of course, is the extent of the ignorance it was designed to obliterate. Is it possible that only two centuries ago, the entire vast space between St. Louis and the Pacific Ocean was terra incognita, untraversed by Europeans? Was there a time when the Great Plains, the Rockies, the Grand Tetons and Yellowstone were not inextricably woven into our vision of America? Could the act of discovery ever have been so finely distilled as to involve merely moving from one location to another and living to tell the tale? And could any thrill surpass an offer to join an outfit that boldy styled itself the Corps of Discovery and had been dispatched by America's renaissance man, Thomas Jefferson, simply to light out for the territories?

The opening and charting of the West by this 1804-06 expedition is one of the greatest of American sagas. Yet in some ways its leaders, Meriwether Lewis and William Clark, regarded their efforts as a failure. When they commenced their journey, they were looking for something they couldn't find, because it wasn't there. The Northwest Passage, the fabled missing link in a continuous navigable waterway between the Atlantic and the Pacific oceans, existed only in Americans' dreams, but no matter: its image was enough to move them forward, and that was enough to alter history. There are much better maps of the West than those that Lewis and Clark created, but no matter: there

MAJESTY *At left, an oxbow of the Snake River with the Grand Tetons behind; the expedition traveled the Snake north of this site. At top are William Clark, left, and Meriwether Lewis. The two leaders of the Corps of Discovery are easily contrasted: Clark was outgoing and genial, while Lewis, formerly an aide to Jefferson, was brooding and intellectual. But both were Virginians, Army officers and veteran outdoorsmen*

HOME ON THE RANGE *An elk herd crosses the Bob Marshall Wilderness Area in today's northwestern Montana, near the Sun River. Like so many who would follow, the members of the expedition feasted on fresh game, including buffalo meat, as they traveled across the Great Plains in the spring of 1805*

are still no better stories of Western exploration. The Corps of Discovery, it turns out, discovered the core of a nation.

THE WAY WEST

The expedition embarked from St. Louis, then the last outpost of U.S. influence in the West, on May 14, 1804, with William Clark leading some 45 young, rawboned frontiersmen into the wilderness; Lewis soon joined them. The party included Clark's slave York, a huge black man whose color would fascinate the Indians. Lewis and Clark saw themselves as Army officers, following orders from Commander-in-Chief Jefferson. Their primary aim was to claim the 800,000-sq.-mi. (2 million sq km) expanse purchased from France in 1803 and whatever wealth it offered for the U.S. With Spanish land to the south, British to the north and everything in the middle up for grabs, America's first space race had begun.

Military discipline was strictly enforced, and courts-

martial for desertion and drunkenness were held. The men of the Corps were soldiers, not saints, and their commanders were realistic men, not cartoon superheroes. Lewis carried a stockpile of medicine, including potions to treat venereal disease. He found more than a few occasions to administer the stuff to his men. Yet if the expansion of power was the group's goal, the expansion of knowledge was also a clear objective: Jefferson insisted that the mission be furnished with scientific instruments and instructed the leaders to keep comprehensive journals. The Missouri River from St. Louis to the Mandan Indian villages in what is now North Dakota was well traveled by trappers and traders, but even so the leaders collected a trove of new plant and animal specimens and mapped the route carefully. Lewis and Clark looked around, not just ahead—at prairie dogs in their burrows, at herds of buffalo massing in grassy valleys, at lights in the sky and seedlings in the soil.

After five months of battling upstream along the

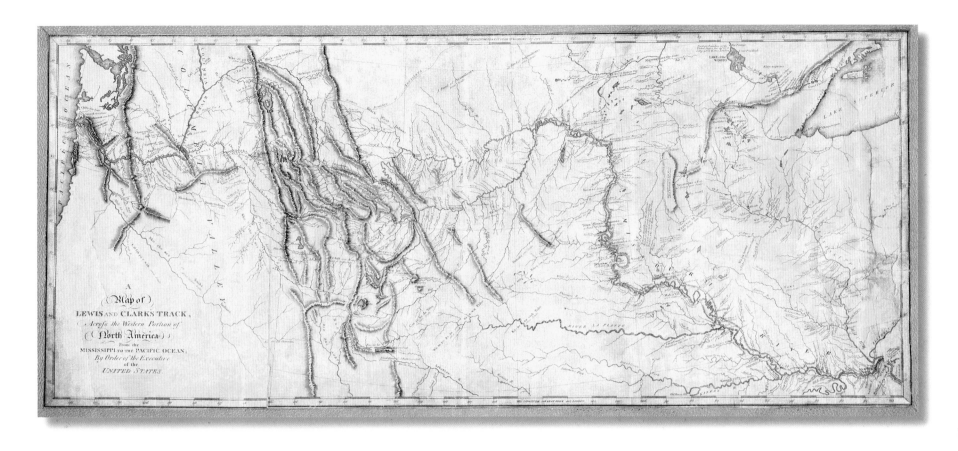

ARTIFACTS *At top is a map of the expedition's route, copied by cartographer Samuel Lewis (no relation to Meriwether Lewis). It was based primarily on journals kept by William Clark and was included in the original publication of the journals.*

Above are sample entries in one of the 13 journal books kept by the two leaders. At near right is a compass used on the trip, made in Philadelphia in 1803.

At far right is a modern replica of a dugout canoe made by the party to run the Columbia River

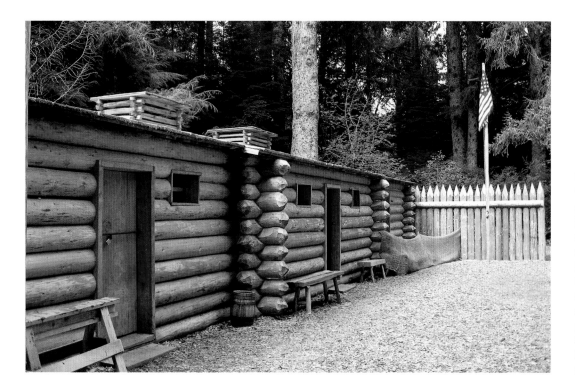

WINTER QUARTERS
The party spent the winter of 1805-06 on the Pacific Coast, setting up camp at Fort Clatsop, named for the local Indians, some five miles south of today's Astoria, Ore. At left is a reconstruction of the officers' quarters; it is most likely more polished than their hastily erected structure would have been

Missouri, the company made camp early in November and spent a bitterly cold winter near what is now the city of Bismarck, N.D. Here an important couple joined the party: the French-Canadian voyageur Toussaint Charbonneau and his wife Sacagawea, a 17-year-old Shoshone who spoke some of the language of the mountain tribes and, more important, knew some of the terrain ahead; her guidance would prove invaluable. She gave birth to a boy, Pomp, before the expedition moved west again.

Lewis and Clark got along well from the start, divvying up their responsibilities: Clark was the better boatman and navigator; Lewis, the planner and natural historian, often walked ashore collecting specimens. Clark had the cooler head. He brokered a crucial early compromise that ended a stare-down with the Teton Sioux. The more mercurial Lewis hurled a puppy into the face of an Indian who angered him, and killed a Blackfeet in the Corps's only violent incident. Nothing reveals the captains more than their treatment of Sacagawea. Lewis could be aloof, dismissing her in the journals as "the Indian woman," observing that "if she has enough to eat and a few trinkets to wear I believe she would be perfectly content anywhere." But the less formal Clark called her "Janey" and treated her warmly. She repaid him with gifts, including "two dozen white weazils tails" on Christmas Day 1805.

We know these details because Lewis and Clark kept scrupulously complete journals—13 volumes of them. We can look over their shoulders as they and their party contend with hunger, disease, blizzards, broiling sun, boiling rapids, furious grizzly bears and unrelenting plagues of tormenting "musquetors." We know about the Indians who helped them, and we know that they had to eat dogs and horses to survive.

After breaking winter camp on April 7, 1805, the men spent weeks crossing the plains, which Lewis described as "beautifull in the extreme." On May 26 he first saw the Rocky Mountains looming in the West. By an incredible coincidence, the first party of Shoshone they encountered, near the Continental Divide, was led by Sacagawea's brother. After spending backbreaking weeks dragging canoes 17 miles (27 km) around the Great Falls of the Missouri River in today's Montana, the party crossed the northern Rockies and made challenging traverses of the Salmon, Snake and Columbia rivers.

In the fall, the men traveled down the Columbia to the Pacific. On Nov. 15, they first saw a bay of the mighty saltwater expanse. "Ocian in view! O! the joy," Clark wrote in the journal. They spent a month exploring the rugged coast, roughed it through a trying winter, then turned themselves around and set their sights on the sunrise the next spring.

THE JOURNEY HOME

The two leaders separated for a time on the way home, as Lewis rode off on horseback to explore the Marias River country, while Clark and the main party traveled down the Yellowstone River by canoe. On Sept. 23, 1806, after 28 months of hardship and wonder, they reached their starting point, St.

UNCHANGED *In winter camp on the Pacific Coast, members of the expedition investigated a whale beached on the shore near Haystack Rock, above. Lewis and Clark National Historic Park encompasses several parks that commemorate the expedition's local explorations during their stay in today's Oregon and Washington State*

Louis. Congress rewarded the two leaders with 1,600 acres of land each; the troops received 320 acres each and double pay.

The last task of the voyagers—publishing their account—fell to Lewis. He had kept the raw notes and journals he and Clark had painstakingly carried to the Pacific and back with the goal of editing them into final form. But unsteady in his new job as Governor of Louisiana Territory, frustrated in his romantic aspirations and sinking into a depression fueled by alcohol and possibly disease, Lewis developed writer's block. He died in 1809; the cause is still hotly debated, although most historians believe it was suicide.

Clark took over the project, and the journals finally came out in a two-volume edition in 1814 that left out most of the expedition's significant scientific discoveries. What it did include was a cartographic masterpiece: Clark's map of the West. For the first time the blank spaces on the continent had been filled in with generally accurate representations of mountain ranges and rivers. Prominently marked on Clark's map were the names of dozens of tribes that lived there, in bold type that continues to undermine the notion that the American West was ever an unpopulated wilderness.

Hundreds of books later, it's hard to imagine the absence of Lewis and Clark from the pageant of popular American history. Without them, there would still be stirring tales of exploration but none that turn on the exquisite irony of a teenaged Indian girl giving crucial advice to two male Army officers. There would still be images of frontier adversity but none so stunning as that of Lewis expecting to see a path to the Pacific and discovering endless ranks of mountains instead. There would still be historical markers on Western highways but none that lead thousands of miles to the sea and allow the pilgrim at every stop to cross-reference the vista spread out before him with the written impressions of those who blazed the trail, boldly going where none of their kind had gone before.

Fantastic Voyages

As they launched their small flotilla of boats up the Missouri River, Lewis and Clark fully expected to find an easy water pathway to the Pacific, but they ran up against the Great Plains and Rocky Mountains instead. The two U.S. Army captains had very little sense of the terrain they would encounter on their long journey, and their hopes of traversing half the continent on large boats proved impossible. The large keelboat they had intended to serve as the headquarters vessel for the journey was left behind in North Dakota. When the expedition was able to find navigable water, dugout canoes proved the most useful vessels.

Even as Lewis and Clark headed toward their meeting point in St. Louis to begin their journey into the West, they passed through a nation still rough and rawboned. Here is Meriwether Lewis' account of one day's travels on the Ohio River, from his journal entry of Sept. 4, 1803, aboard the red pirogue he had apparently purchased in Pittsburgh:

"The Perogue was loaded as his been my practice since I left Pittsburgh, in order as much as posseble to lighten the boat, the [men] who conducted her called us in distress about an hour after we had got under way. We came too and waited her coming up, found she had sprung a leek and had nearly filled; this accedent was truly distressing, as her load consisting of articles of hard-ware, intended as presents to the Indians got wet and I fear are much damaged; proceeded about three miles further.

"Got fast on a bar below georgetown, and with the assistance of some of the neighboring people got overe it with much difficulty; at Georgetown. Purchased a canoe compleat with two paddles and two poles for which I gave 11$, found that my new purchase leaked so much that she was unsafe without some repairs; came too about a mile below the riffle on the east shore pretty early in the evening where we stayed all night having made about thirteen miles this day."

GRAPHIC FOR TIME BY LON TWEETEN; TEXT BY JACKSON DYKMAN

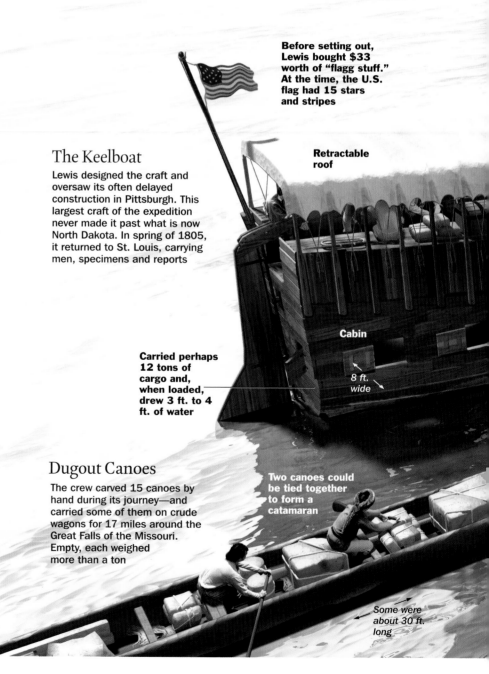

The Boats

The corps used 25 vessels throughout the journey. A 26th boat—a custom-designed collapsible iron frame covered with skins—was carried all the way to what is now Montana, where it failed upon hitting the water

Before setting out, Lewis bought $33 worth of "flagg stuff." At the time, the U.S. flag had 15 stars and stripes

The Keelboat

Lewis designed the craft and oversaw its often delayed construction in Pittsburgh. This largest craft of the expedition never made it past what is now North Dakota. In spring of 1805, it returned to St. Louis, carrying men, specimens and reports

Retractable roof

Cabin

Carried perhaps 12 tons of cargo and, when loaded, drew 3 ft. to 4 ft. of water

8 ft. wide

Dugout Canoes

The crew carved 15 canoes by hand during its journey—and carried some of them on crude wagons for 17 miles around the Great Falls of the Missouri. Empty, each weighed more than a ton

Two canoes could be tied together to form a catamaran

Some were about 30 ft. long

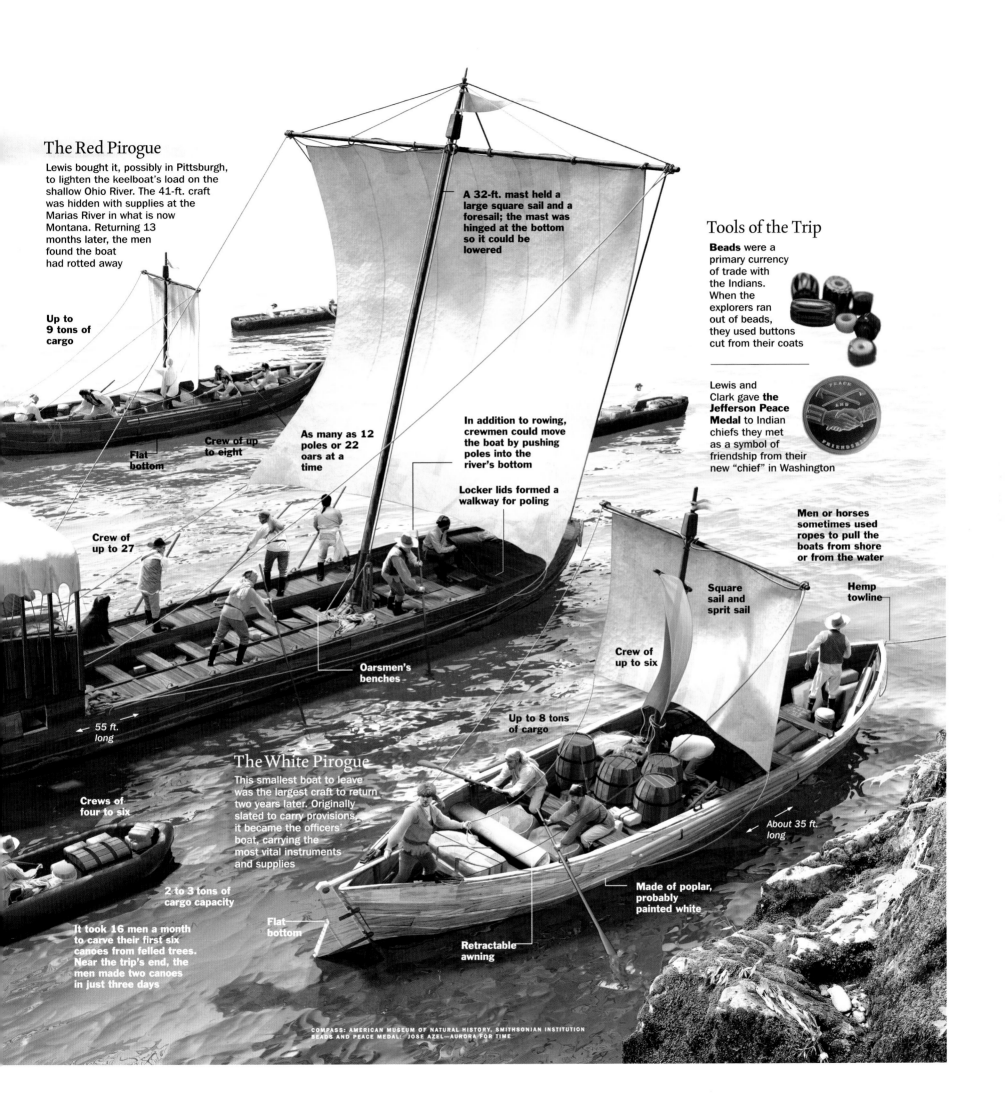

The Red Pirogue

Lewis bought it, possibly in Pittsburgh, to lighten the keelboat's load on the shallow Ohio River. The 41-ft. craft was hidden with supplies at the Marias River in what is now Montana. Returning 13 months later, the men found the boat had rotted away

Up to 9 tons of cargo

Crew of up to eight

Flat bottom

A 32-ft. mast held a large square sail and a foresail; the mast was hinged at the bottom so it could be lowered

Tools of the Trip

Beads were a primary currency of trade with the Indians. When the explorers ran out of beads, they used buttons cut from their coats

Lewis and Clark gave **the Jefferson Peace Medal** to Indian chiefs they met as a symbol of friendship from their new "chief" in Washington

As many as 12 poles or 22 oars at a time

In addition to rowing, crewmen could move the boat by pushing poles into the river's bottom

Locker lids formed a walkway for poling

Men or horses sometimes used ropes to pull the boats from shore or from the water

Crew of up to 27

Square sail and sprit sail

Hemp towline

Oarsmen's benches

Crew of up to six

Up to 8 tons of cargo

Crews of four to six

The White Pirogue

This smallest boat to leave was the largest craft to return two years later. Originally slated to carry provisions, it became the officers' boat, carrying the most vital instruments and supplies

55 ft. long

About 35 ft. long

2 to 3 tons of cargo capacity

It took 16 men a month to carve their first six canoes from felled trees. Near the trip's end, the men made two canoes in just three days

Flat bottom

Retractable awning

Made of poplar, probably painted white

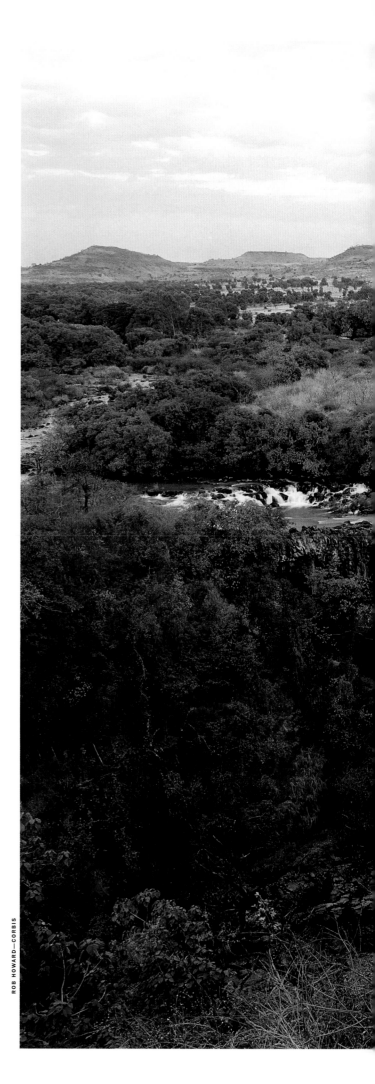

Search for the Source of the Nile

The 19th century was the great age of geographical exploration, when armchair travelers around the world relished breathless newspaper and magazine accounts of the latest deeds of far-flung adventurers. If it's sometimes difficult to recall what all the fuss was about from a remove of 150 years—well, to paraphrase *Sunset Boulevard,* these heroic explorers *were* big; it's the planet that got small. In an age when one can fly from London to New York City in eight hours, a title like *Around the World in 80 Days* is long past its sell-by date.

Yet back in the day, at a time when large parts of the globe remained to be trekked and charted, fame and fortune awaited those who could claim to be the first to reach and map these unknown regions. Britain, then the mightiest world empire, was the epicenter of geographical inquiry, which also served as the advance guard of political, religious and commercial colonialism.

In this age of strenuous outreach, no geographical puzzle enticed adventurers more than the one first propounded by the 2nd century A.D. Roman scientist and geographer Ptolemy: Where in "Darkest Africa" was the source of the Nile River? For thousands of years this great body of water had nourished Egyptian civilization with its mighty annual floods, which crossed hundreds of miles of sizzling desert sands before reaching and refreshing the delta area, where more than 90% of Egyptians lived.

Surely the water came from the elevated highlands deep in the unmapped interior of central Africa. But where exactly? And what about the vague stories that the river was born in an upland region of giant lakes and snow-capped mountains—snow-capped near the equator, no less? Were they fact or legend? The search for this geographical grail drove one of history's great tales of exploration, as two eminent Victorians, Richard Burton and John Speke, threw their lot together and mounted an expedition to discover the source of the Nile—only to turn into bitter rivals, whose animosity ended in a tragic death.

The story of Burton and Speke, once familiar to every schoolboy, has been largely forgotten. It has never been better told than in Alan Moorehead's classic 1960 account, *The White Nile,* while Hollywood took a stab at the story in the 1990 film *The Mountains of the Moon.*

Previous explorers who had attempted to follow the Nile upriver from its delta had never penetrated beyond the marshes of Sudan that lie past Khar-

Upriver *The Blue Nile, here seen at the Tisisat Falls in Ethiopia, is the major source of the Nile's flow. But the White Nile is far longer and its unknown source was long the subject of conjecture*

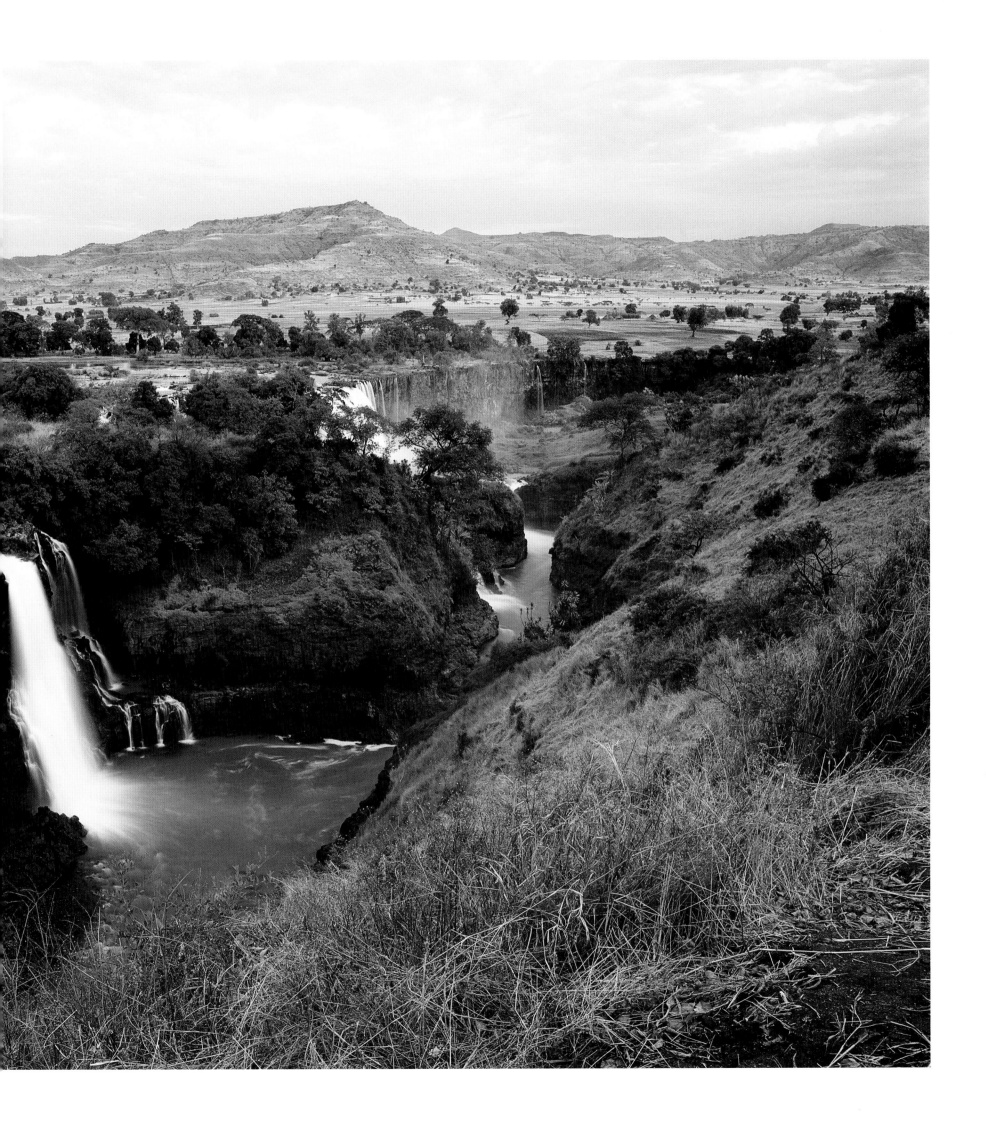

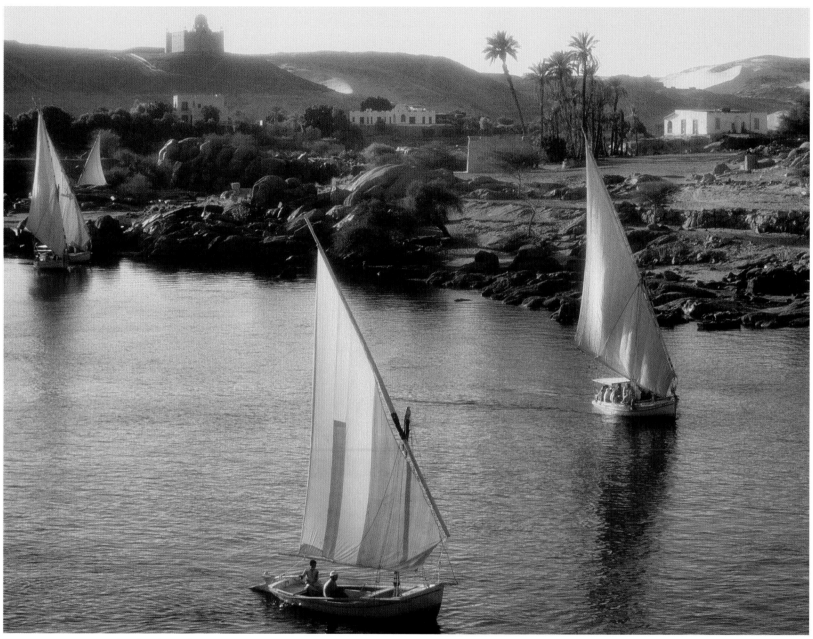

FELLUCAS AT SUNSET *After the Blue and White Nile join at Khartoum in Sudan, the united river flows north into the lush region of Aswan in Egypt, above*

toum, where the Blue branch of the great river flows out of Ethiopia to join the longer White branch. Burton and Speke chose to come at the presumed source of the river sideways, penetrating the African continent from the island of Zanzibar. Exploration at this time resembled a long safari: when Burton and Speke began their journey on June 27, 1857, their single-file caravan included more than 100 native bearers, guards and guides, who marched through the jungle with bugles blowing to warn natives of their approach.

The pace was leisurely, but far from pleasant: Speke was temporarily stricken blind and deaf, while Burton, battling malaria, was sometimes borne in a hammock,

babbling in delirium. Their progress through today's Tanzania was aided by the region's ruling class: tribal kings, village elders and Arab slave traders, most of whom welcomed the Britons as ambassadors of European civilization.

In February 1858 the caravan reached Lake Tanganyika; a few months later, Speke branched off from the main caravan, leaving an ailing Burton behind. Speke became the first European to see Lake Victoria (Victoria Nyanza), which he assumed—with scant proof—was the Nile's source. He so informed Burton, who was unmoved. When Speke returned to Britain before Burton and declared he alone had discovered the source, Burton *was* moved: he was furious.

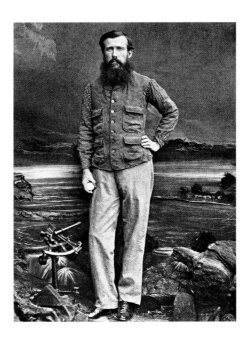

RICHARD FRANCIS BURTON, 1821-1890

Burton may take the honors for boasting the longest list of occupations in a single Wikipedia entry; he is described as "explorer, translator, writer, soldier, orientalist, ethnologist, linguist, poet, hypnotist, fencer and diplomat." The colorful Victorian remains the paradigm of the British orientalist, inexorably drawn to the Middle East and Africa. He won fame by dressing in mufti, darkening his skin and becoming the first Englishman to penetrate both Islam's sacred city of Mecca and the walled city of Harar in Ethiopia. An expert linguist, he translated *The Book of 1000 Nights and a Night (The Arabian Nights)* from the Arabic and the Indian erotic texts the *Khama Sutra* and *The Perfumed Garden.*

Burton despised the puritanism of Victoria's Britain: he courted the notoriety he attracted with his interest in the sexual practices and texts of foreign cultures. He was a great explorer, a poor diplomat, a fine scholar—and a bit of a rogue.

JOHN HANNING SPEKE, 1827-1864

Speke may be posing in front of a diorama in a Victorian photographer's studio in the portrait above, but his credentials as an adventurer are beyond dispute. The officer in the British Indian Army first tasted the exhilaration of exploration when he traveled through the Himalayas to Tibet while on leave. He met Burton in India and happily accepted the older officer's offer to explore Somalia in 1854-55. Speke was badly injured in a skirmish with natives and could have blamed Burton for the fiasco, yet he again accepted Burton's offer to join him on a journey to the rumored great lakes and mountains of the African interior.

Speke suffered severely on the journey—he was so blinded by disease he could barely see Lake Tanganyika, one of the trip's major discoveries. The two men's friendship died somewhere along the exhausting trail to the interior and never revived, filling Speke's final years with bitterness.

On a later, equally harrowing journey that began in today's Uganda, Speke and James A. Grant followed, intermittently, the northbound Nile from Victoria Nyanza to Gondokoro in southern Sudan, convinced the lake was the river's source.

In the years that followed, Burton and his allies strenuously fought Speke's claim, pointing to major inconsistencies in his account. As the rivalry grew increasingly bitter, it generated great interest in their dueling tales. A showdown of sorts was scheduled for Sept. 16, 1864, when each man was to plead his case to the Royal Geographic Society. As the crowd waited for a tardy Speke, word arrived that he had been found shot dead by his own hand. Was his death an accident? Or had a shaken Speke, fearing Burton's arguments, taken his own life? No one knows—and that mystery continues to drive interest in their story. As for that other mystery: the White Nile's most distant source is the Rukarara River in Rwanda, whose waters then flow through Victoria Nyanza on their journey to the Mediterranean.

THE SMOKE THAT THUNDERS

When the weather conditions are right, the crashing waters of Victoria Falls, one of the planet's greatest cataracts, can be heard some 10 miles away—a sonic wonder that is almost a match for its visual splendor. Where the falls of the Zambezi River plunge off a black basalt cliff, they form a curtain of falling water that is the widest on the planet— almost a full mile in breadth. Pouring into the gorge more than 350 ft. (108 m) below, the cascade sends a column of spray more than 1,000 ft. into the sky, giving rise to the African name for the cascade: *mosi-oa-tunya* (the smoke that thunders). And there's more magic here: on nights when the full moon is ascendant, one of Earth's most elusive natural wonders can be seen in the evanescent spray—a moonbow, a faint, shimmering spectrum formed when rays of lunar light play across the watery mist.

The echoes of this mighty natural wonder had reached European ears in the form of rumors and legends for more than 1,000 years, and as northern adventurers began to probe the secrets of central Africa early in the 19th century, a number of Portuguese explorers attemped to proceed upstream, working against the river's flow, in hopes of confirming the great cataract's existence and location. But they failed, driven back by the Zambezi's raging torrents. The first European to glimpse the falls arrived from the other direction, traveling downstream on the river after a years-long trek; he was that paradigm of Victorian exploration, Dr. David Livingstone, the Scottish missionary and geographer who was instrumental in opening up the interior of the continent, which Britons insisted on calling "Darkest Africa."

On his journeys through central and southern Africa, Livingstone was guided by the three lodestars of the Victorian era of exploration: Christianity, commerce and civilization. Ironically, Livingstone proved a superb proponent of the last two principles, but his missionary work, which drove his heroic explorations into the unknown and made him a hero across the British Empire, proved largely unsuccessful: in his 32 years of evangelizing, he succeeded in baptizing only one African family into Christianity. Livingstone first saw the falls he would name for his Queen in 1855, when he was nearing the end of his first, four-year trek through central Africa, the journey of discovery that would make him a legend.

LONG WAY DOWN *A visitor takes in the view from atop a bluff at Victoria Falls. The Zambezi River forms the boundary between Zambia and Zimbabwe. The waterfall was named a UNESCO World Heritage Site in 1989*

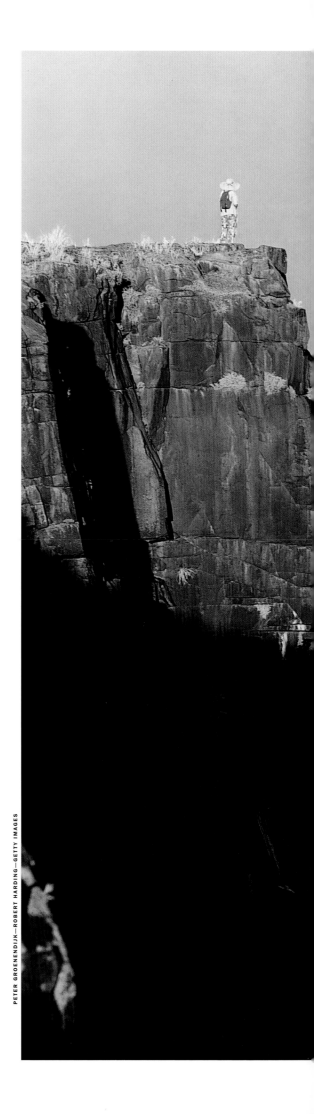

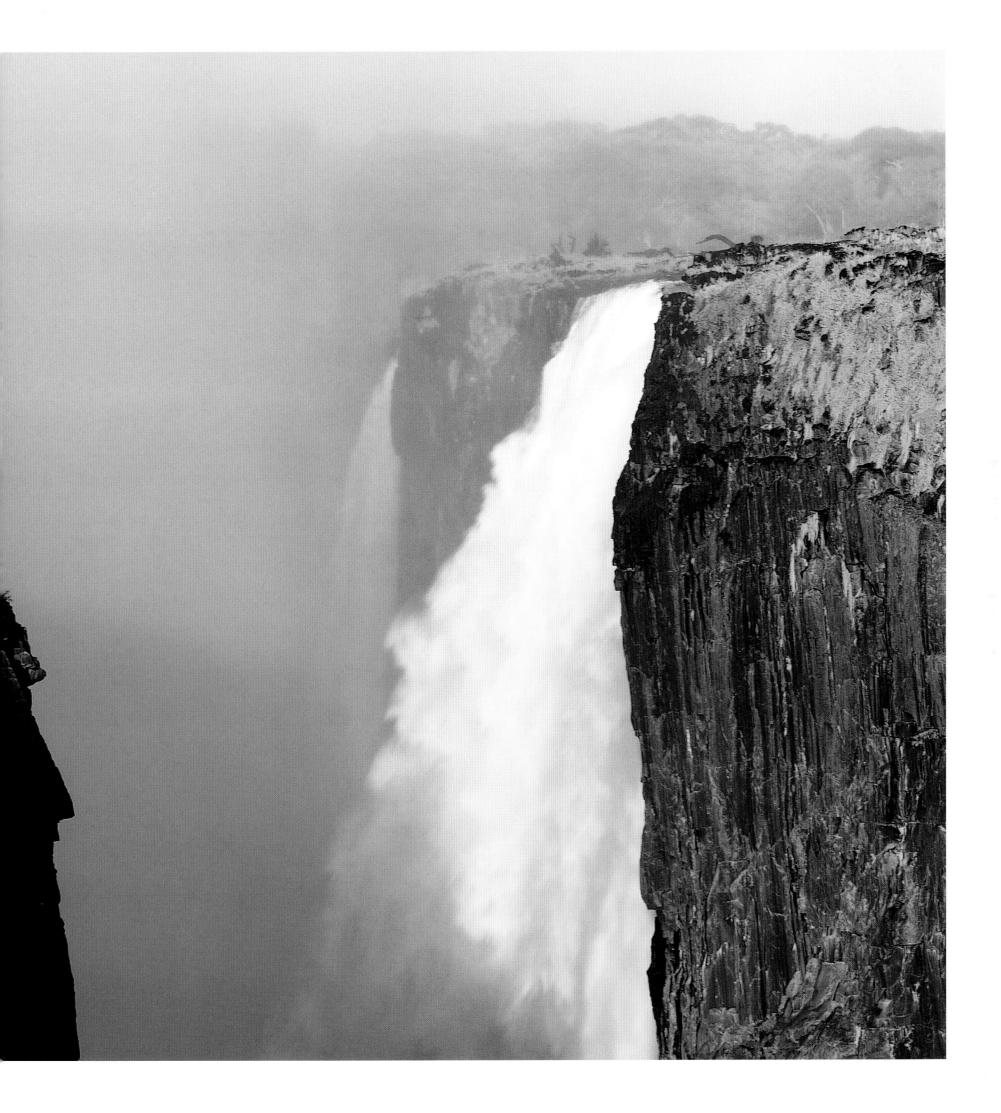

Yellowstone: Percolating Again

The bizarre natural features that make Yellowstone National Park unique—spewing geysers and bubbling mud pots, colorful mineral hot springs and wispy fumaroles—were known to Native Americans long before the descendants of Europeans encountered them. The first mountain man to visit the area, drawn by Indian accounts, was John Colter, a member of the Lewis and Clark Expedition, who explored the region after his stint in the Corps of Discovery. Other mountain men followed, but their accounts of its wonders were discounted by some as tall tales. The area's renown kept growing, particularly after the 1871 expedition led by federal geologist Ferdinand Hayden, who was accompanied by pioneering Western photographer William Jackson and the landscape artist Thomas Moran. Their accounts and images of the Wyoming area so captivated the American public that in 1872 Congress set aside more than 1 million acres of Yellowstone to be preserved as the first U.S. national park.

Tectonic theory explains Yellowstone's geothermal properties as the result of its position: it is being borne by the North American Plate over a stationary "hot spot" in the planet's crust, where magma rises close to the surface. In the 1960s and '70s another discovery was made: the Yellowstone basin is a vast volcanic caldera. Throughout history the area has been rocked by the enormous eruptions of what we now call supervolcanoes. The most recent such big bang took place some 642,000 years ago, geologists say, and shaped the vast Yellowstone Caldera.

The latest discoveries about Yellowstone suggest that more surprises may be near. Because it sits atop such a geologically active area, Yellowstone typically records some 2,000 small earthquakes a year. But in a one-week period around New Year's Day 2009, 500 tremors were recorded. Moreover, scientists have reported that the gradual upward movement of the caldera floor has strongly accelerated since 2004, with the basin floor now rising about 3 in. (7 cm) each year. The unmistakable conclusion: beneath Wyoming's famed hot spot, things are heating up again.

AS THE EARTH BURBLES *Visitors are entranced by Yellowstone's hydrothermal oddities, which include, clockwise from top left: Boiling River Hot Springs; a field of other hot springs with a grazing bison; Castle Geyser in the Upper Geyser Basin; Minerva Spring and a passing elk; a mud pot in Pocket Basin*

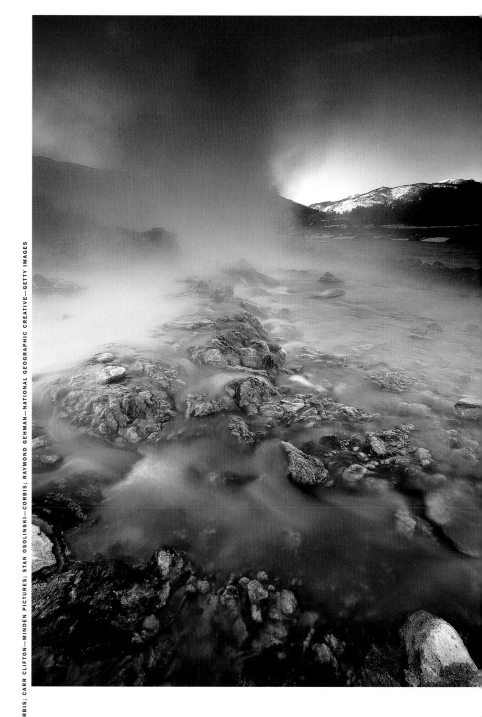

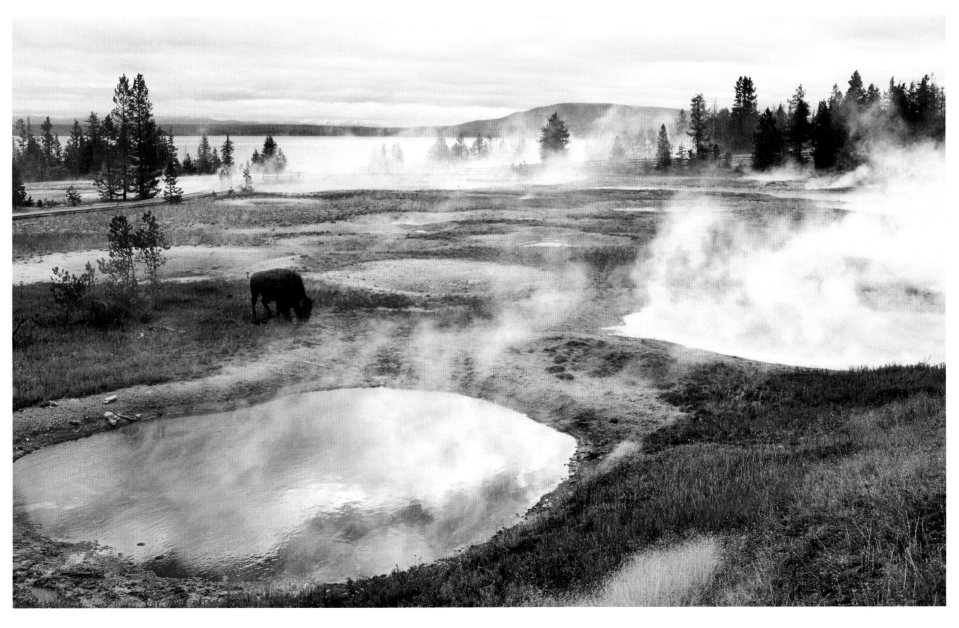

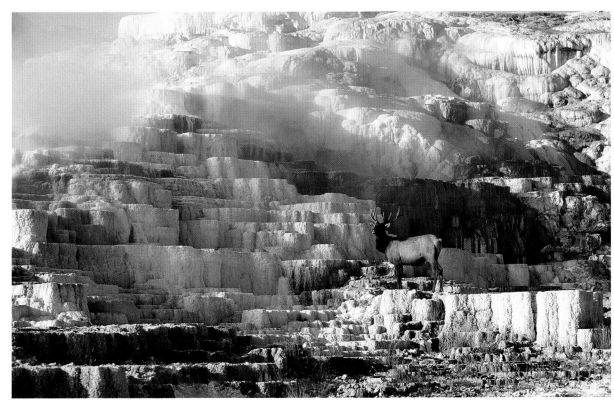

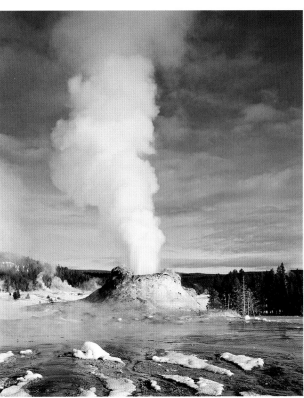

To the Ends of the Earth

In the late 19th century, the brave souls who are drawn to a life of adventure and exploration found themselves facing a terrifying possibility: there was entirely too much *terra cognita* on the planet and an alarming shortage of its opposite. Lewis and Clark had explored America's West; Commodore Perry had opened Japan to the West; "Darkest Africa" had been illuminated by Burton, Speke and Livingstone—so where could explorers look for glory? The answer: to the extreme north and south, where the frozen wastes of the Arctic and Antarctic presented both a finite goal—to be first to the pole!—as well as the extreme, high-pressure conditions essential to the distillation of heroism. What's more, there was a large market for ripping yarns of polar peril: newspapers and magazines funded expeditions, and syndicates backed others to satisfy the demand for photos and, later, films of anorak-clad adventurers.

The great age of polar exploration that ensued lasted for some 6 decades and produced such driven characters as American Robert E. Peary, Norwegian Roald Amundsen and Britons Robert F. Scott and Ernest Shackleton. It featured such memorable events as the long-running dispute between Peary and Frederick Cook over who reached the North Pole first and the tragic failure of Scott's 1910-12 Antarctic expedition.

Until recently, the exploits of British explorer Shackleton had been almost forgotten in popular culture, but writer Caroline Alexander brought them to vivid life in her well-researched 1998 narrative *The Endurance* (Knopf). The book featured photos of the 1914-16 Antarctic expedition taken by Australian Frank Hurley, who accompanied the team to document its triumphs— and ended up recording its narrow escape from death.

ESCAPE! *Shackleton is wearing a broad-brimmed hat in the photo at top right; with him is photographer Frank Hurley, who documented the hardships of the expedition. After the* Endurance *sank, the starving, exhausted men dragged three of the ship's small boats to open water, then sailed for seven days in extreme weather before reaching Elephant Island. Shackleton and a small group of men then sailed the 22-ft. (6 m) whaleboat at right for 16 days through polar gales to reach South Georgia Island, 800 miles (1,287 km) to the northeast, where they sent a team to rescue their colleagues. All 27 men survived*

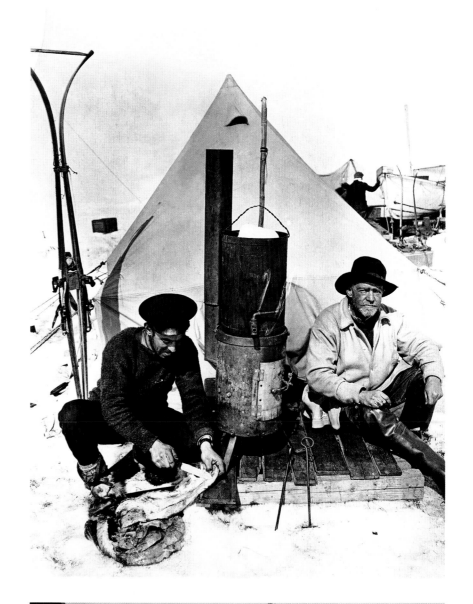

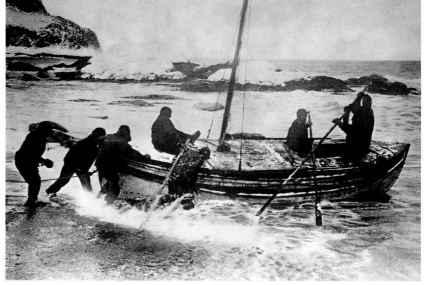

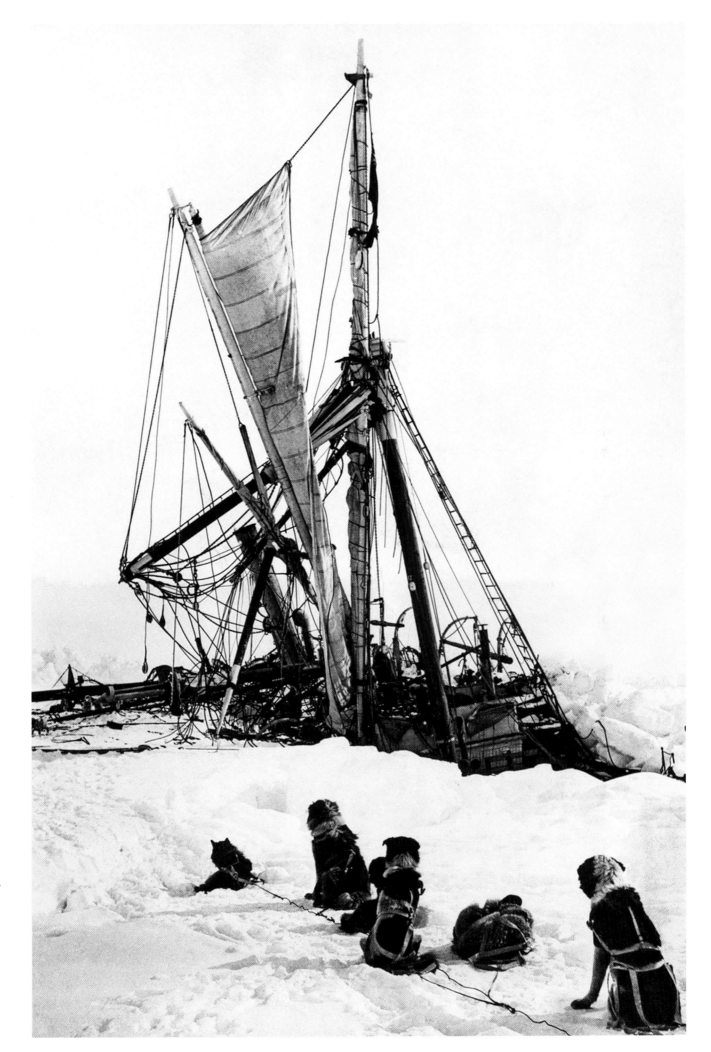

TRAPPED *Shackleton's 1914-16 Antarctic expedition aimed to traverse the continent across the South Pole. But his ship,* Endurance, *was trapped amid ice floes in the Weddell Sea for 10 months, right, and sank late in 1915, weeks after Hurley's lens captured the canting ship deeply mired in the ice, right.*

Before Endurance *sank, Hurley stripped to the waist and hacked through 4 ft. (1.2m) of mushy ice to salvage the waterproof tin boxes that held his finished glass plates. Then he and Shackleton opened the boxes, examined the negatives and dumped some 400 because weight would be crucial in any rescue; they kept 120 of the best of them, thus preserving the history of their ill-fated journey*

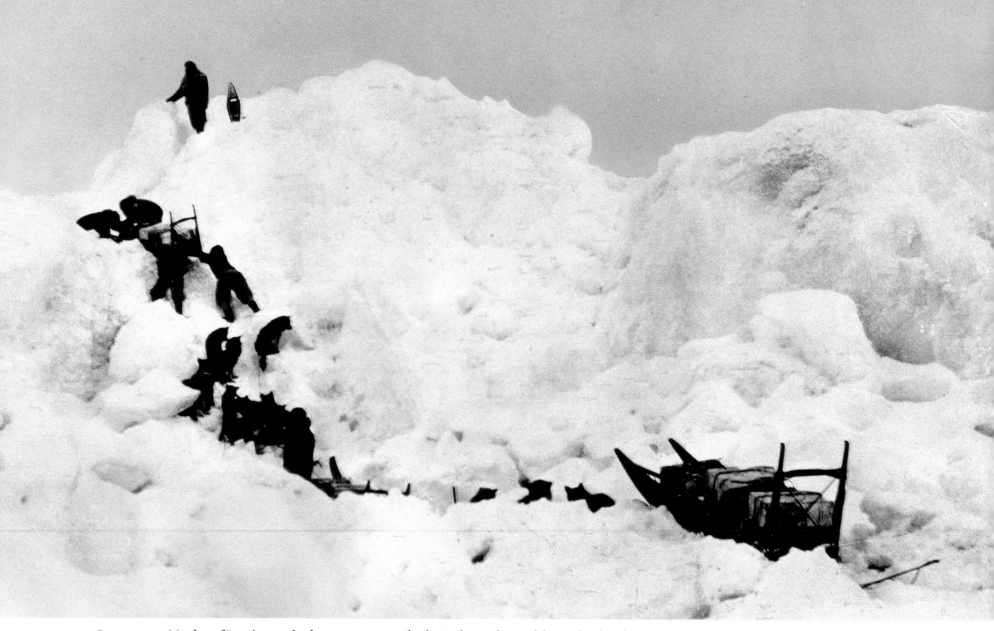

SLOW GOING *Members of Peary's party clamber over a pressure ridge during their push toward the North Pole on his 1908-09 expedition*

ROBERT PEARY AND THE ATTRACTION OF THE POLE

In his book *Ninety Degrees North* (Grove Press; 2002) historian Fergus Fleming describes the noted American polar explorer Robert Peary as "probably the most unpleasant man in the annals of polar exploration." That's quite a claim, for the frenzied search for renown that drove decades of polar probing produced a swarm of characters whose egos were as puffed up as their parkas and whose blood often seems to have run about as warm as the climes they explored. Consider the bitter dispute between Peary and a onetime colleague, Frederick Cook, over which of them had been the first to reach the North Pole. A century after it first flared, it has some sizzle left in it. Cook's claim to have reached the pole has long been refuted, but while the majority of historians doubt that Peary ever reached the pole, some still support his claim, including one of his original

sponsors, America's respected National Geographic Society.

Peary hatched his polar dreams in a suitable incubator, the jungles of Nicaragua, where the young officer in the Navy Corps of Engineers was working in the 1880s on a proposed trans-isthmus canal. He enlisted the steady fellow Navy man Matthew Henson, a rare African-American polar hand, as his colleague, and the two prepared well for the Arctic. Peary made several trips to Greenland in the 1880s and 1890s, and, like Roald Amundsen, he learned survival skills from the local Inuit he employed: he relied on dogs to haul men and sleds, lived in igloos, wore animal skins for warmth and relied on caches of supplies to support his quick dashes toward the pole with a handpicked party. In these years, Peary mapped many locations in Greenland and the Arctic Circle, achievements still widely admired.

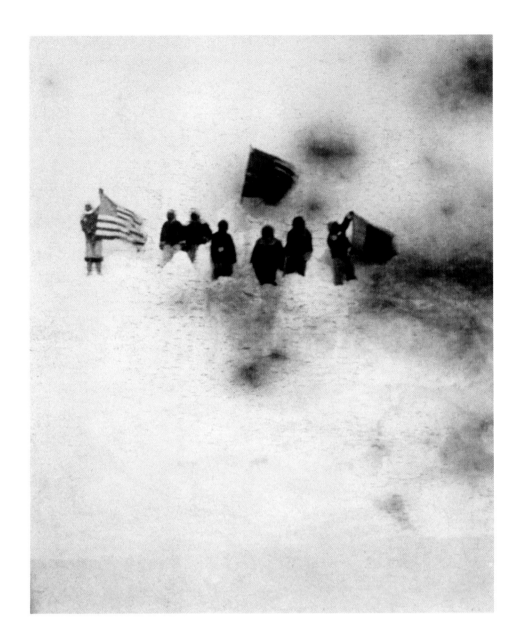

COLLEAGUES *Above, Peary and a few favorite sled dogs are shown aboard a ship after his 1909 drive for the North Pole*

SHADOWS *The photograph at left offers an example of how new technologies attempt to glean fresh information from old artifacts. The picture shows Robert Peary and his party in 1906, supposedly at 87°06' latitude, further north than any humans before them had stood. Using a technique called photogrammetric rectification, in 1990 a group from the U.S. Navigation Foundation, sponsored by the National Geographic Society, studied the shadows in the picture. After correcting for perspective and determining the sun's elevation on this date, they concluded that Peary's claim was correct. The 1990 study also concluded that Peary had indeed reached the North Pole or very near its vicinity in 1909. Skeptics remain unconvinced*

Peary launched his first attempt to reach the North Pole in 1906. But as his party moved into the deep north, a major storm separated its members. He claimed that on April 21, 1906, he and a small group had reached the farthest point north ever attained, at 87°06' latitude. Yet his own account seems to contradict the possibility that he could have reached so far north, given his stated location on April 20, although a 1990 review of photographic evidence using new technology, above, supported Peary's claim.

On his next expedition, Peary claimed that he, Henson and four Inuit reached the pole on April 6, 1909. But when he returned to civilization, he learned that Cook, his former colleague, claimed to have reached the pole first, in 1908. The dispute simmered for years, until the U.S. Congress stepped in and awarded the honor to Peary in 1911.

Historians agree that Cook's claim is simply without merit.

Peary's supporters continue to assert that he reached the pole in 1909. But Fleming and many others argue that he consistently overstated the distances he claimed to have traveled in a very short time, once his final party was reduced to a small unit—and no other observers capable of taking position readings were present. Reviewing Fleming's book, the New York *Times* declared, "The evidence is as damning as it needs to be." TIME's John Skow, reviewing *Noose of Laurels,* a 1989 book by Wally Herbert that also disputes Peary's claim, wrote of Peary, Cook, Henson and others: "[Their] real accomplishments were extraordinary. They were married to the Arctic, and perhaps the truth of the matter was that if they had to fake triumphs in order to return there, they would fake them." The reader's view may vary.

RIVALS *Roald Amundsen, left, with four other men and 52 sled dogs, reached the South Pole on Dec. 14, 1911. They traveled a shorter route than Scott's team and moved much more quickly, relying on dog teams to haul their sleds. Amundsen died an explorer's death in 1928, when his airplane crashed near the Barents Sea in the Arctic while his party was searching for survivors of a crashed Italian airship. His body was never found. In 2009 the Norwegian government announced it would launch a new search for the wreckage of the plane, using an unmanned submarine to reconnoiter the sea floor near the presumed crash area.*

Robert F. Scott, right, was lionized by the British public in the decades after his death, but more recent biographers have been less kind, questioning both his judgment and his leadership

DEADLY RACE TO THE SOUTH POLE

Norway's Roald Amundsen easily qualifies as one of the greatest explorers in history. He was the first to navigate the famed Northwest Passage across North America—though the path he traversed in the years 1903-05, across the icy subpolar waters of northern Canada, was far too forbidding to become the transcontinental trade route dreamed of by earlier explorers. In Canada, Amundsen learned the survival techniques of the Inuit: using sled dogs to haul men and supplies; wearing animal skins rather than heavy wool parkas for warmth; traveling lightly and moving as quickly as possible. His next goal: the North Pole. But when he learned in 1910 that two men already claimed to have reached it, he reversed direction. In October 1911, he sent a telegram to an expedition also aiming south: BEG LEAVE TO INFORM YOU FRAM PROCEEDING ANTARCTIC. AMUNDSEN.

The man who received that message, Britain's Robert Falcon Scott, was also schooled in polar survival. After rising fast in the Navy, in 1900 he was named commander of the National Antarctic Expedition aboard H.M.S. *Discovery*. On his successful mission, his group discovered and named King Edward VII Land and was frozen in ice for nearly two years off Ross Island. Scott next served aboard four warships, but he never stopped dreaming of being first to reach the South Pole. Finally, in 1910, backed by government funds, he got his chance, as he steered H.M.S. *Terra Nova* toward the Antarctic.

A month after receiving Amundsen's telegram, Scott started south overland from winter quarters on Cape Evans with motorized sleds, shaggy ponies, heavy sledges—and too few dog teams. But the motors soon broke down, and the ponies were killed to feed men and dogs. Phenomenally good weather was soon followed by blizzards. Deep snow held the party in a soft vise. On Dec. 14 Scott wrote, "We are just starting our march with no very hopeful outlook." That same day Amundsen's party, traveling fast by a different route, became the first humans to stand at the South Pole.

Still 140 miles (225 km) from his goal, Scott and four hand-picked men split off from the others for the final dash. They reached the Pole on Jan. 16—where they were staggered to find a tent and flag left by Amundsen. "Great God!" Scott wrote. "This is an awful place, and terrible enough for us to have labored to it without the reward of priority." On the 800-mile (1,287 km) trek back, sickness, starvation and bad weather ground the five men down. Edgar Evans collapsed, became delirious and died. Days later, Lawrence Oates left his tent, saying, "I am just going outside and may be some time." He never came back. Eight months later, a search party found Scott's tent, half buried in snow. Inside, three bodies were frozen in their sleeping bags.

In 1926, Roald Amundsen finally crossed the North Pole in the airship *Norge;* he and a fellow traveler, Oscar Wisting, became the first people ever to reach the two ends of the planet.

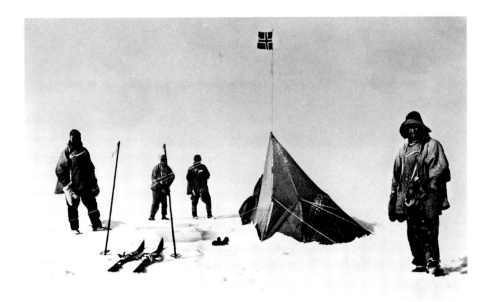

we shall stick it out to the end but we are getting weaker of course and the end cannot be far.

It seems a pity but I do not think I can write more—

R Scott

Last Entry—

For Gods Sake look after our people

SECOND PLACE *After a grueling trek to the South Pole, the five members of Scott's polar party recorded the scene above that greeted them on Jan. 16, 1912: a tent and flag left behind to indicate that Amundsen's party had arrived one month before them. All the men in this photograph died attempting to rejoin the main party, whom they had left behind in their eagerness to reach the pole before their rivals. From left to right: Robert F. Scott, H.R. Bowers, Edward Wilson, Edgar Evans; the photograph was taken by Lawrence Oates*

LAST WORDS *Evans and Oates were the first to die during the return journey, leaving three members of the group alive. Scott's journal was found eight months after he, Wilson and Bowers perished in a tent as they waited out a days-long storm. At left is the last entry, in Scott's hand; it is dated March 29, 1912*

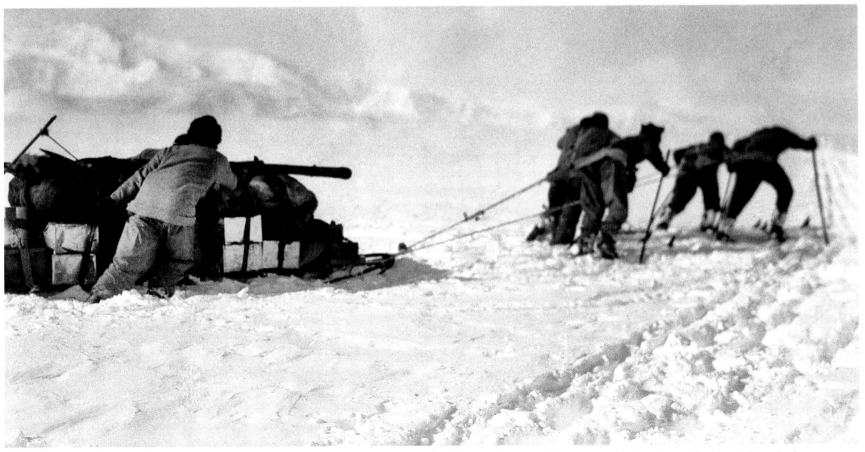

LONG HAUL *With their ponies, motorized sleds and dogs lost, the men of Scott's expedition haul their supplies on a sled as they cross the Beardmore Glacier, which involved a 100-mile (160 km)-long ascent. After the last party of five reached the South Pole and began the journey home, Edgar Evans died on Feb. 17, near the base of the glacier*

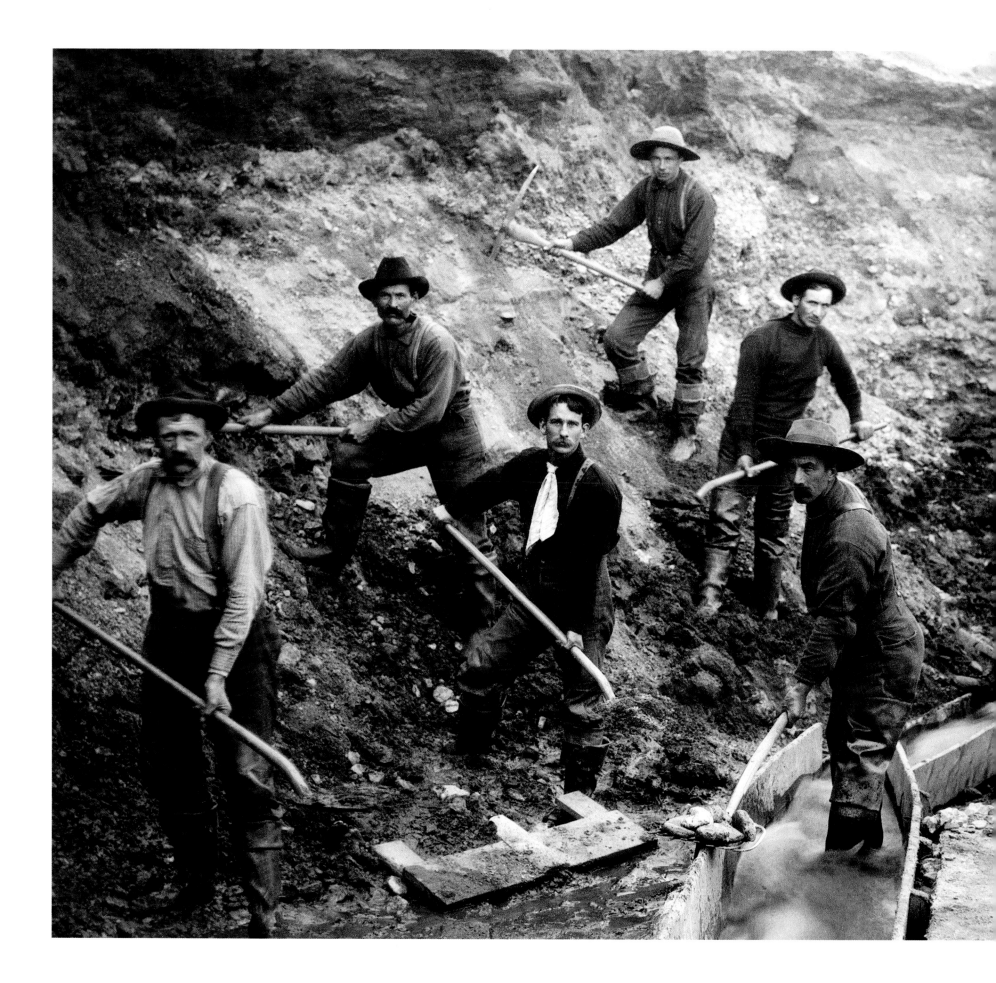

IN QUEST OF MINERAL RICHES

In May 1848, a California printer and retailer named Samuel Brannan conducted what may have been the single most influential one-man demonstration in American history. Hoisting a bottle filled with gold flakes, he strode through the streets of San Francisco, shouting, "Gold! Gold! Gold from the American River!" At the time, San Francisco was a town of some 1,000 inhabitants. But the gold rush that Brannan touched off (after he had bought up the burg's entire supply of shovels and buckets for his store) transformed the sleepy coastal outpost into a boomtown of 25,000 in 18 months—and transformed the nation as well. The quest for gold—and not long after, silver—was a dynamo that drew Americans west, creating demand for railroad and steamship lines and accelerating the growth of the U.S. into a transcontinental nation.

Not all of history's great discoveries are scientific: some are driven by the need—or desire—to harvest the planet's riches. Early humans delved into the ground for tin, copper and salt, while the allure of silver and gold are as old as history, yet ever fresh. An ongoing gold rush in Brazil is transforming that nation just as yesteryear's prospectors changed the U.S. Meanwhile, the worldwide demand for diamonds and rubies continues to help fund oppression in such gem-spangled nations as Sierra Leone and Myanmar (Burma).

The contemporary equivalent of 19th century mineral frenzies is the quest for petroleum. When we first began to tap into the ground for this substance, it was primarily used as a source of fuel for lamps. But with the invention of the internal combustion engine, petroleum became the modern equivalent of gold, showering riches on nations seemingly at random, from Saudi Arabia to Venezuela, altering the map of world wealth and political power. The quest for mineral wealth continues. A February 2009 New York *Times* story declared, "In the rush to build the next generation of hybrid or electric cars, a sobering fact confronts both automakers and governments seeking to lower their reliance on foreign oil: almost half of the world's lithium, the mineral needed to power the vehicles, is found in Bolivia." Lithium rush, anyone?

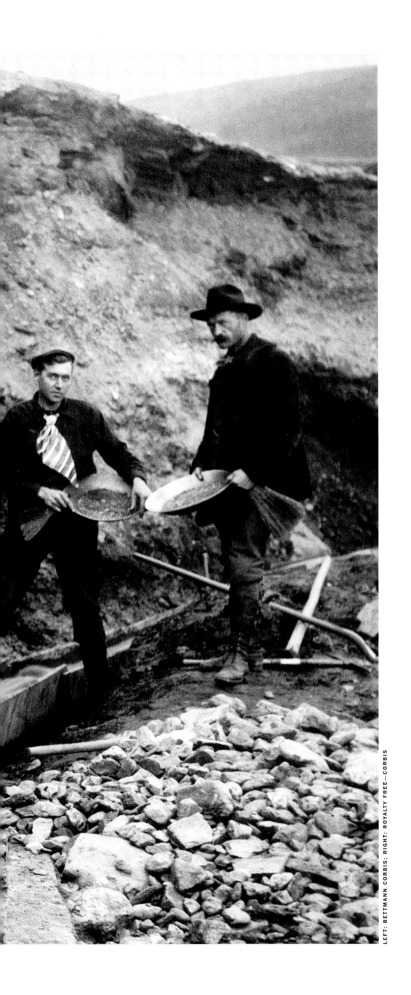

GREAT EXPECTATIONS *Prospectors pan for gold in a sluice in the Yukon during the second great 19th century U.S. gold rush. Americans derided remote Alaska as "Seward's folly" after Secretary of State William Seward purchased the land from Russia in 1867. But the 1897-98 gold rush brought hundreds of thousands of adventurers to the thinly populated region*

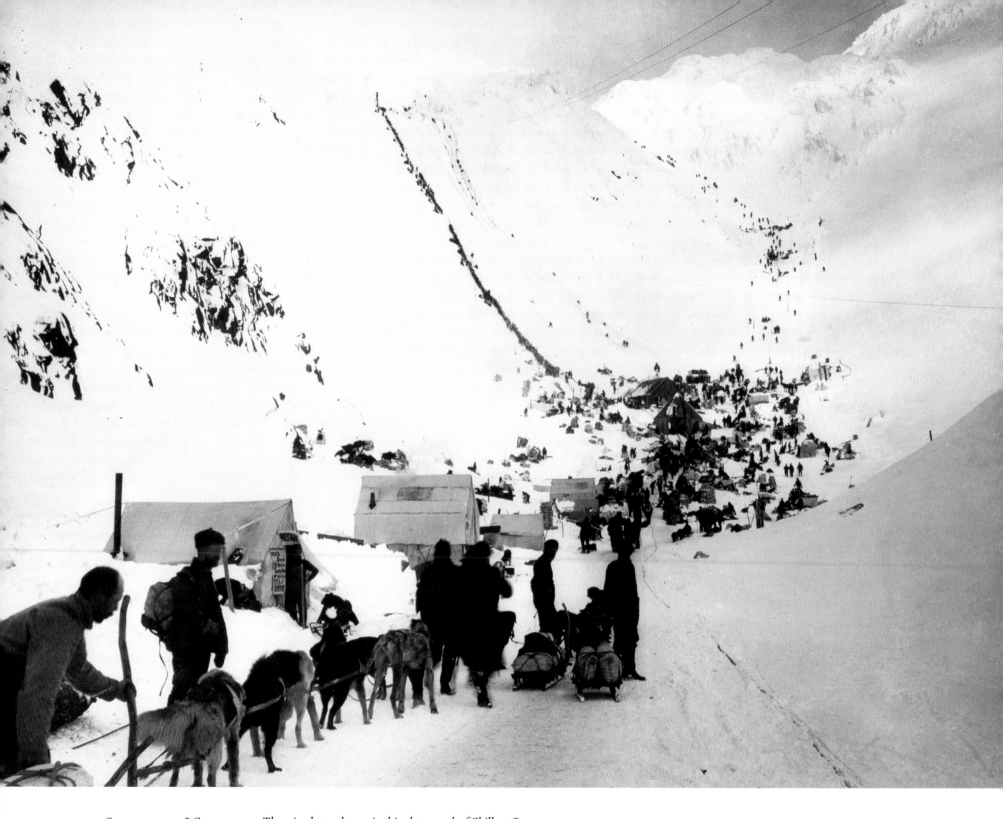

SEEKING GOLD? GET IN LINE *There is a lot to observe in this photograph of Chilkoot Pass in the Yukon at the height of the late-19th century gold rush. But the most arresting element is the long vertical line stretching up and to the left of the snow-covered slope: it is composed of humans, dogs and mules, drawn north by the lure of gold. Like the California gold rush 50 years before, the 1897-98 Yukon rush made fortunes for a few, dashed the hopes of many and converted Seattle, gateway to the northland, into a major U.S. city.*

The days of gold miners as go-it-alone prospectors have passed. In contrast to the scene above, a modern operation such as the Batu Hijau open-pit gold and copper mine on the Indonesian island of Sumbawa uses explosive devices to blast minerals out of the rock. The raw minerals are hauled to immense crushing machines by a fleet of enormous 220-ton Caterpillar trucks. After crushing, the refined rock travels on a 4-mile-long (6.8 km) conveyor belt to be refined and concentrated. Power for the project is generated by an onsite coal-burning power plant. In an average year, the operation produces 1.1 million tons of copper concentrate containing 325,500 tons of copper and 719,000 oz. of gold

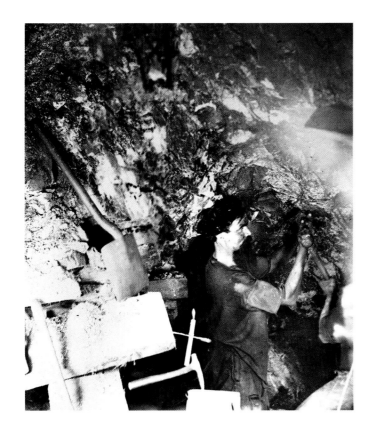

THE SILVER RUSH *Silver's allure, like that of gold, is as old as antiquity: the city of Athens owes its rise in part to the discovery and mining of silver in the Lorion mines some 37 miles (60 km) to the southeast. Slaves operated the mine and were harshly treated. Mining has often walked hand in hand with exploitation: the Roman salt mines were so notorious they live on in the English language as a metaphor for hard labor. The greatest silver rush in American history took place in 1859, after the rich and fabled Comstock Lode was discovered in Nevada. At left, a worker quarries ore some 900 ft. (274 m) underground, circa 1867. At its peak, in 1876-78, silver ore worth about $36 million was extracted here annually*

UP FROM THE DEPTHS *Below, workers emerge from cars in the shaft of a Comstock mine in Virginia City, circa 1867-68. Operators here created new technologies that revolutionized mining. The hemp ropes originally used to support the shaft elevators, for instance, were so long that their own weight became a disadvantage, until engineer A.S. Hallidie created a much lighter rope made of flat woven wire. The use of compressed air to power drills, elevator motors and fans was pioneered here, as were diamond-tipped drills. At right, silver ore*

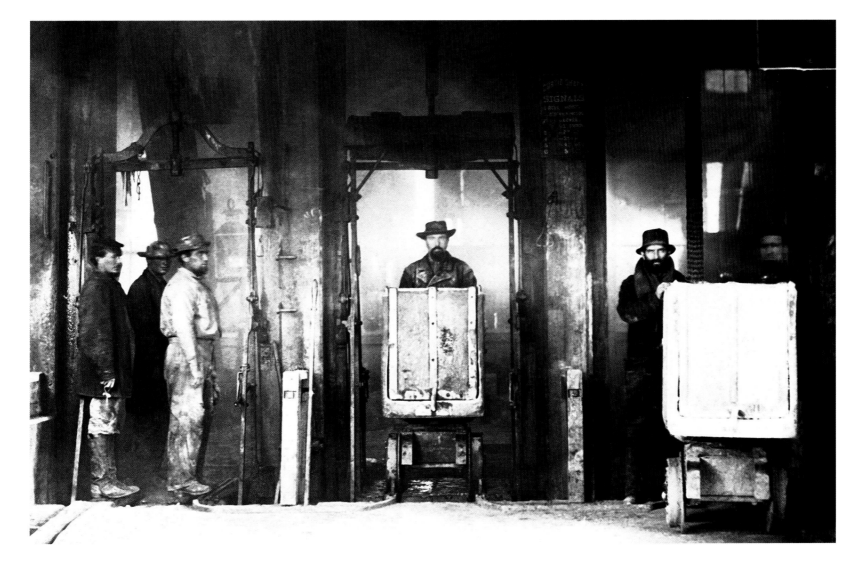

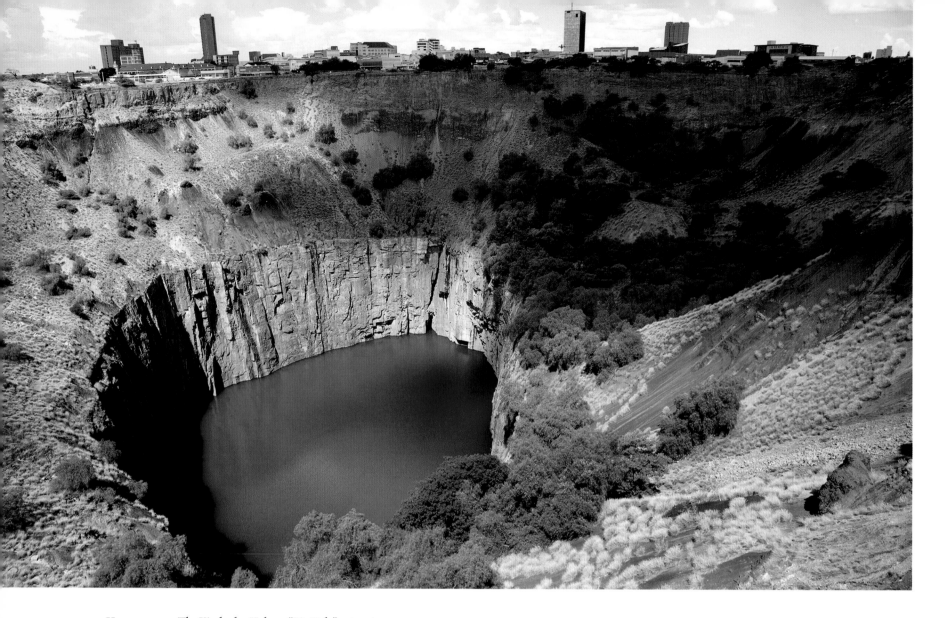

HAND-MADE *The Kimberley Hole, or "Big Hole" open-pit diamond mine in Kimberley, South Africa, was entirely dug by human hands to a depth of 790 ft. (240 m). Thousands of ill-paid workers toiled here with picks and shovels from 1871 to 1914. South Africa's history was shaped by the discovery of huge deposits of gold in the Transvaal in 1886 and of rich diamond deposits in the 1870s. European immigration surged, triggering the Boer Wars between settlers of English and Dutch descent and increasing the suppression of native blacks by white colonists.*

Below, the "Lesotho Promise" gem was cut from the 15th largest diamond ever found, a 603-carat behemoth, in 2006

THE HARDEST MINERAL *The precious gems located in the streams of Sierra Leone, above, and those of some other African nations, have become known as "blood diamonds," for the mining process is often run by warlords or political groups who use vicious tactics to recruit and control workers. Laborers may receive as little as 25¢ a day in pay. In hopes of ending such practices, international diamond traders in 2002 adopted the Kimberley Process, a system that seeks to identify and boycott gems mined in such fashion*

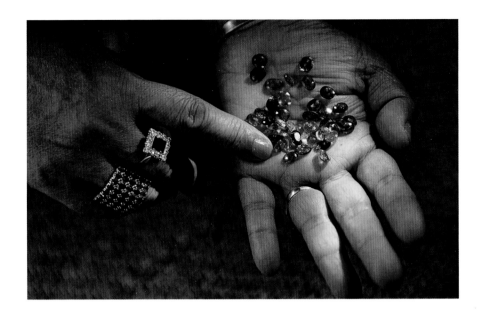

RED AS BLOOD *The finest rubies in the world—known as "pigeon's blood" because of the depth of their red hue—are mined in the famed Mogok district of Myanmar (Burma), below. The mountainous region is some 125 miles (200 km) north of Mandalay. The mining of rubies—as well as sapphires, lapis lazuli, garnets and other precious gems—predates written history in this region, but the technologies used in the process have advanced little over the centuries.*

Human-rights organizations charge Mogok mine operators with using drugs to increase worker productivity and employing needles multiple times, increasing the risk of HIV infection. Those charges, in addition to widespread revulsion with Myanmar's harsh ruling junta, has led some nations to boycott Burmese rubies. The gems are also mined in Tanzania, Kenya, Vietnam and Pakistan, and deposits have recently been located in Greenland

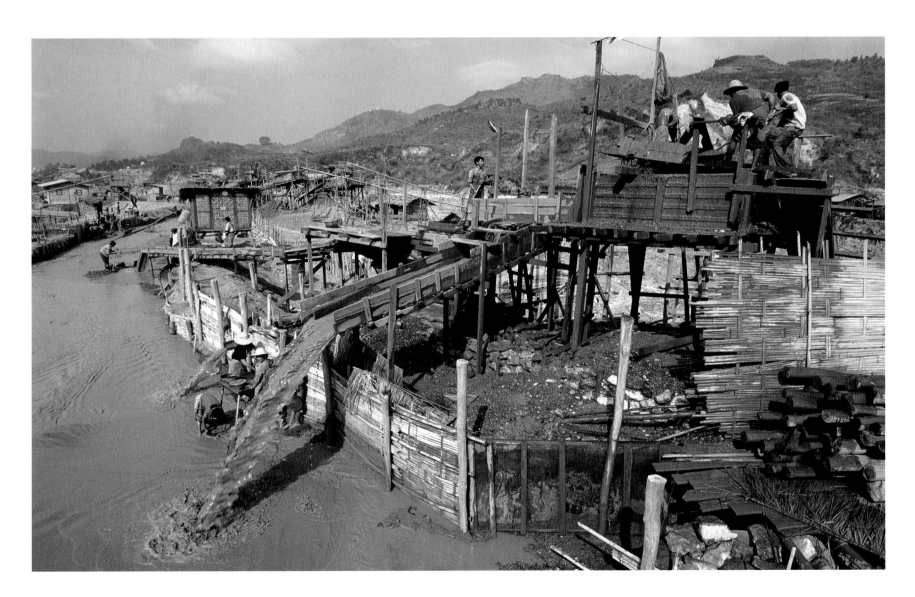

THRILL OF THE DRILL *The world's first petroleum well was drilled in Titusville, Penn., in 1859, ushering in an oil rush that has only accelerated in the past 150 years, as petroleum, a hydrocarbon, became an essential source of energy for the industrialized world. The investors who paid for the Titusville project were attracted to the site because small amounts of petroleum were said to bubble up from beneath the ground in the area, an indication that large reserves of oil might be present, under pressure, below the surface. Former railroad conducter Edwin Drake, at right, conceived the idea of drilling for underground oil deposits along the lines of drilling for water.*

The oil rush made millionaires of locals fortunate enough to own land in the area. In similar fashion, oil wealth has reshaped the world's political and financial map, as nations rich in petroleum reserves, including Saudi Arabia, Venezuela and Iran, have acquired vast wealth and influence as a result of a fortunate coincidence of geology. In turn, the quest for oil wealth has given geologists powerful new tools to explore the realms beneath the planet's surface

BIG RIG *At right, a monster dry dock that will house an offshore oil rig is under construction in Norway. Modern-day oil hunters use sophisticated technologies to search for petroleum. Gravity meters detect changes in the earth's gravitational field that could indicate the presence of oil beneath the surface, while highly sensitive magnetometers search for telltale magnetic irregularities. Electronic noses known as "sniffers" are used to detect the aroma of hydrocarbons. But the most commonly used search technique is borrowed from seismology: geologists create shock waves that travel through the ground, then read the echoes of the waves' passage, which can indicate the presence of oil.*

Nations boasting "oil sands" rich in petroleum will profit as new technologies make retrieving oil from such sandy deposits more affordable. Reporting on Alberta's rich oil sands in 2008, TIME said: "Canada is poised to become Venezuela north … as the biggest oil boom in North American history hits terminal velocity."

The supply is finite, but the discoveries continue: in May 2009, geologists reported they had discovered a vast new oil field in northern Iraq's Kurdistan region

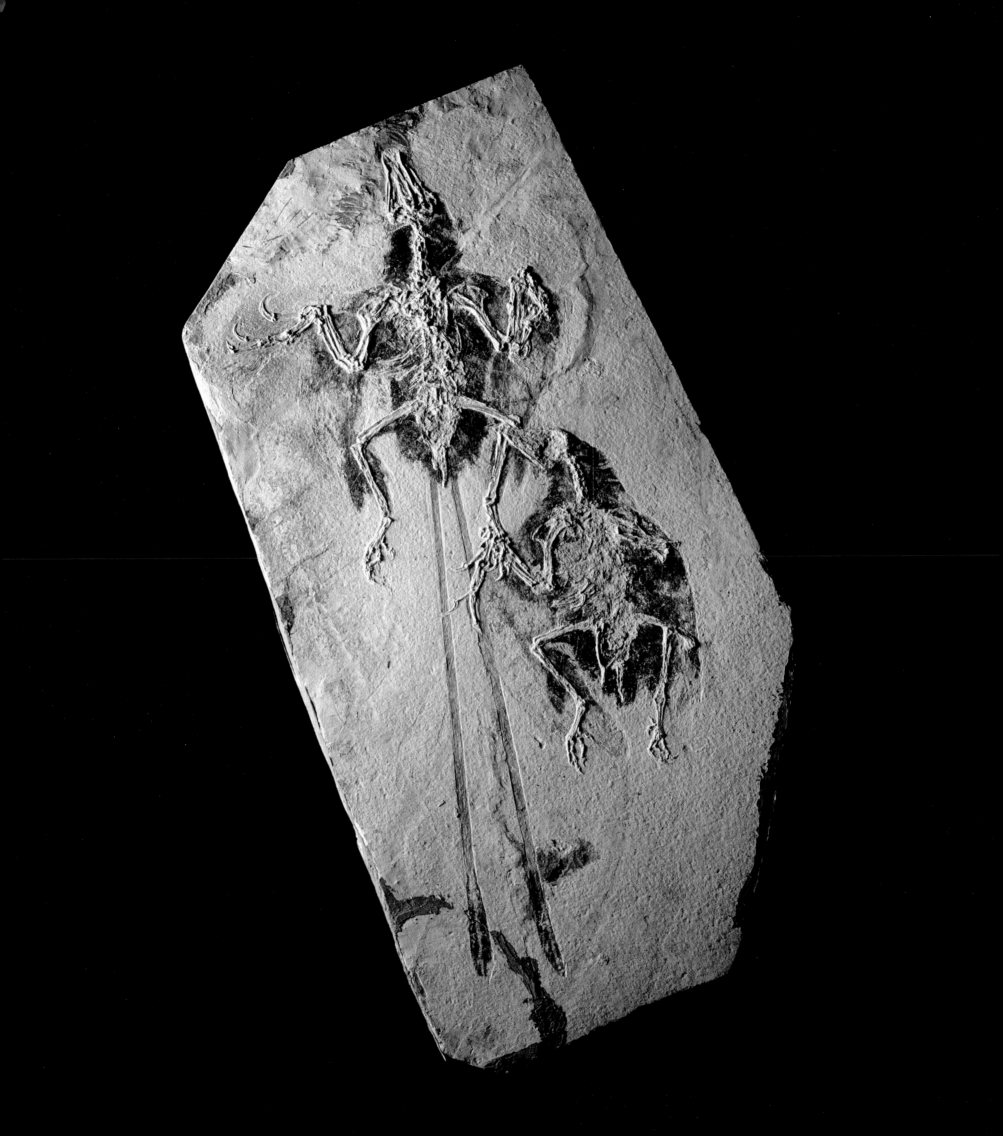

Exploring Life on Earth

"*Confuciusornis:* genus of extinct crow-sized birds that lived during the Late Jurassic and Early Cretaceous (roughly 161 million to 100 million years ago). *Confuciusornis* fossils were discovered in the Chaomidianzi Formation of Liaoning province, China, in ancient lake deposits mixed with layers of volcanic ash. These fossils were first described by Hou Lianhai and colleagues in 1995. *Confuciusornis* was about 25 cm (roughly 10 inches) from beak to pelvis. It possessed a small triangular snout and lacked teeth.

"*Confuciusornis* held a number of physical characteristics in common with modern birds but possessed some striking differences. Beautifully preserved specimens show impressions of its feathers, from which it can be inferred that the wings were of comparable size to those of similar flying birds today.

"*Confuciusornis* had a short tail, a common feature in modern birds, and its caudal vertebrae were reduced in size and number … In some specimens, as in the related *Changchengornis,* a pair of long, thin feathers proceeded from each side of the tail and expanded distally into a teardrop-shaped surface. It has been suggested that these feathers were sexually dimorphic structures and possibly indicative of males."

—Britannica Online Encyclopedia

Mates? *This* Confuciusornis *fossil shows both a male specimen, left, with long tail feathers, and a female, of these early beaked birds*

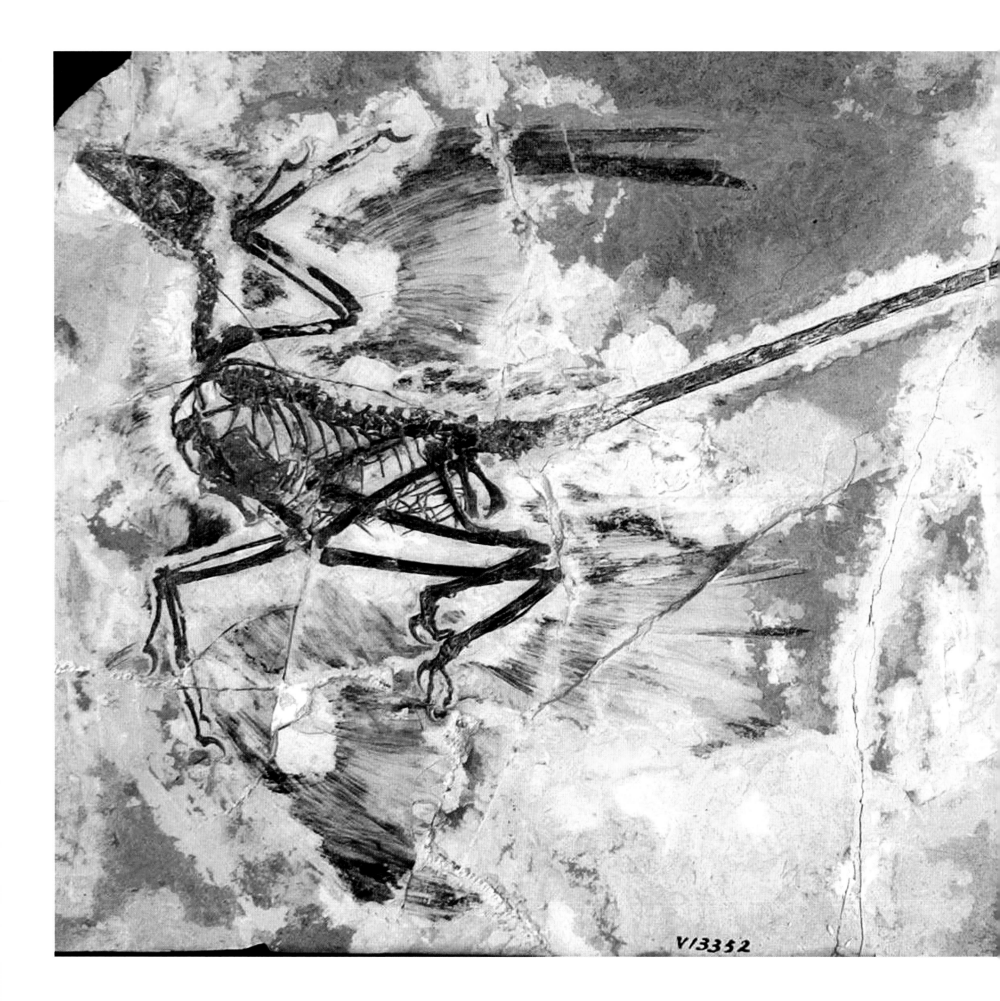

V/3352

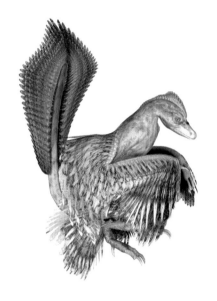

CHINA'S FEATHERED DINOSAURS: A LINK NO LONGER MISSING

It seems hard to believe, but it wasn't that long ago that the idea of birds evolving directly from dinosaurs seemed just a little flaky. Sure, they shared generally similar body plans—paleontologists have known that for more than a century—but that hardly constituted an airtight case for the connection. Over the past couple of decades, however, scientists have uncovered all sorts of detailed characteristics common to birds and dinosaurs: wishbones, swiveling wrist bones and, most recently, proof that plenty of dinosaurs sported feathers. There's behavioral evidence too. Some dinosaurs made nests and sat on them, and the four-winged, feathered dino-bird shown at left evidently glided like a flying squirrel.

The flurry of new finds has confirmed that the pigeon you see in the park had an ancestor that once ruled the earth. The vast majority of the discoveries are coming from the nation that in the past 15 years has become the white-hot hunting ground for dinosaur remains of all sorts: China. And a surprising number of

FOUR WINGS GOOD *The dinosaur at left,* Microraptor gui, *lived some 128 million years ago. It was 30 in. (77 cm) long and boasted a fairly long tail. Its co-finder, paleontologist Xing Xu, believes it may have glided, using all four wings for lift. Above, an artist's conception*

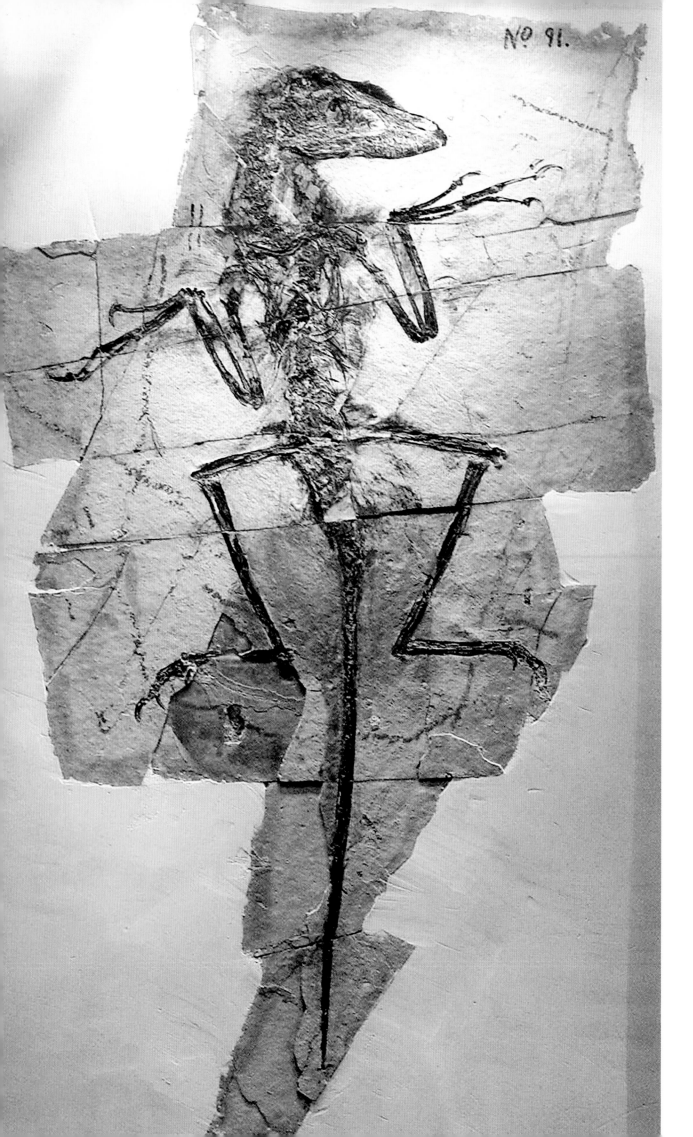

No 91.

FUZZY RAPTOR *One of the most significant of the host of feathered dinosaurs discovered in recent years in China is* Sinornithosaurus, *whose two species,* millenii *and* haoiana, *are widely accepted as the most tangible evidence for the link between dinosaurs and birds.*

The fossil at left, informally dubbed "Dave," was unearthed in Liaoning province by Xing Xu and two colleagues in 2000; it is the third specimen of the genus, and it may be either a third species or perhaps an adolescent of the millenii *species. All the* Sinornithosaurus *specimens are dromaeosaurs, small, feathered, meat-eating hunters. The "fuzzy raptor" had a wrist that scientists believe may represent an important step in the evolution of forelimbs to wings.*

"It doesn't look anything like what most people think dinosaurs look like," said Mark Norell, one of its finders. "When this thing was alive, it looked like a Persian cat with feathers"

Dragon finder
Xing Xu, who turned 40 in 2009, is the most important among China's recent history-making paleontologists. Though he was interested in becoming a software designer, his government forced him to major in geology at Beijing University. Now, he loves his work; he told USA Today in 2008: "Going into the desert to discover new species, to explore the unknown, is the best job in the world." At left, he hunts for specimens in Liaoning province

the recent discoveries have been the work of a paleontologist based at Beijing's Institute of Vertebrate Paleontology and Paleoanthropology who has probably become tired of hearing himself referred to as "China's Indiana Jones," Xing Xu. In the past 15 years, Xu has uncovered some 30 new dinosaur species, and he has named more new species than any other living paleontologist. To clarify: when fossil-hunters dream at night, they dream of finding and naming just one species, a career highlight that guarantees immortality for any modern-day Adam lucky enough to do so.

Xu's primary stomping ground is a geological formation in China's northeastern province of Liaoning, now the world's most renowned fossil bed. Since the late 1990s, digs in Liaoning have produced an astonishing array of exquisitely preserved plants, insects, primitive mammals, birds and, most famously, feathered and winged dinosaurs.

A Sleeping Beauty and a Feathered Friend

Two such finds were revealed in 2004, when Xu and U.S. paleontologist Mark Norell of the American Museum of Natural History in New York City announced the discovery of a dinosaur that evidently slept curled up in a posture identical to that of a sleeping duck; the other was the first tyrannosaur ever found with feathers. The second discovery was especially significant because the tyrannosaur family is thought to be among the closest relatives of modern birds.

Luckily for paleontologists, the beds in Liaoning are divided into different layers that yield different sorts of

fossils. The sleeping dino, for example, was found in what Norell calls the "Pompeii layer," a 10-ft. (3m) -thick stratum of ash and sand. It was deposited so quickly that, like the ash from Italy's infamous eruption, it buried creatures alive wherever they were standing—or snoozing. This one was tiny: excluding its tail, it was about the size of a Rock Cornish hen. That some of its bones had not completely fused indicates that the specimen was not quite fully grown.

Xu and Norell named the new species *Mei long,* from the Chinese for "soundly sleeping dragon" (Xu delights in viewing dino-birds as dragons). But the specimen, dating to some 139 million and 128 million years ago, is clearly an early troodontid, an evolutionary cousin of tyrannosaurs. "Not only are troodontids very closely related to birds," Norell told Time, "but this particular one is in a stereotypical resting pose of birds." The sleeping dragon was found sitting on its hindlimbs, its forelimbs folded at its side, its head tucked under its left elbow and its long tail curled around its body. Experts believe modern birds sleep in a similar position to conserve heat; presumably *Mei long* did too, which suggests that the animal was warm-blooded. If that was the case, says Norell, it also explains the value of feathers: "It's likely they first evolved for insulation rather than flight." Birds, he suggests, simply found another use for them.

While the Pompeii layer preserved natural body postures, it was too coarse to make imprints of soft tissues and delicate structures, so there's no way of knowing whether *Mei long* had feathers. But other strata of the Liaoning fossil beds

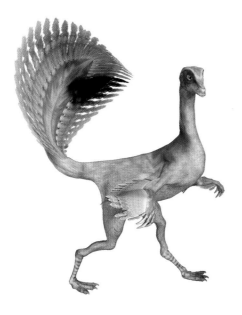

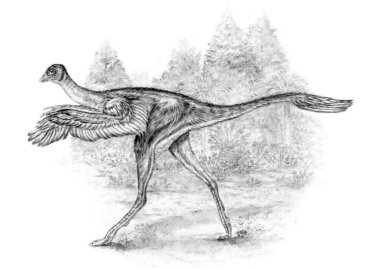

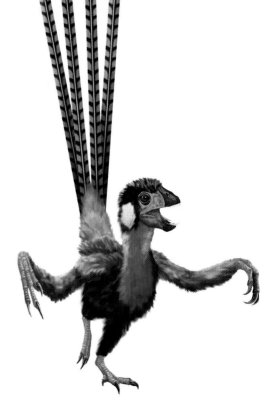

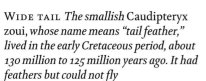

Wɪᴅᴇ ᴛᴀɪʟ *The smallish* Caudipteryx zoui, *whose name means "tail feather," lived in the early Cretaceous period, about 130 million to 125 million years ago. It had feathers but could not fly*

Sʟɪᴍ ᴛᴀɪʟ Protarchaeopteryx robusta *had distinct feathers on its arms, which strongly resemble wings, and on its tail; it was covered with feathery down. This small, speedy ground dweller was carnivorous*

Tᴀʟʟ ᴛᴀɪʟs Epidexipteryx hui *sported four long, erect tail feathers. They do not branch into individual filaments, like those of modern birds, but are instead made up of a single ribbon-like sheet. The fossil is at right*

are much finer grained. That's where Xu and Norell found the feathered tyrannosaur, which they named *Dilong paradoxus* ("surprising emperor dragon"). It's one of the oldest known tyrannosaurs, and one of the emu-size specimens has clear traces of primitive feathers on its tail and jaw. Those filaments, which are not quite an inch long and are branched like modern feathers, are the first direct evidence that tyrannosaurs sported plumage. Because *Dilong paradoxus* is one of the earliest tyrannosaurs, scientists infer that its larger, more advanced relatives, including *T. rex,* must have had feathers for at least part of their life span.

Fifteen years of Startling Finds

The pair of finds announced in 2004 made paleontologists rewrite their textbooks, but in fact, that process began in the 1990s, as a steady drumbeat of astonishing discoveries transformed the dino-bird connection, once a bitterly disputed hypothesis, into a widely accepted scientific theory.

The rumbles began in 1995 in Liaoning, when fossilized birds captured in ancient sediment were uncovered by local farmers. They were slightly more advanced than *Archaeopteryx,* the most primitive bird yet discovered, which lived some 150 million to 145 million years ago and is considered the ancestor of modern birds. The Liaoning fossils, named *Confuciusornis* by Chinese scientists, lacked long bony tails

and toothed jaws but still had wings with distinct fingers ending in claws. Many of the fossils were found in large groups, indicating that *Confuciusornis,* the oldest bird with a beak yet discovered, lived in flocks.

A year later, a Liaoning quarry yielded a new small theropod dinosaur, a voracious, bipedal hunter. *Sinosauropteryx* had a fringe of "unbranched integumentary structures"—otherwise known as fluff—along its backbone. Excited scientists suggested the warm-blooded little dinosaur—which could not fly—used the primitive type of feathery covering for insulation.

In 1997, remains of the *Caudipteryx* and the *Protarchaeopteryx* dinosaurs were found in the same quarry. Both fossils had feathers similar to those of modern birds, though they still lacked the distinctive, asymmetrical feathers needed for them to become airborne. (Flight feathers have narrow leading edges and are sculpted on the wing to provide lift.) Only one *Protarchaeopteryx* specimen exists. The sweeping action of its long arms, scientists say, later developed into an avian flight stroke.

Another piece of the feathery puzzle fell into place in 1999 when farmers in Liaoning unearthed what some called the missing link. Xu and his colleagues christened the find *Sinornithosaurus* ("Chinese bird lizard"), but it was soon widely known by a snappier handle: the "fuzzy raptor." The

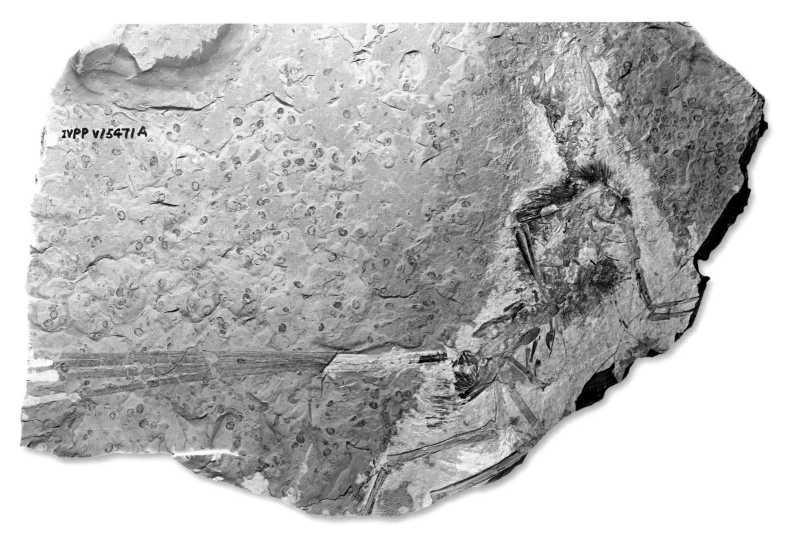

RECORDED IN THE ROCK *This single fossil is the only specimen of* Epidexipteryx hui *found to date. Its body was covered with downy feathers and was 10 in. (25 cm) long; the tail feathers, incomplete in the fossil, add 7.5 in. (19 cm) in length. The dino-bird weighed some 6 oz. (170 g) and lived around 168 million to 152 million years ago. The specimen was studied and named by a team that included Xing Xu and Fucheng Zhang; it was found in Inner Mongolia*

remarkable 124 million-year-old juvenile dinosaur fossil had the bony, duck-size skeleton of a meat-eating *Dromaeosaurus* and the feathers of a bird.

This relative of *T. rex,* dating from 147 million to 124 million years ago, was a hat trick of a find: it had no fewer than three different types of feathers: a thick, fuzzy mat of short, hollow fibers on the head; plumelike "sprays" of extremely thin fibers on the shoulders and torso; and multiple filaments arranged in a classic herringbone pattern around a central stem on the backs of its arms and legs. Even the tail was thick with feathers, with a fan, or tuft, at the end.

The fuzzy raptor's perfectly preserved downy body feathers conclusively resolved the long-standing mystery of the evolutionary link between dinosaurs and birds, many paleontologists argued. And it helped cement the view of many biologists that feathers originally arose not as a means of flight but simply to keep dinosaurs warm. The bone structure of dinosaurs shows that, unlike modern reptiles, they grew as fast as birds and mammals—which dovetails

with a growing body of evidence that dinosaurs were, in fact, warm-blooded.

In China, the accelerated pace of discoveries continues: in 2007 Xu and others announced the 2005 discovery of *Gigantoraptor,* the largest dino-bird yet found, which was 26 ft. (8 m) long. In a rare stroke of fortune, the discovery was captured on film: as Xu was routinely cleaning what he believed was the fossil of a sauropod during the making of a Japanese documentary film, he realized that the specimen was in fact the remains of a previously undescribed type of dinosaur.

In 2008 Xu and his colleagues announced yet another major find: *Epidexipteryx hui,* a pigeon-sized dinosaur with four flashy tailfeathers. In 2009 a team led by Xu announced the discovery of a new specimen of *Beipiaosaurus inexpectus,* first found in 1999, which appears to have very early versions of feathers composed of single filaments. If Xu and his fellow paleontologists keep digging up dino-birds at this pace, kids had better get used to the idea that *T. rex* may have started life looking a lot like Tweety Bird.

MASTER OF HIS DOMAIN *This artist's conception of the 42-ft.-long* Titanoboa's *habitat in Colombia shows other reptiles that also grew to a large size at this time*

BIG, BAD, ANCIENT—AND HUNGRY

Everyone loves dinosaurs and other prehistoric critters, it seems. And if there's anything the *Jurrassic Park* audience loves more than an extinct predator, it's an extinct predator in a jumbo-sized package. So when separate teams of scientists announced in recent years that they'd located the remains of a pair of outsized prehistoric hunters, the findings were big news around the planet. And did we mention that one of the new discoveries was that of a colossal ancient snake?

Scientists from the University of Florida and Smithsonian Tropical Research Institute announced their discovery of the remains of the enormous reptile early in 2009 in the science journal *Nature.* And they knew just what to call the serpent, which resembled a modern boa constrictor: *Titanoboa cerrejonensis.* The second term refers to the open-pit coal mine in Cerrejón, Colombia, where the big snake's remains were found, along with 28 other fossils of ancient snakes.

And now to the main point: Just how titanic was

Titanoboa? Cue the scientists in sound-bite mode. He was as long as a school bus and weighed as much as a small car, said the press release announcing the find. That comparison was informative but lacked dash, so Jonathan Bloch, a University of Florida vertebrate paleontologist and co-leader of the Colombia team, deployed the trusty *Tyrannosaurus rex* yardstick. At 42 ft. (13 m), he said, the big snake was as long as the famed *T. rex* "Sue" at the Field Museum in Chicago.

Bloch's colleague Jason Head, a paleontologist at the University of Toronto in Mississauga who was the *Nature* paper's senior author, chose a scarifying scenario closer to home: "The snake's body was so wide that if it were moving down the hall and decided to come into my office to eat me, it would literally have to squeeze through the door." Bloch fired back, finally resorting to putting *Titanoboa's* heft in terms even the least scientific among us could understand: "The snake that tried to eat Jennifer Lopez in the movie *Anaconda*

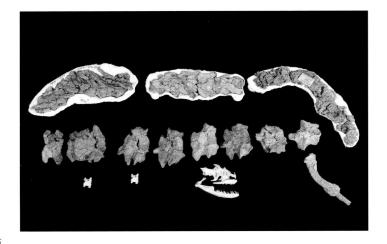

LARGE SNAKE *The top picture at left shows fossilized rib bones (top row) and vertebrae of* Titanoboa. *For comparison, the brighter, much smaller vertebrae and skull of a modern 17-ft. (5-m) anaconda are shown beneath.*

The bottom image compares a single vertebra from each animal, suggesting the enormous size of the ancient snake, which is estimated to have weighed 1.25 tons

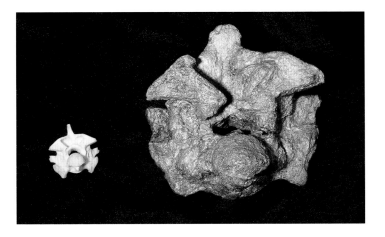

LARGE PLIOSAUR *At right, an artist's conception of the giant pliosaur found in Norway, showing its short neck, massive head and large flippers. The reptile is seen attacking a much smaller marine reptile, a plesiosaur.*

Below right is a fossil of a much smaller, and thus more typical, pliosaur, which was found in Australia's Outback, suggesting that the current desert was once deep underwater

is not as big as the one we found," he declared. Hey, that's *really big!*

But size matters in the case of *Titanoboa,* for the cold-blooded reptile's unusual dimensions indicate that it must have lived in a climate of extreme ambient heat. And since dating showed that the snake lived some 58 million to 60 million years ago, the discovery team posits that the Colombian rain forests were experiencing a period of high warming at the time—which runs counter to current theories, which propose that the rain forests maintain a steady temperature even during periods of global warming.

A GIANT MARINE PREDATOR

News of the *Titanoboa* find came about a year after a team of scientists announced they had discovered in 2006 the remains of a massive prehistoric sea reptile at Spitsbergen, part of Norway's far-northern Svalbard archipelago, in a polar wasteland where the fossilized remains of 40 other ancient sea reptiles were also found. The creature was a pliosaur, and the largest such marine hunter ever found: it was estimated to have lived some 150 million years ago, during the Jurassic era, when the current boneyard would have been deep underwater and the ocean teemed with large, meat-eating reptiles.

And that reminds us: Just how big was the newly discovered pliosaur? At 50 ft. (15 m) long, with a 10 ft. (3 m) skull, the creature was so large, reported *National Geographic,* that scientists had dubbed it "the Monster" or "the Sea Monster." Close, but not quite there. To the rescue came Jorn Hurum of the University of Oslo Natural History Museum in Norway, a co-leader of the expedition: The pliosaur, he declared "was the *T. rex* of the ocean." Got it.

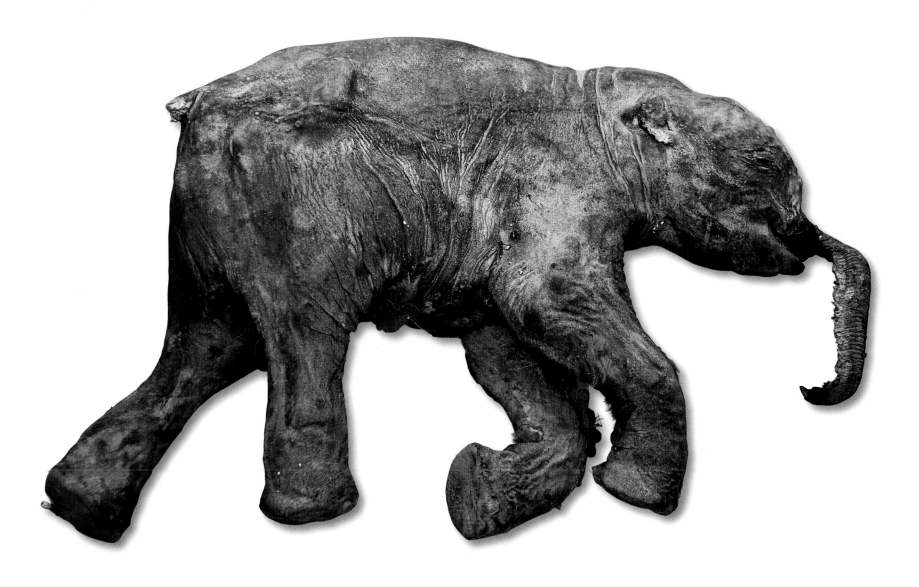

Frozen for 40,000 Years, a Baby Mammoth Steps into the Spotlight

Lyuba the mammoth died a horrible death some 40,000 years ago: at the age of only 1 month, she wandered away from her herd and fell into a swampy bog from which she was unable to extricate herself. As her mouth and trunk filled up with sediment, she was asphyxiated. Yet when her body was recovered from the permafrost of Siberia in 2007, she still wore the smile, above, that makes this extinct species, close relatives of today's elephants, so irresistibly charming.

Lyuba's corpse, like those of the human bog bodies treated earlier in this book, was preserved from decay by the unique chemistry of the bog in which she died. So when a native reindeer herder on Siberia's northwestern Yamal Peninsula, Yuri Khudi, and his three sons discovered her

body near the Yuribey River in the spring of 2007, her pickled tissue was still soft to the touch, though the covering of wool characteristic of the species had mostly vanished. Though Lyuba was not the first frozen mammoth to be discovered, she was by far the best-preserved specimen, almost entirely complete. At 1 month, she measured 52 in. (132 cm) from trunk to tail, stood about 3 ft.(91 cm) tall and weighed 110 lbs. (50 kg).

We're fortunate to be able to cite these facts, for the day Lyuba's body was found, it was snatched. When Khudi returned to haul her body away, it was missing: it had been stolen by the herder's cousin, who knew mammoth artifacts fetched a good price. He had sold the corpse to a local store-

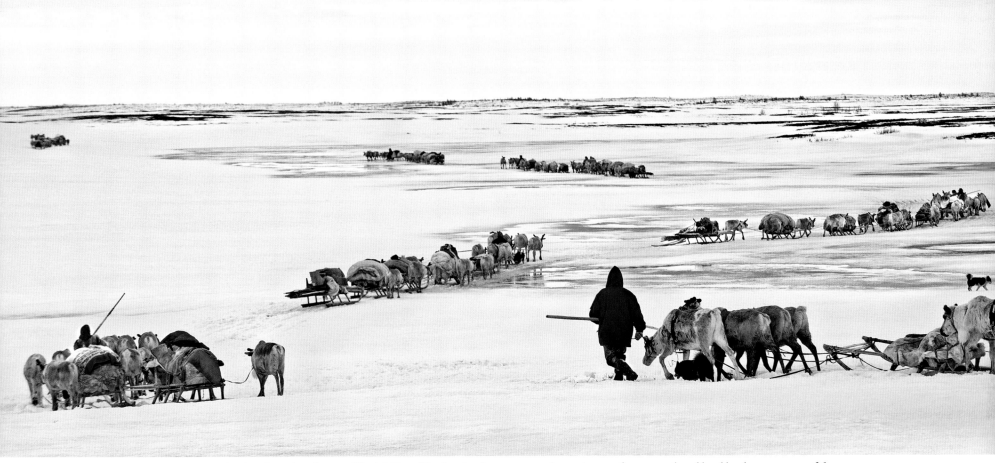

HISTORIC PRESERVATION *During the spring thaw on Siberia's Yamal Peninsula, above, mammoth remains are often exposed, and local herders are aware of the booming global black market for tusks and other specimens. Lyuba's body , left, was discovered in May 2007, which is earlier than the spring thaw, suggesting that her corpse, pickled by the chemicals of the bog in which she lay for 40,000 years, was exposed to the elements for a year before its discovery, without decaying*

keeper for a pair of snowmobiles and a year's food supply. Thanks to local police, Lyuba reached the proper authorities, who named her for Khudi's wife, and scientists began to investigate her life and death.

Paleontologists hope that Lyuba will help them answer a long-simmering question: Why did woolly mammoths—as well as other mammals of the then temperate northern steppes such as bison, beavers and woolly rhinos—suddenly die out around 10,000 years ago? Most scientists agree that two hypotheses are the most likely: climate change and the rise of human hunters. The climate-change argument asserts that grazing creatures flourished as the northern plains of Siberia underwent a long warming spell due to rising global temperatures, extending their feeding range. But under this model, the warming trend also allowed trees to flourish in the former wide open spaces, finally reducing the amount of land for grazing.

Those who support the hunting hypothesis point to the rise of tool-bearing modern humans, who may have reached the temperate plains where the mammoths flourished around 10,000 years ago. The mammoths would have been no match for these wily hunters, they argue, leading to their demise. According to lead researcher and mammoth maven Dan Fisher, a University of Michigan paleontologist, early evidence based on examination of Lyuba's milk tusks, forerunners of her adult tusks, indicated that mammoths at her time were adjusting well to global warming, advancing the hunting hypothesis as the cause of their extinction.

Examining the contents of Lyuba's intestinal tract, scientists began to construct a profile of her abbreviated life. Within her intestines, they found residue of both her mother's milk—infant mammoths nursed for about 4 years after birth—and her mother's fecal matter. This latter discovery suggests that, like modern elephants, infant mammoths ate their mother's droppings in order to inoculate the vegetarians' digestive tracts with microbes essential to absorbing food. As scientists devote more time to the study of Lyuba, no doubt there will be new findings to, um, chew upon.

CURRENT EXPLORATIONS

One Small Step for Mankind? The Riddle of Indonesia's "Hobbits"

For generations, residents of the Indonesian island of Flores, located 350 miles (563 km) east of Bali, told stories of a race of little people called the Ebu Gogo: hairy, human-like creatures that hid in the island's limestone caves. Like leprechauns, the Ebu Gogo (the name roughly means "grandmothers who eat everything") were assumed to be mythical. That was until a team of Australian and Indonesian researchers excavating a cave on the island in 2003 uncovered ancient bones that included the 18,000-year-old skeleton of a 3-ft. (1 m) -tall female, whose skull showed she had a brain the size of a grapefruit.

In 2004, the paleontologists announced their discovery in the respected science journal *Nature* and argued that the bones were the remains of a previously unknown species of human. They named the new species *Homo floresiensis* and nicknamed them "hobbits," after the diminutive folk of J.R.R. Tolkien's Middle-earth. The researchers also said that their dating suggested these unusually small hominids had coexisted for a time with modern *Homo sapiens.* If true, this remarkable claim would demand that the history of human evolution be rewritten. For a moment, it seemed, myths could be true.

Or perhaps the story *was* too good to be true. From the start, skeptical anthropologists raised questions about the

Flores team's claims. Did the remains really belong to a special race of tiny humans? If so, where did this new species fit into man's evolutionary tree? Were they instead small *Homo sapiens,* like Africa's Pygmies? And how did they get to Flores? Had their ancestors migrated from Africa? Or were these tiny people the result of the process known as "island dwarfing," in which animals confined to a small space and facing no natural predators are subject to genetic downsizing?

Five years after the discovery of the bones on Flores, scientists have begun to reach a consensus on some of these issues. But the path to getting there has proved an illuminating and—for noncombatants— sometimes amusing example of the scientific method in progress. After all, it's rare that the size of a scientist's chest, rather than his ego, makes headlines.

A New Species of Human?

Uncovering a new species was the last thing the scientists who discovered the hobbit specimens expected when they began their excavations. They were on the trail of *Homo erectus,* the hominid precursor to modern man, which arose in Africa but had spread all the way to Southeast Asia by 1.8 million years ago (the celebrated Java Man was the first to be discovered). Previous excavations in central Flores had already uncovered primitive stone tools, dating to about 800,000 years ago.

Reasoning that caves would be the best place in which to find undisturbed fossils, team leaders Michael Morwood and Peter Brown of the University of New England in Armidale, Australia, and R.P. Soejono from the Indonesian Center for Archaeology decided to dig in a large limestone cave in Liang Bua, in Flores' western region, where prior limited excavations had shown evidence of human habitation.

The team had dug about 20 ft. down into the cave floor by September of 2003 when they came upon the tiny skull, and with it a nearly complete skeleton. The body was only about the size of a modern 3-year-old. "At first we were sure we'd found a child," Morwood told TIME in 2004. On closer study, though, the extent of

MEET THE HOBBIT *At right, an artist's conception of* Homo flore-siensis. *Since this illustration was created, new evidence suggests the creature's foot would have been longer than shown here, and the lack of an arch would have made his feet flat, making running impossible.*

At left, the cave near Liang Bua on the island of Flores, site of the ongoing excavation of the Homo floresiensis *remains*

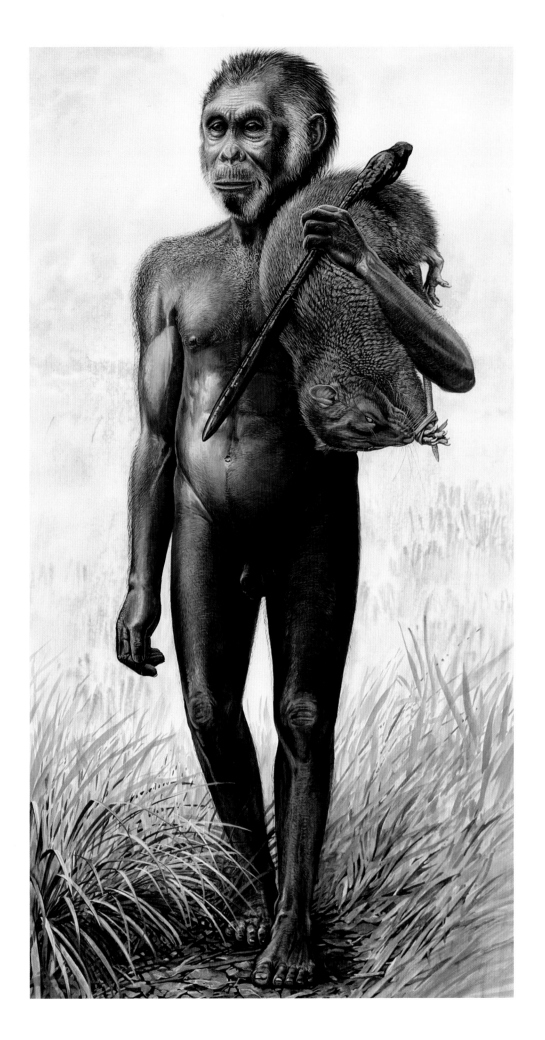

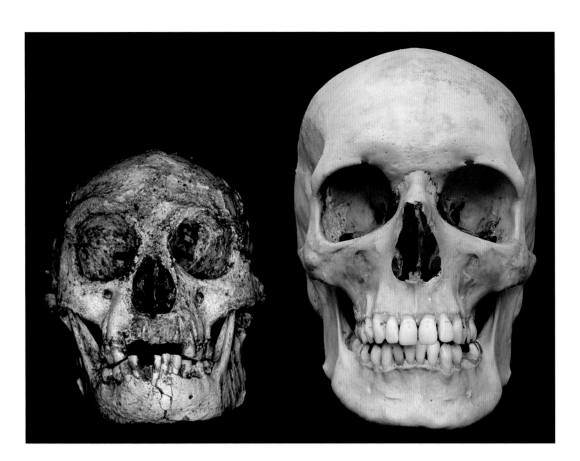
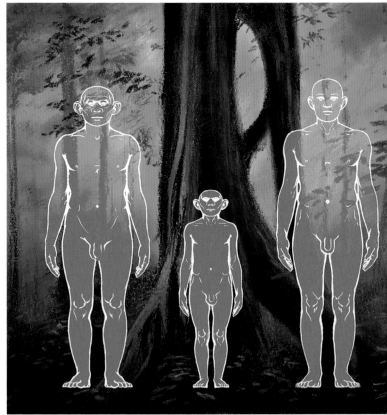

wear on the teeth, evidence that the third molars had come in, and the maturity of the limb bones made it clear that they were dealing with a fully grown adult. The shape of the pelvis showed that the skeleton was female, and dating tests indicated that she lived as recently as 18,000 years ago. Ultimately the team found fragments of six more individuals, the oldest from 95,000 years ago and the youngest from only 13,000 years ago.

Yet from the start, said Morwood, "it was pretty obvious that this was not a modern human. It had a big brow and a massive nutcracker jaw," some of the telltale characteristics of *Homo erectus*. But, he said, "it's very unlike the *Homo erectus* you get in Java. It's obvious," he concluded, "that human evolution has been much more complex than we'd realized."

And so is the study of it. News of the hobbit find rocked the world of paleoanthropology when it was revealed in 2004. What made the discovery truly shocking was that the beings were not, like a group of Pygmies that now lives in Flores, just a short variety of modern *Homo sapiens*. Instead, the discovery team argued, they represented an entirely new twig on the human family tree. Scientists had previously believed that Neanderthals, who died out some 30,000 years ago, were the only human species that coexisted for any length of time with people like us. But the dating of the hobbit bones indicated that these creatures were evolving on their island while *Homo sapiens* was spreading across the globe—and to students of evolution, that was an astonishing claim.

While the general trend in human evolution over the past 7 million years or so has been toward larger bodies and larger brains, *H. floresiensis* went the other way, Morwood's team argued: not only was its body small but, again unlike Pygmy or midget *H. sapiens,* its brain was smaller than that of a modern chimpanzee.

From Doubters, Discouraging Words

Then again—what if the discovery team was incorrect in its analysis? Their extraordinary claims soon attracted critics, who asked tough questions. Some who doubted the Flores findings expressed their reservations in a 2006 study published in the journal *Proceedings of the National Academy of Sciences* (*PNAS*). A team of researchers from the U.S., Indonesia and Australia reported on their own investigation of the original Flores bones and concluded that the so-called hobbit wasn't a separate species but just an unfortunate Pygmy with a form of microcephaly, a developmental disorder that keeps the head and brain from growing properly.

The authors noted that many of the features of the jaw and teeth cited as evidence that it belonged to a separate species—such as the lack of a chin—could be seen among modern Flores Pygmies. It's that last part—the fact that a population of Pygmies can still be found living just a stone's throw away from the Liang Bua cave where the original bones were found —that helped clinch the argument for Robert Eckhardt, a

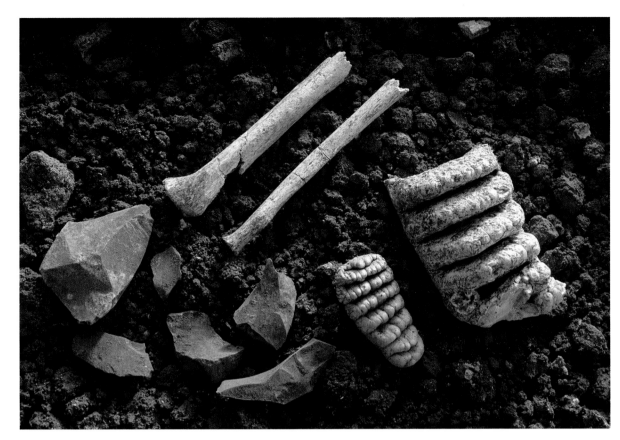

developmental geneticist at Penn State and one of the authors of the PNAS report. Archaeologist Alan Thorne, another author, directed a memorable barb at *H. floresiensis:* "They *are* just like hobbits. They're the products of someone's imagination."

The questions were fair, but the two sides quickly descended from debating the finer points of human fossils to slagging off on each other's ethics. Hobbit finder Peter Brown accused Teuku Jacob—the lead author of the PNAS paper and one of Indonesia's most venerable anthropologists—of removing the original Flores fossils from their legal depository without authorization and damaging them while making a copy. Jacob denied the charges, and Thorne came to his defense: "This is a very senior academic," he said of the Indonesian scientist. "This is not some guy off the street stealing bones."

Such sharp animosity isn't unusual in the disputatious field of human evolution studies, where, as Thorne points out, "there are more human evolutionists than there are fossils to go along with them." But the Flores debate seemed to bring out the inner fifth-grader in grownups with Ph.D.s. After Brown was quoted in *Discover* magazine saying that Eckhardt was "thick as a plank" for trying to refute *Homo floresiensis,* Eckhardt attended a scientific meeting where he took off his shirt and had his wife measure his chest. "We were able to establish to the satisfaction of the audience of 300 people that I was in fact thicker than two short planks," he declared.

The fireworks over *H. floresiensis* have subsided somewhat with the passage of time. As of spring 2009, the argument that the hobbits do represent a new species on the human family tree was gaining more adherents. In a paper published in *Nature* that May, a team of paleoantropologists reported that new remains—an almost complete left foot and parts of the right—suggested that *H. floresiensis* walked upright like other hominids, had five toes, with the big toe outsized like that of a chimp and had unusually long feet at 7 in. (17 cm), much longer in relation to the creature's height than that of modern humans. The feet were flat, for the navicular bone that helps form the arch in modern feet was primitive, and thus may have precluded the hobbits from running. Team leader William L. Jungers, a paleoanthropologist at the Stony Brook University Medical Center on Long Island, argued that the new evidence showed that *H. floresiensis* was not a subgroup of *H. erectus* but indeed represents a separate species.

At a symposium in Stony Brook where the new findings were announced, members of the original discovery team also pointed to the revelations about the creature's feet to support their argument that *H. floresiensis* is a new species on the evolutionary tree. Critics, including Eckhardt, remained skeptical yet kept their shirts on. But if the hobbits are to be accepted as a new species, the questions of where they came from, how they got to Flores and why they died off will still have to be answered. Many riddles remain.

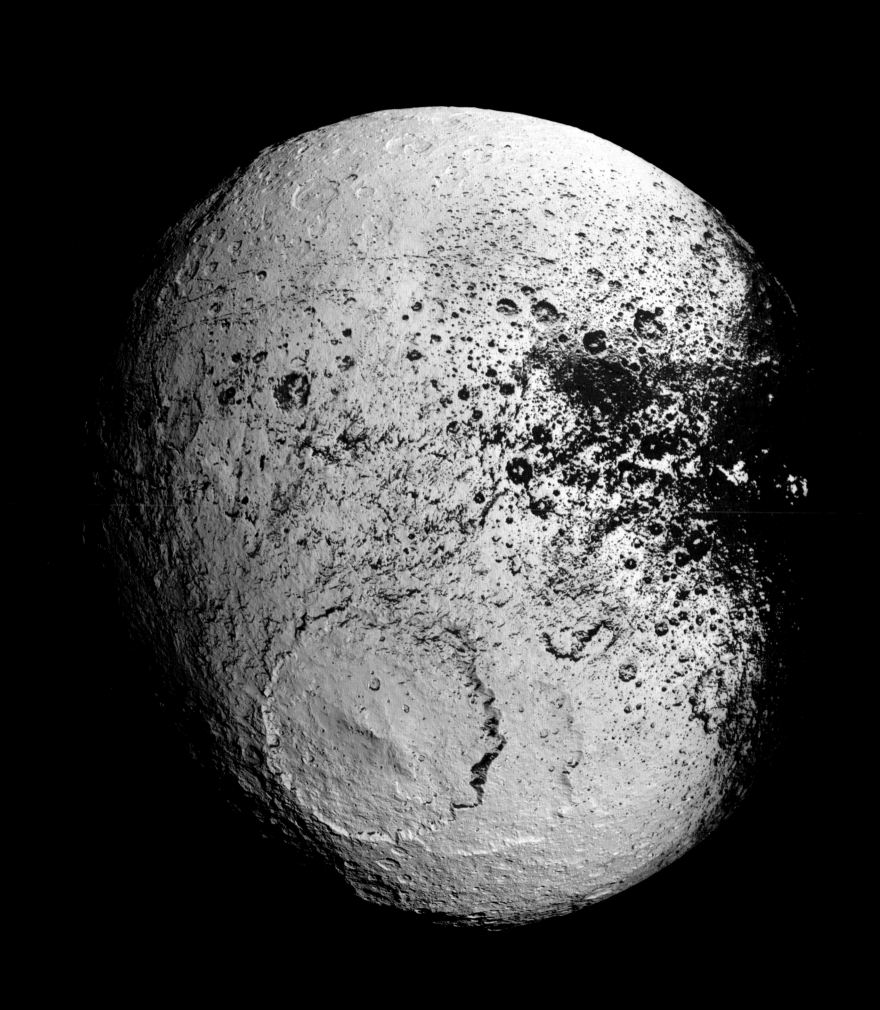

Exploring
The Solar System

"This false-color mosaic shows the entire hemisphere of Iapetus (1,468 km, or 912 miles, across) visible from Cassini on the outbound leg of its encounter with the two-toned moon in September 2007. The central longitude of the trailing hemisphere is 24 degrees to the left of the mosaic's center.

"Also shown here is the complicated transition region between the dark leading and bright trailing hemispheres. This region, visible along the right side of the image, was observed in many of the images acquired by Cassini near closest approach during the encounter.

"Revealed here for the first time in detail are the geologic structures that mark the trailing hemisphere. The region appears heavily cratered, particularly in the north and south polar regions … The most prominent topographic feature in this view, in the bottom half of the mosaic, is a 450-km (280-mile) -wide impact basin, one of at least nine such large basins on Iapetus. In fact, the basin overlaps an older, similar-sized impact basin to its southeast."

—NASA PHOTO CAPTION, CASSINI-HUYGENS MISSION
(IMAGES TAKEN ON SEPT. 10, 2007)

TWO-TONE WORLD *Saturn's moon Iapetus was first seen through a telescope by Italian astronomer Giovanni Cassini on Oct. 25, 1671*

THE MAPPING OF MARS: A TRIUMPH OF LONG-DISTANCE CARTOGRAPHY

About 100 years ago, many earthlings firmly believed that Mars, our closest planetary neighbor in the solar system, boasted long irrigation canals through which water flowed, nourishing the Martians' agriculture and civilization. The most eminent astronomer of the era, Percival Lowell, had seen and charted the canals, first observed by Italian scientist Giovanni Schiaparelli. The discovery of the canals ushered in a vogue for the Red Planet, and youngsters coming of age in the first part of the 20th century were entertained by tales of Mars, from H.G. Wells' *The War of the Worlds* to Edgar Rice Burroughs' series of yarns starring John Carter of Mars.

As of 2009, the geography of Mars is no longer a subject of conjecture and fantasy. In the past 12 years—in what must be considered one of the greatest exercises of cartography in human history—the mapping of Mars has steadily progressed, as a gaggle of orbiters and a quartet of landing vehicles have mapped the planet's surface, taken its temperature, analyzed its minerals, chronicled its changing seasons and sent back

postcard-style views of its most eye-catching sights. Today our knowledge of the geography of Mars is so extensive that it is accessible to all in online, interactive form. You've heard of Google Earth, no doubt? If you love exploration and outer space, do yourself a favor and spend some time with Google Mars—and enjoy your visit to the Red Planet.

The mapping of Mars began in 1965, when the U.S. craft Mariner 4 did a quick fly-by of the planet, while Mariner 9 went into orbit around Mars in 1971. In these early decades of space exploration, Mars acquired a reputation as a cosmic Bermuda Triangle: more than half of all the missions sent to the Red Planet failed. Two Soviet landers reached the surface in 1971 but could not maintain communication. Two U.S. missions, Viking 1 and 2, successfully landed probes in 1976, which sent back fascinating color pictures of the surface, but a pair of Soviet probes launched to Mars and its moon Phobos in 1988 were not successful. The U.S. Pathfinder mission had better luck: its Sojourner

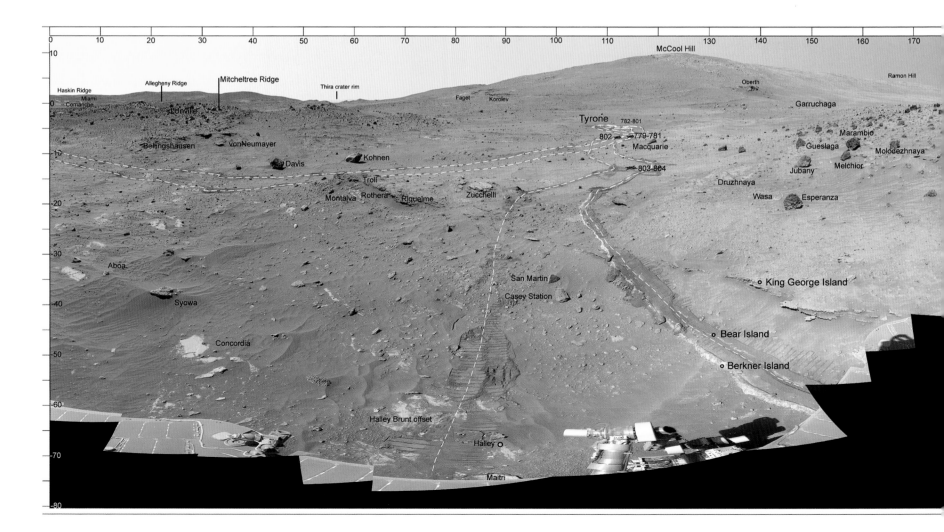

lander reached and studied the surface of Mars in 1997.

The U.S. was stung by two major failures in the year 1999, when two expensive missions, the Mars Polar Lander and the Mars Climate Orbiter, were lost. The very public failure of these very pricey missions forced NASA to change its approach: rather than concentrate its Mars efforts on a few high-risk, high-price missions, the space agency decided to begin putting its eggs in many cheaper baskets. That strategy has paid off, although it began with the success of the Mars Global Surveyor mission, which reached Mars orbit in September 1997, before the two 1999 failures.

Why does Mars draw so much attention? Because it is the only other planet in the solar system that seems capable of having once supported life. If it never had canals, it shows many signs of having at one time been home to large seas and great lakes. Thanks to the work of recent years, we now know that water still exists on Mars, that clouds of water vapor cling to its mountains, that there are ice deposits beneath the planet's surface. Those discoveries have come as the result of six separate, successful missions that

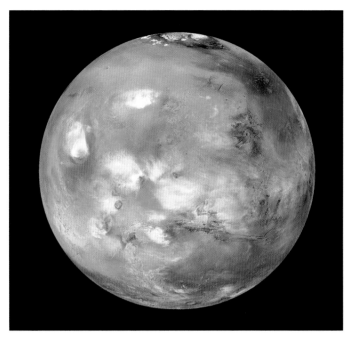

LEARNING THE NEIGHBORHOOD *Above, Mars has been called the "Red Planet" since astronomers with early telescopes first saw the reddish hue conferred by the large amounts of iron oxide on its surface. Below is a landscape panorama made by the Spirit rover in the winter of 2006, while it sojourned in a place called Winter Haven, with its solar panels pointed toward the sun. Scientists gave informal names to geological features, many of which commemorate the early explorers of the Antarctic*

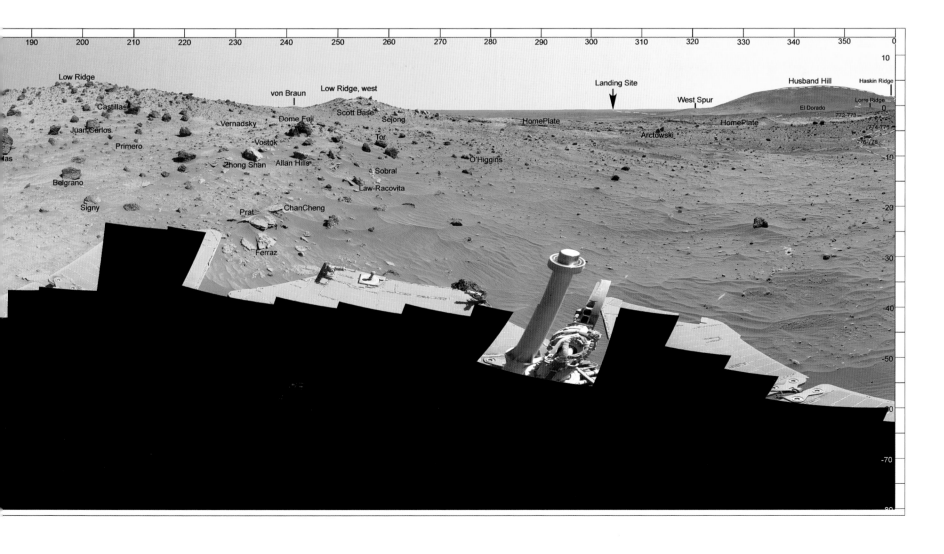

have put the "curse" of exploring Mars firmly to rest. As of May 2009, a swarm of advanced probes was hard at work on the mapping of Mars: three were in orbit and two were on land, while a polar lander's valuable mission had concluded in November 2008.

Exploring the Surface: A Trio of Landers

The twin robotic ships Spirit and Opportunity landed on the Red Planet in January 2004 with an expected life-span of 90 days. Yet they have chugged along ever since—surviving paralyzing cold, blinding dust and long periods without sun, all of which occasionally left them silent and still, but only until conditions improved and they shook off the dust, stirred to life and puttered off to do more work. The rovers, now beloved legends, have revealed more about Martian history than any other spacecraft in a half-century of space exploration.

The dune buggy–size vehicles are the latest of NASA's family of Mars rovers, descendants of the 2-ft. (.6 m) -long Sojourner craft, which arrived on Mars in the summer of 1997. Like its bigger siblings, Sojourner came with only a very brief factory warranty—just 30 days—and like its bigger siblings, easily exceeded it, operating for five months before finally surrendering to the Martian elements. (NASA tends to lowball these estimates, making it more likely that the machines will perform better than advertised—and that taxpayers will feel as though they're getting their money's worth.) Still, when flight controllers on the rover teams began reporting for work in January 2004, few thought they'd be doing the same jobs in January 2009.

The rovers were launched atop separate boosters. Spirit left Earth on June 10, 2003, and Opportunity followed on July 7. After seven months in transit, Spirit landed first, bouncing down in a swaddle of air bags in Mars' Gusev Crater. Opportunity followed three weeks later, landing on the other side of the planet in what is now known as Eagle Crater. The two spots were chosen for a very good reason. Despite the caps of ice in Mars' polar regions and the deposits of ice we now think lie beneath the soil, the planet is a desiccated place. But that doesn't mean Mars wasn't once wet, and its topography—scarred with what appears to be ancient river channels and dry seabeds—suggests that the planet once fairly sloshed with water. If you want to find signs of ancient life, the key is to follow that water—or at least the places it used to be.

Spirit and Opportunity did just that, aiming for vast basins that have the look of land that was once submerged. Spirit soon uncovered evidence of salts in the soil, a substance that would have been abundant in Martian seas, just as it is in Earth's. Opportunity discovered deposits of BB-sized pellets—which NASA nicknamed blueberries—that are rich in hematite, a mineral that forms only in watery environments. And by pure serendipity, in 2007 a balky wheel on Spirit dug a shallow trench in the ground, revealing the presence of white silica, another sign of water. So far, neither rover has uncovered hard evidence of life, but their findings haven't ruled it out either.

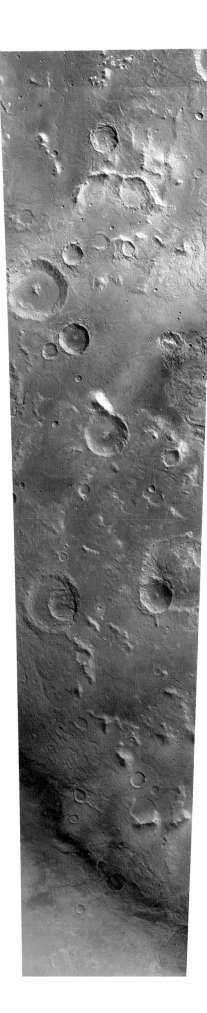

COLORFUL CRATERS *At left is a photo of impact craters taken by the Mars Express Orbiter in 2006 in the Red Planet's southern highlands region. Most of the top of the image is the extensive land mass Tyrrhena Terra. Near the bottom, the lip of the planet's largest impact crater, Hellas, runs diagonally across the picture*

WIND AND SAND *At top right is a striking image of bright ripples and dark dunes of Martian sand, taken by the Mars Reconnaissance Orbiter at Proctor Crater*

EMINENT VICTORIAN *At bottom right is a photo montage of Victoria Crater, including the dramatic promontory called Cape Verde. The imposing cliff of layered rocks is about 165 ft. (50 m) away from the rover and is about 20 ft. (6 m) tall. The taller promontory beyond that is about 325 ft. (100 m) away. This is an approximately true-color rendering of images taken by the panoramic camera on the rover Opportunity in 2006. Victoria Crater is in the Meridiani Planum, near the planet's equator*

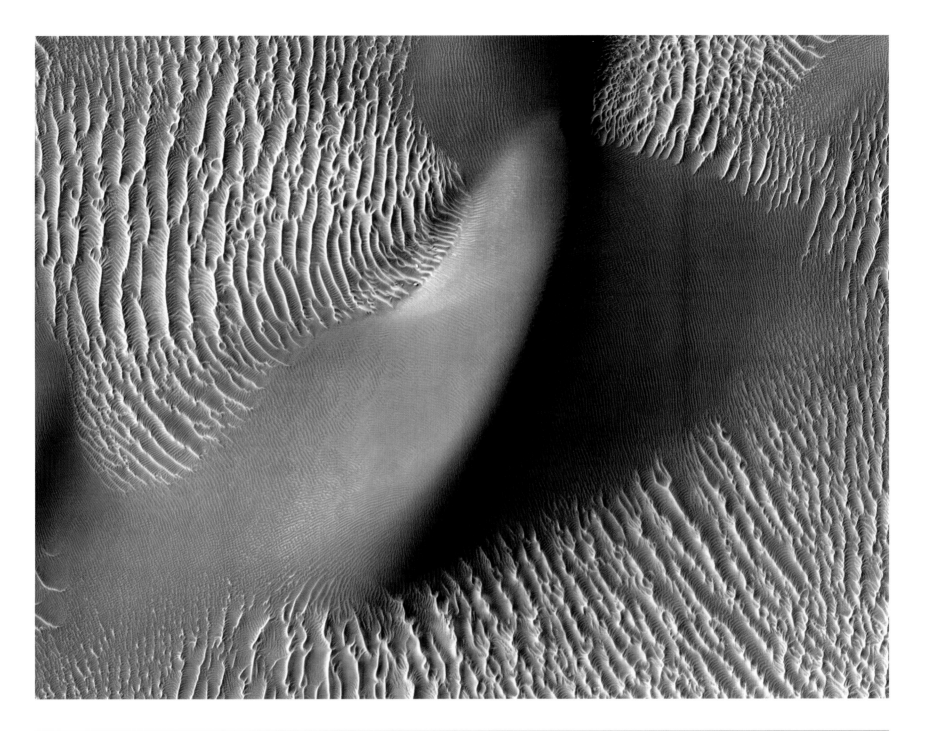

Spirit's busted wheel is not the only lame limb on the aging rovers. Opportunity's robotic arm—which carries many of its exploration tools, including its rock drill—has what amounts to an arthritic elbow; it toddles along with a sort of perpetual salute. Spirit itself has been reduced to driving backward, dragging its broken wheel in the soil as it moves along. As of late May 2009, its wheels were dug into the soil up to its hubcap near the Goddard Crater, and attempts to free the rover were still in progress; the craft may be retired by the time this book reaches print. Opportunity was moving slowly toward its new goal, the Endeavour Crater, some 7 miles (11 km) away; the journey could take two years, if the rover survives.

On May 25, 2008, NASA's Phoenix polar lander joined the two rovers on the surface; it touched down near the North Pole to search for ice deposits beneath the surface. Within two months, Phoenix confirmed that there is indeed water ice on Mars, but unlike the two rovers, Phoenix conked out on schedule when the North Pole entered the winter season and the lander no longer had enough solar power to run its equipment.

ABOVE THE PLANET, EYES IN THE SKY

Before and after Spirit and Opportunity began their close encounters with the surface of Mars, orbiting probes were conducting the large-scale mapping and measuring of the planet. First up was the Mars Global Surveyor, whose main camera took hundreds of thousands of images over 10 years, mapping the entire surface. Next was the European Space Agency's (ESA) small probe Mars Express, which continues to search for water beneath the surface with a special imaging device built by NASA. But the Express mission's attempt to land a probe, the Beagle 2, failed when it did not transmit data after it touched down on the surface of the planet.

Two satellites, Odyssey and Reconniassance, were hard at work in 2009, performing highly successful missions. NASA has teamed up with the University of Arizona on the Reconnaissance mission, and the satellite continues to take the finest high-resolution pictures ever made of the planet. And the Odyssey orbiter has been as much a workhorse as the two rovers; it went into Mars orbit late in 2001 and is still training two of its three instruments on the planet. In May 2002, NASA reported that Odyssey's gamma-ray spectrometer had recorded large amounts of hydrogen at the South Pole, indicating there was water ice close beneath the surface. That prediction was confirmed by the Phoenix lander in 2008.

The mapping of Mars continues. It may not star John Carter, but when you've got a cast that features Spirit and Opportunity, you don't need fiction to spice up your science.

MISSIONS TO MARS: 1996-2009

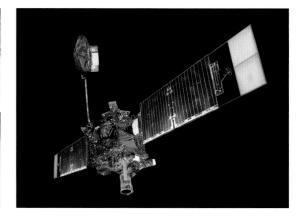

MISSION: Mars Global Surveyor
LAUNCH: 11/7/96
COST: $219 million
STATUS: After four extensions, mission ended on 11/2/06

OVERVIEW: *Ushered in the new era of Mars study after a 10-year hiatus; designed to map the planet from polar orbit and to search for signs of water and geological activity. The craft took images of apparently fresh gullies indicating water may still flow on the surface of Mars. Picture: contrasting shots of a crater in the Terra Sirenum section in 2001 and '05 show new gullies have formed*

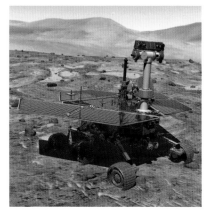

MISSION: Spirit and Opportunity Rovers
LAUNCH: Spirit: 6/10/03; Opportunity: 7/8/03
COST: $800 million
STATUS: Now past five years of service and still (barely) ticking

OVERVIEW: *Landers designed to study rocks, soil and minerals on the surface; to explore geological processes; and to search for past and present signs of water. Mission extended five times as of 2009. Picture: spherules of hematite, dubbed "blueberries," were found by Opportunity in the Meridiani Planum, 2 miles (3.2 km) south of the equator and are strong evidence of past water on the surface*

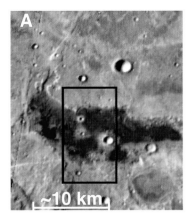

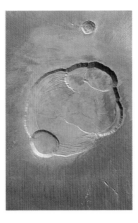

MISSION: Mars Odyssey
LAUNCH: 4/7/01
COST: $297 million
STATUS: Mission extended three times; now slated to end 9/10

OVERVIEW: *Designed to search for water and volcanic activity as well as minerals. Serves as advanced communications link to send data from rovers Spirit and Opportunity. On extended service, it is measuring year-to-year changes in Martian climate, especially at polar ice caps and in clouds and dust storms. Picture: salt deposits (blue) recorded by Odyssey's thermal imaging system*

MISSION: Mars Express Orbiter
LAUNCH: 6/2/03
COST: $350 million
STATUS: Mission extended twice; slated to end on 12/31/09

OVERVIEW: *The ESA orbiter searches for water and signs of past or present life. It carried a small lander, the Beagle 2, which was released on Dec. 19, 2003, but failed to maintain contact. Partner NASA operates its MARSIS device, a subsurface radar beam that searches for water. Picture: Express photo of the caldera of the Olympus Mons volcano, which towers 14.3 miles (23 km) above ground*

MISSION: Mars Reconnaissance Orbiter
LAUNCH: 8/12/05
COST: $720 million
STATUS: Misson slated to end on 12/31/10; may be extended

OVERVIEW: *Designed to search for water on Mars, it carries powerful cameras and has advanced telecommunications that allow it to send messages to and from rovers on surface. HiRISE (High Resolution Imaging Science Experiment) camera has sent the most detailed pictures of Mars yet taken. Picture: erosion patterns indicate water may once have flowed on the planet's surface*

MISSION: Mars Phoenix Lander
LAUNCH: 8/4/07
COST: $417 million
STATUS: Service ended as planned, on 11/2/08

OVERVIEW: *Landed near planet's North Pole to study ice deposits beneath surface with robot arm and scoop. On 7/31/08, Phoenix made history by confirming presence of water ice on Mars; it went out of service when Mars' winter halted solar power. Pictures: left, a false-color shot of the "Snow White" trench shows frost forming; right, Phoenix took its own picture, with solar panels deployed*

SPOTTED ON THE SUN: TORNADOES, TWIN FLARES AND STARQUAKES

The giant magnetic storms created by the sun may be the cause of the enchanting auroras that shimmer over Earth's polar regions, but they also pack a punch. When these streams of radiation bombard the Earth, they can penetrate even the miles of atmospheric gases that compose the planet's barrier of air to play havoc with power systems, communications devices, satellites and travel. "When airplanes fly over the poles during solar storms, they can experience radio blackouts, navigation errors and computer reboots—all caused by space radiation," says Steve Hill of NASA's Space Weather Prediction Center. Solar storms can also disable satellites used for weather forecasts and GPS navigation. Radio bursts from solar flares can directly interfere with cell phone reception. And when coronal mass ejections—gigantic emanations of radiation—plow into Earth, they can cause electrical power outages. "The most famous example is the Quebec outage of 1989, which left some Canadians without power for as much as six days," says David Hathaway of NASA's Marshall Space Flight Center.

Seeking to understand the workings of the star that powers life on Earth, NASA and European Space Agency (ESA) scientists launched the Solar and Heliospheric Observatory (SOHO) into solar orbit on Dec. 2, 1995. Built in Europe, the craft carries an array of 12 instruments that continue to map, record, analyze and monitor solar activity, enormously increasing our knowledge of the closest star.

On Jan. 4, 2008, SOHO recorded an event solar scientists had been eagerly anticipating: the appearance of a reverse-polarity sunspot high above the latitude of the sun's equator. Sunspots are magnetic storms on the surface of the sun, and the reversal of magnetic polarity in this case indicated the start of a new 11-year solar cycle. Such cycles follow predictable patterns: starting slowly, they build within three to four years to a climax of intense solar activity, which is followed by a longer period of deceleration. In the early phases of a cycle, sunspots appear high above the latitude of the solar equator, and as the cycle wears on, more spots begin to occur closer to the equator. The last cycle peaked with a furious burst of activity around 2000-02, then declined gradually. After the first reverse-polarity spot appeared in January, 2008 was a very quiet year on the sun. The new cycle is expected to peak in 2012, when auroras in both of earth's polar areas promise to be breathtaking—and their interference with communications and power grids promises to be aggravating.

Among other revelatory discoveries from SOHO's groundbreaking mission: the sun is home to massive tornadoes that form funnels spinning at 310,685 m.p.h. (500,000 km/h. And in 2008, SOHO confirmed a 30-year-old theory that massive solar flares can set the surface of the sun oscillating, rippling in waves that scientists have dubbed a "starquake."

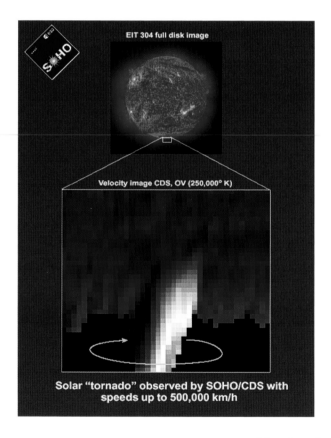

SOLAR STORM *In 1998, SOHO scientists announced that the craft had recorded tall, spinning storms on the surface of the sun, as shown in the image above. The storms appear most frequently at the North and South Poles of the sun, and a single such solar tornado can easily surpass the size of Planet Earth. The speed of the gyrating funnels can reach 310,685 m.p.h.*

At right, the SOHO craft recorded a rare occurrence on March 18, 2003, as two giant prominences shot out from the sun's surface. Prominences are large clouds of relatively cool, dense plasma suspended in the sun's hot, tenuous corona. These shapes extend out from the star to a distance equal to the girth of 20 Earths

Astonishing Auroras: Magnetic Rope Tricks

No sight on our planet is more dazzling than the ethereal auroras, which sweep across the skies of regions near the poles, delighting viewers with vast emanations of light that can swirl and dance, ripple like a shimmering curtain or form long beams like those of a flashlight. The origin of these natural marvels, which illuminate the thermosphere, the upper region of Earth's atmosphere, was determined in the early 20th century primarily by Norwegian physicist Kristian Birkeland. He explained the lights as the result of the collision of charged particles released by the sun with Earth's magnetic field, which is strongest at the poles. Scientists have long understood that the auroras peak during periods of high solar activity, as additional charged particles, or plasma, are released by the star into the stream of energy that is called the solar wind.

Our understanding of the nature of the aurora borealis (northern lights) and aurora australis (southern lights) is continuing to evolve, with a number of significant discoveries coming in recent years, thanks to NASA's THEMIS mission (Time History of Events and Macroscale Interactions during Substorms). In this project, NASA launched a fleet of five satellites in February 2007 to observe the auroras from space and linked the satellites to a network of cameras in 20 observatories on the ground in Canada and Alaska. In August 2007, NASA released the first findings from the mission, which confirmed the existence of giant magnetic formations that connect the sun and its third planet. "The satellites have found evidence of magnetic ropes connecting Earth's upper atmosphere directly to the sun," says David Silbeck, a project scientist for the mission at NASA's Goddard Space Flight Center in Maryland. "We believe that solar wind particles flow in along these ropes, providing energy for geomagnetic storms and auroras." Silbeck describes the "ropes" as twisted bundles of magnetic fields similar to nautical lines. Such magnetic formations can be almost as wide as Earth itself, the THEMIS satellites found, forming and unraveling in just a few minutes to provide a brief but significant conduit for solar wind energy.

The THEMIS satellites also observed a number of powerful explosions created by the force of the solar wind as it plowed into Earth's magnetic field, creating a "bow shock" like the bow wave in front of a boat. NASA scientists found that the auroras moved twice as fast as they had previously thought possible, crossing an entire polar time zone, or 400 miles, in 60 seconds. As they decipher the secrets of the auroras, scientists hope to be able to better predict the intensity of magnetic storms, which can wreak havoc upon communications and power systems on Earth. But as with the well-known optics of the rainbow, no amount of discoveries will ever dim the splendor of the northern and southern lights.

LIGHT SHOW *The aurora borealis, or northern lights, fills the sky above Hammerfest, Norway. The frequency and intensity of the displays rise and fall according to the fluctuations of the 11-year cycle of solar activity*

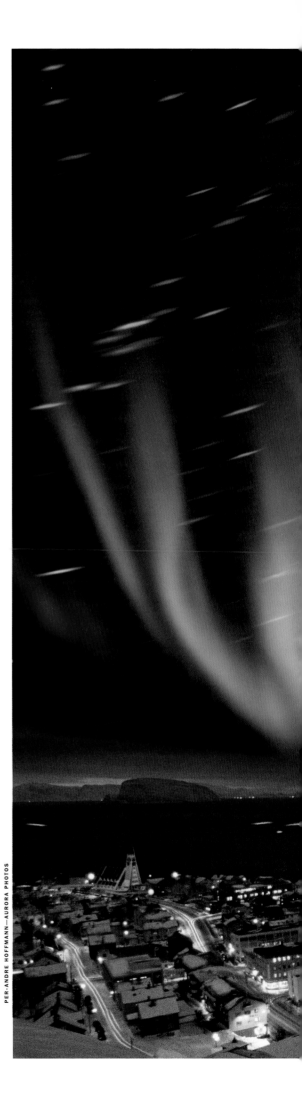

PER-ANDRE HOFFMANN—AURORA PHOTOS

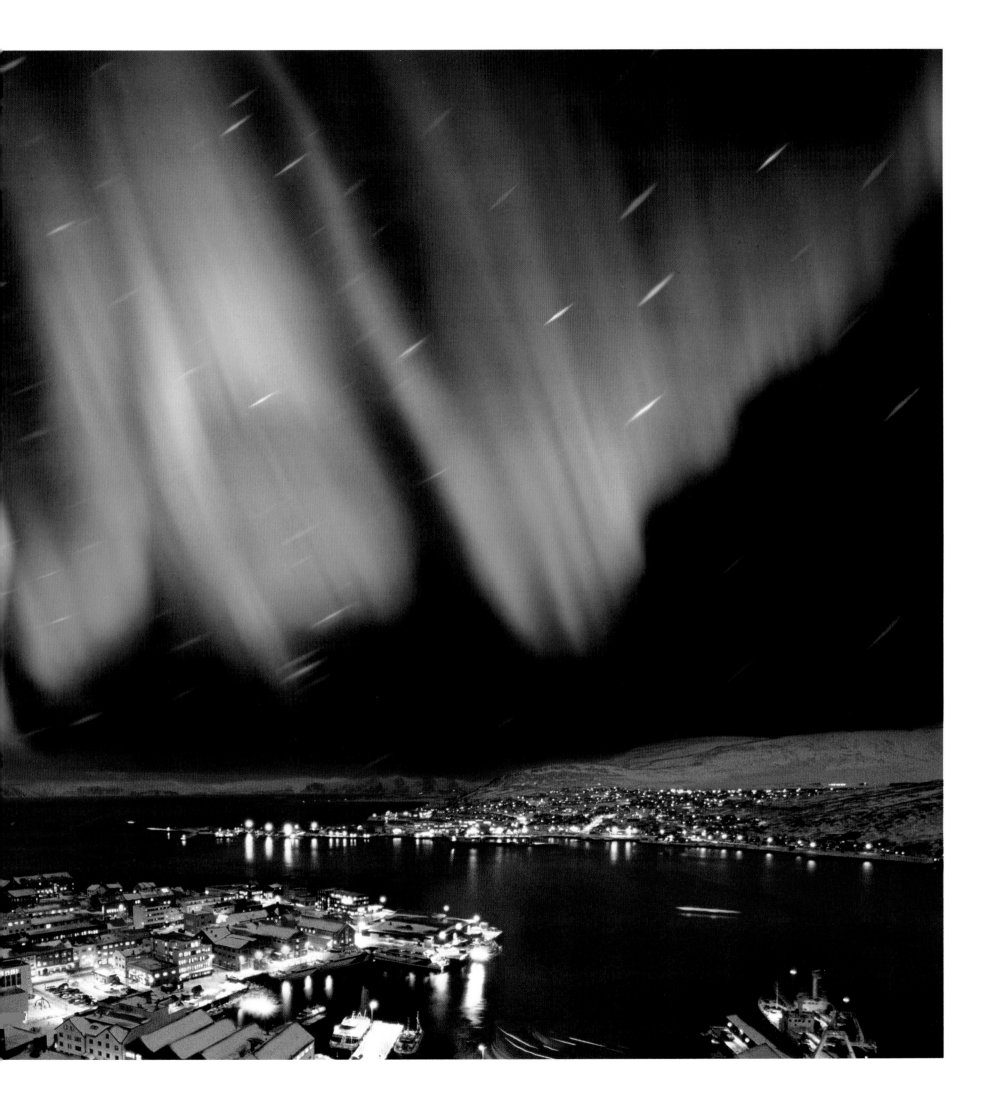

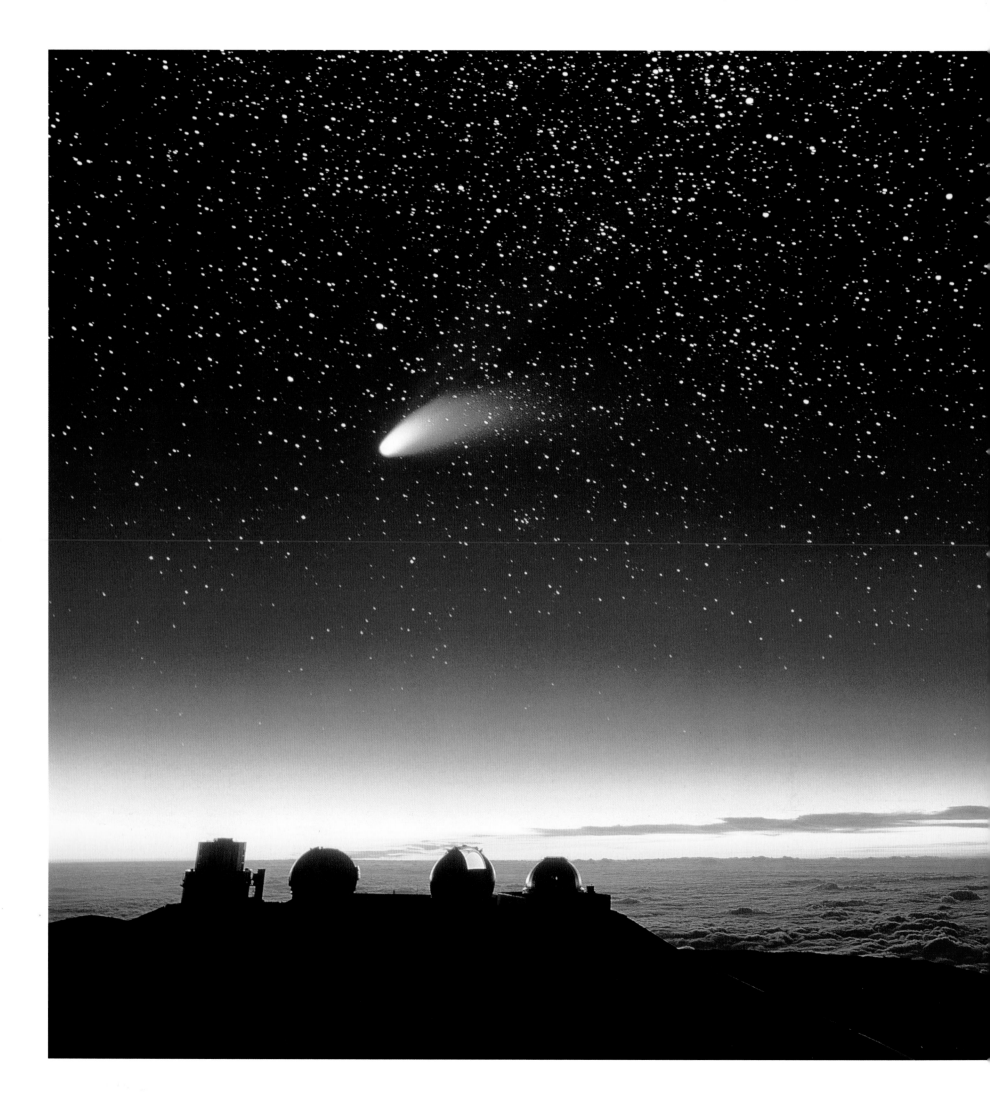

WONDERS OF THE HEAVENS, SCOURGES OF EARTH

Comets are welcome interlopers in Planet Earth's skies, where their luminous trails enthrall both learned astronomers and amateur skygazers. Some comets make surprise appearances and are named for the lucky earthlings who first spot them, like Hale-Bopp and Shoemaker-Levy 9. And some, like the famed voyager named after British astronomer Edmund Halley, are periodic comets that keep regular appointments: Halley's Comet will next be visible from Earth in 2061. Periodic comets are our fellow travelers around the sun, and in the past century we have learned a great deal about them. In 1950 Harvard University professor Fred Whipple first posited that comets could be compared to "dirty snowballs," whose frozen water vapor and gas are heated up as their orbits bring them close to the sun, leaving the long trails of dust and gases that are their signature scrawl. And thanks to decades of study by modern astronomers, we now know that most periodic comets are Trans-Neptunian Objects (TNOs), heavenly bodies that are aggregated in three large formations that lie beyond the orbits of Neptune and Pluto: the Oort Cloud, the Kuiper Belt and the "scattered disk." When a TNO is diverted from its location by gravitational tugs exerted by the outer planets, a nearby star or a large object passing through space and is placed on a solar trajectory, it becomes a comet.

In 1994 the entire world watched in wonder as Comet Shoemaker-Levy 9 broke into a "string of pearls" whose 21 fragments crashed into Jupiter in the most violent events ever witnessed in the solar system. It is precisely this scenario—the crash of heavenly objects into Earth—that has become one of the hottest frontiers of comet studies. Or, perhaps, the coldest frontier, for the latest news in this area comes from ancient ice-fields. In January 2009 astronomers at Columbia University's Lamont-Doherty Earth Observatory announced that they now believed that a comet's impact with the planet in the year A.D. 536 hurled clouds of dust and soil into the atmosphere, creating a "dry fog" that lasted for 18 months, making temperatures plummet and crops fail. The scientists found tiny balls of condensed rock vapor called "spherules" inside Greenland ice cores that dated to that year. The Columbia team has tentatively identified two craters whose age fits the timing of the global cooling event, one in Australia's Gulf of Carpentaria, the other in the North Sea near Norway. A similar but much more powerful collision is now widely believed to have led to the demise of the dinosaurs some 65 million years ago—although, as TIME reported in April 2009, some scientists are now questioning the currently accepted timeline for that event. But one conclusion remains unquestioned: comets, like the man-made fireworks that mimic them, are best enjoyed from a distance.

JUST PASSING THROUGH *Comet Hale-Bopp, one of the brightest comets of the 20th century, passes in front of four telescopes on Mauna Kea in Hawaii in 1997: from left, Subaru, Keck 1, Keck 2,* NASA *Infrared Telescope Facility*

Jupiter, Saturn and the Mysteries of Their Moons

The first years of the 21st century are proving to be exciting ones for planetary scientists. Even as NASA missions to Mars are revealing the secrets of the Red Planet, other NASA probes are bringing us fascinating new discoveries about the two mammoth planets that dominate the middle reaches of the solar system, Jupiter and Saturn. And it's not just the planets that are, um, stars: the moons that orbit them include some of the most geologically active and intriguing bodies in the solar system.

Jupiter and Saturn are systems unto themselves, each a majestic presence surrounded by courtiers. At least 63 moons, many of them quite small, orbit Jupiter, and more are likely to be found. Saturn is also surrounded by a flotilla of more than 60 moons. Both Jupiter's largest moon, Ganymede, and Saturn's largest moon, Titan, are larger than the planet Mercury. And Saturn's regal rings remain the most dazzling wonder of the solar system.

Jupiter's World

The discovery of the moons of Jupiter is a pivotal moment in the annals of astronomy. It was Galileo Galilei who peered through his rudimentary telescope in 1610 and first identified four moons orbiting the planet: Ganymede, Callisto, Io and Europa. More than 360 years later, close-up exploration of the Jovian system began with a series of NASA missions that kicked off in 1972, when the Pioneer 10 probe was launched on a direct flyby of Jupiter. A year later, Pioneer 11 was sent on course for a tour past both Jupiter and Saturn. The two ships performed flawlessly, sending back a travelogue of images in the mid-1970s that showed two worlds that were both remote and colorful—science and eye candy in every shot.

Next up were NASA's Voyager missions, a pair of probes launched in 1977. They reached Jupiter in 1979 and Saturn in 1980-81; the images of Saturn's rings they returned have become icons of space exploration. Some 15 years later, NASA's Galileo mission to Jupiter yielded a host of significant discoveries. Launched in 1989 and entering Jupiter's orbit in 1995, Galileo conducted an eventful and illuminating eight-year mission in the

JUPITER: NEW QUESTIONS At right, Jupiter's volcanic moon Io is shown in front of the planet in a composite photo based on images from the New Horizons probe in 2007. The image was taken in the infrared range, so Jupiter's famed Great Red Spot shows up as blue. Look closely at the Io picture, and a volcano can be seen erupting in the dark quadrant at the top right

This pair of images shows a new feature on the surface of Io photographed in 2008 by the New Horizons probe; it was not present on the photo at left taken by the Galileo probe in 1999. It is believed to be residue from an active volcano

Above, scientists were surprised in 2006 by the appearance of a smaller red spot below and to the left of Jupiter's famed Great Red Spot, as recorded by the Hubble Space Telescope; it was dubbed Red Spot Jr. The formations are believed to be enormous storms on the surface of the planet

RIGHT: LABORATORY/SOUTHWEST RESEARCH INSTITUTE/GODDARD SPACE FLIGHT CENTER. LEFT, FROM TOP: NASA—JPL; NASA—JOHNS HOPKINS UNIVERSITY APPLIED PHYSICS LABORATORY—SOUTHWEST RESEARCH INSTITUTE; NASA/JOHNS HOPKINS UNIVERSITY APPLIED PHYSICS LABORATORY/SOUTHWEST RESEARCH INSTITUTE/GODDARD SPACE FLIGHT CENTER

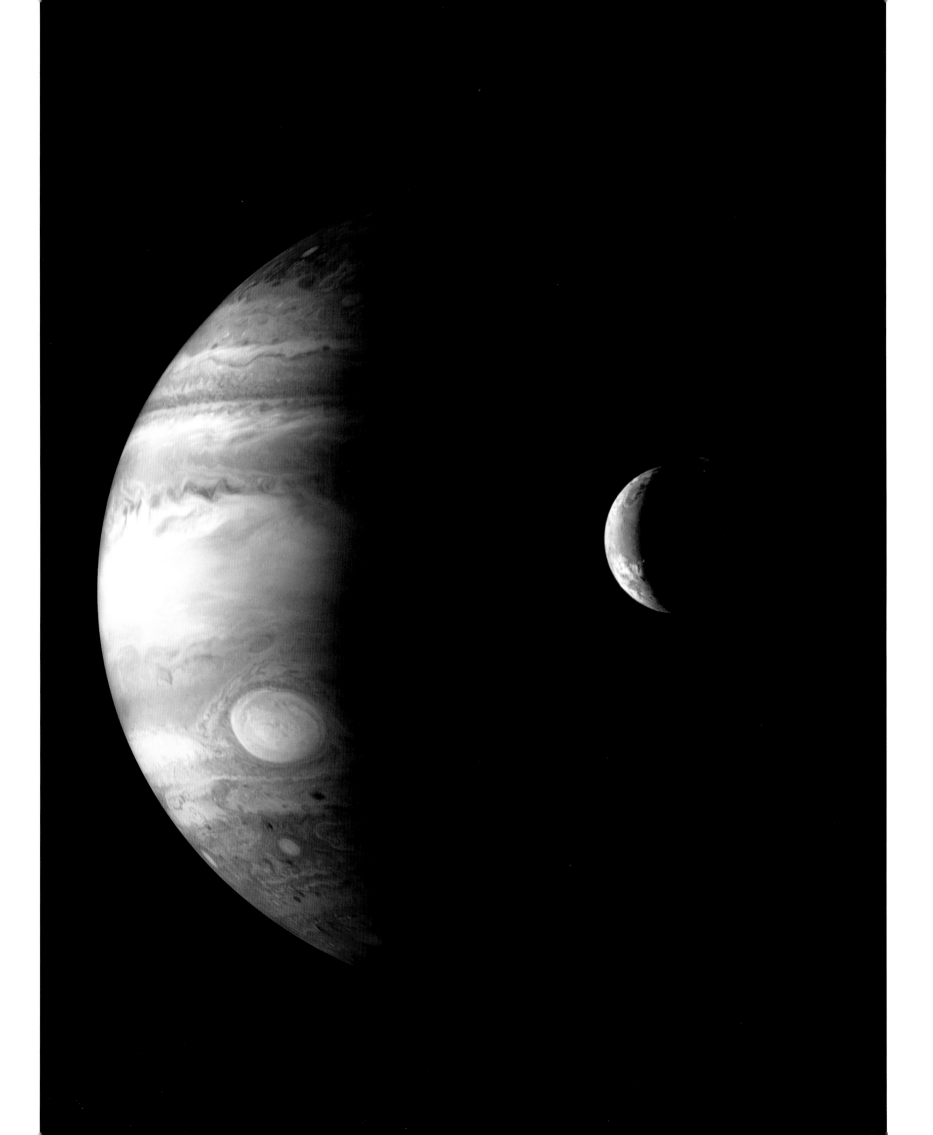

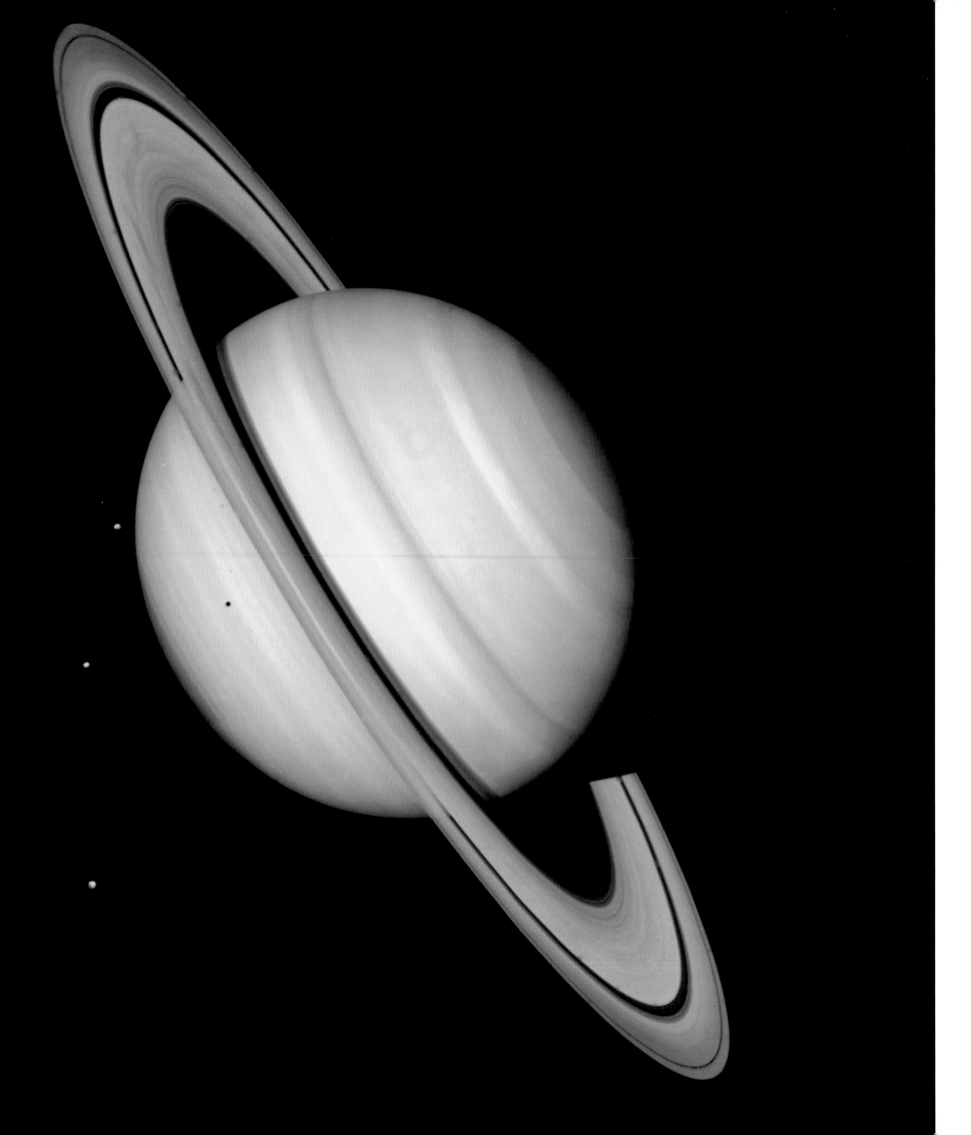

Jovian system. After NASA scientists cobbled together a patchwork fix that overcame communication glitches, Galileo provided revelatory information about the planet and its moons before the probe, its power spent, was sent on a suicide path into Jupiter in 2003. Galileo returned data until it collapsed and melted from pressure and heat.

Thanks to the Voyager and Galileo missions, scientists learned that Jupiter's moons Ganymede, Europa and Callisto probably have saltwater oceans beneath their surfaces; that Io is churning with volcanic activity far greater than that found on Earth; and that Io is also brimming with highly charged electrical activity. As of 2009, scientists are getting a chance to further explore the findings of earlier missions, thanks to the New Horizons probe, which was launched in 2006 on a mission to explore Pluto—and all points in between. The Hubble Space Telescope also continues to yield insights into the realms of Jupiter and Saturn—including a big surprise in 2006, when its cameras revealed that a second red spot had joined the famous Great Red Spot on Jupiter's surface. Both are believed to be giant storm systems.

SATURN'S WORLD

Like Jupiter, Saturn is bursting with mysteries, and NASA's Cassini orbiter, which was launched in 1997 and reached Saturn orbit in 2004, is seeking to unravel some of them. Its mission through the Saturnian system was first scheduled to end in 2008 but has been extended until 2010. On Jan. 14, 2005, the small (3-ft./1-m diameter) Huygens probe was released from Cassini and parachuted into the atmosphere of Saturn's largest moon, Titan, landing in a dark area that had been thought to be a hydrocarbon sea but turned out to be semisolid ground that NASA scientists described as "mud." Its cameras showed a landscape tinted orange by gasses and littered with forms scientists believe to be water ice. It also showed evidence of cryovolcanism—volcanic activity producing a mixture of water ice and ammonia rather than hot lava, as on Earth. The probe was able to broadcast for 90 minutes after landing before its batteries were exhausted.

On March 12, 2008, Cassini executed a dramatic dive through an icy geyser that reaches 950 miles (1,530 km) into space from the Saturnian moon Enceladus. Passing just 120 miles (190 km) above the moon's surface, Cassini sampled an icy exhaust that researchers didn't even know existed until the spacecraft spotted it in 2005. The ice is tantalizing to NASA researchers, for it hints at subsurface water and the attendant possibility of life. Other close-brush flybys followed, including an October 2008 high-wire plunge that dropped the spacecraft a scant 16 miles (26 km) above Enceladus' surface. By collecting particles from the plumes of gas and water vapor bursting out of Enceladus at approximately 800 m.p.h., scientists hope to better understand the composition of both the moon's interior and its surface. Cassini has already shown that water vapor and complex hydrocarbons are venting from the geologically active South Polar Region. The next question: Is there any liquid water—an essential component in supporting life—below the moon's iced surface? If the Cassini probe continues to function flawlessly, such questions may soon be answered.

LORD OF THE RINGS *At left, Saturn was photographed by Voyager 2 in 1981. Three moons are clearly visible: from top, Rhea, Dione and Tethys, whose shadow appears as a dot on the planet's surface. Below, three ongoing explorations of the Saturnian system*

Above, images of the moon Iapetus taken by the Cassini probe reveal sharp contrasts of darkness and light on the surface, which scientists have yet to explain fully

Above, a Hubble Space Telescope image from 1997 shows auroras circling Saturn's poles. In November 2008, new Cassini images showed auroras far larger than ever seen before, leading scientists to suspect that the planet's magnetosphere is more powerful than previously believed

Above, a close-up Cassini image of the surface of the moon Enceladus shows "tiger stripes" that have been seen to vent fumes of water and ice, suggesting volcanic activity below the surface. The grooves are estimated to be 490 to 900 ft. (150 to 300 m) deep

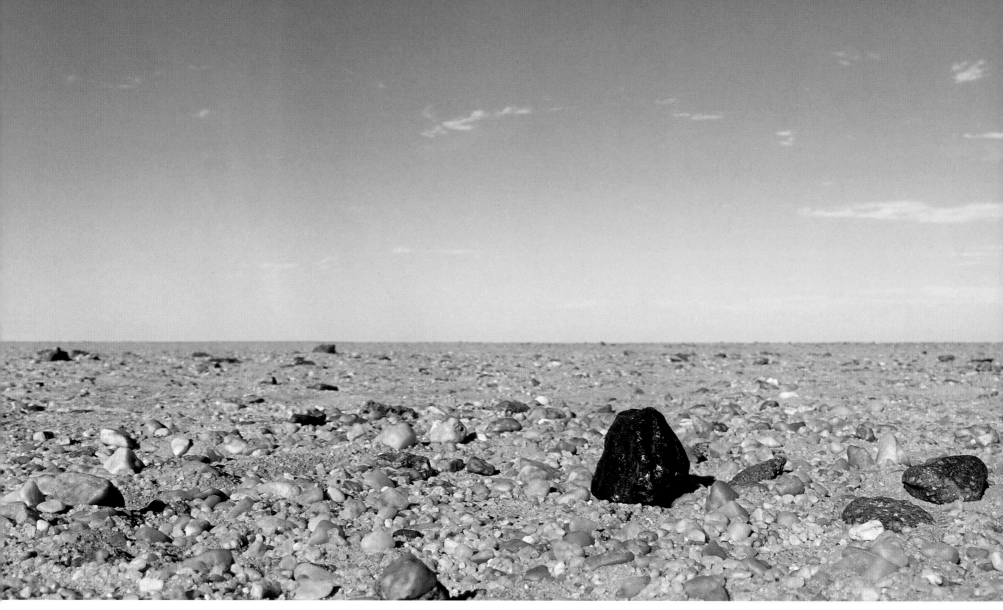

JUST DROPPED IN *The black rock in the foreground, resembling no other rocks around it in Sudan's Nubian Desert, fell to Earth on Oct. 7, 2008, and was retrieved in December*

CURRENT EXPLORATIONS

METEORITES: ENVOYS FROM DISTANT SPACES AND FARAWAY TIMES

You can think of meteors and asteroids as messengers from the far reaches of the solar system—or, a bit more prosaically, as simple space junk, hunks of rock that circulate through the heavens until they are captured by the gravity of a larger object and either enter into orbit around it or, more often, plow directly into it. When that happens on Planet Earth, the result can be a sublime spectacle: as meteors heat up and then disintegrate, they etch a sizzling scrawl across the upper reaches of the atmosphere. According to NASA, more than a million such small rocks enter Earth's atmosphere every day. When they hit ground, they are called meteorites; larger space rocks are called asteroids.

Some meteorites are interesting because of their place of origin; those traced back to Mars and the moon can provide valuable information about those bodies. These objects are parts of the surface of Mars and the moon, blasted into space when large meteorites smack into them.

Yet scientists are primarily interested in these so-called shooting stars as messengers in time as well as space. Many of these asteroid fragments have been traveling the heavens since the solar system formed, and they can harbor clues as to the conditions that prevailed at the time. Because meteorites absorb and record cosmic radiation, the time when they plowed into Earth can be measured, providing information about the development of our home planet.

And that leads to a question: If meteorites land all

across the surface of the planet, in which locations are they best preserved and most easily found? Answer: the polar regions and deserts. Both of these environments offer perfect conditions to be meteorite museums: minimal human intrusion, extreme weather suited to the preservation of mineral objects, the relative absence of airborne industrial pollutants, and landscapes that increase one's chances of spotting meteorites with the naked eye. Of course, those extremes of weather also make for challenging hunting.

Japanese scientists found the first concentrations of meteorites in the Antarctic in 1969, and since the 1970s, Japan and the U.S. have been in the forefront of the effort to retrieve them. The U.S. effort is led by ANSMET, the Antarctic Search for Meteorites, established in 1976 as a cooperative effort of NASA, the Smithsonian Institution and the National Science Foundation. The agency estimates its scientists have retrieved more than 16,000 extraterrestrial objects since the late '70s.

Two of those objects recently raised a fuss among space scientists. In early January 2009, ANSMET scientists announced in the science journal *Nature* that during their 2006-07 field season in a region of the Antarctic ice known as the Graves Nunatak icefield, they had retrieved two light-colored meteorites quickly recognized as being different from all previously known meteorites.

"What is most unusual about these rocks is that they have compositions similar to Earth's andesite continental crust—what makes up the ground beneath our feet," said the University of Maryland's James Day, lead author of the study. "No meteorites like this have ever been seen before." Andesite is an igneous rock common on Earth in areas where colliding tectonic plates generate volcanoes, such as those in the Pacific Ocean's Ring of Fire. The meteorites contain minerals thought to require large-scale processes such as plate tectonics to concentrate the right chemical ingredients, yet further study revealed that they most likely originated on an asteroid rather than another planet (or onetime planet) in the solar system. They were dated as being 4 billion to 5.5 billion years old, which would place their origin near the birth of the solar system as we know it. The scientists anticipate that further study of the composition of the two meteorites may help explain how Earth's crust formed as the planet took shape.

Meteorite hunters made history in 2008 at another extreme location: the Nubian Desert of north Sudan. On Oct. 6, telescopes of the automated Catalina Sky Survey in Arizona spotted an asteroid that scientists named 2008 TC3. At dawn of the next day, TC3 was seen arcing across the skies of Sudan. Astronomer Muawia Shaddad of the University of Khartoum, aided by NASA scientists, enlisted students and staff to comb the area for surviving fragments. On Dec. 6, 2008, only two hours after the search began, a meteorite was found. The team ultimately collected almost 300 small meteorites: the first time remains have been retrieved from an asteroid detected in space before crashing into Earth's atmosphere.

GRA 06128,0

METEOR TRAIL *At top is an* ANSMET *map showing the location of recent major meteorite finds in Antarctica. Further information on the Antarctic Search for Meteorites can be found on the* NASA *website*

ROCK STAR *The meteorite above, designated GRA06128, has shiny to glassy black patches of fusion crust, which scientists hope may help illuminate the processes by which Earth's crust took shape*

THE KEPLER TELESCOPE: SEARCHING FOR PORCH LIGHTS IN SPACE

Think you could stare at a single spot without blinking for 3½ years? Then be glad you're not NASA's Kepler Telescope, which blasted into space from Cape Canaveral, Fla., on March 7, 2009. Kepler's job may sound boring, but it's designed to accomplish something extraordinary: the discovery of the first Earth-like planets orbiting sun-like stars.

Humans have been looking for other planets ever since astronomers first turned telescopes to the sky. But once we got beyond the planets of the solar system, we had no luck. The problem is, stars are huge, and by comparison, even big planets are tiny. Squint all you want; you're not going to see them. That obstacle was overcome in 1995 when astronomers Michael Mayor and Didier Queloz discovered the planet 51 Pegasus b orbiting the eponymous star 51 Pegasus. The astronomers made their find not by spotting the planet directly but by measuring the minute gravitational wobbles it causes in its parent star as it orbits. With those scraps of data, they could calculate the planet's mass, velocity, orbital altitude and more.

That was big news if you were hunting for planets but no news at all if you were hunting for life. A planet with enough gravitational oomph to jiggle a star is probably a gas giant like Jupiter, orbiting so close to the fires of its sun that nothing living would have a chance. What biology needs in order to get going is a relatively small, rocky planet orbiting in what's called a star's habitable zone—a place where things get hot but not too hot, cold but not too cold. A temperate planet like Earth, in other words. By 2009, astronomers had counted a total of 342 planets orbiting 289 stars, but none of them is of the so-called terrestrial variety.

Kepler is designed to find them. It carries just one main piece of scientific hardware: an imager that detects fluctuations in light so tiny they're measured by counting the electrons they etch onto a silicon surface. This will allow Kepler to spot planets by the previously invisible change in luminosity they cause as their orbit carries them around the facing side of their parent star.

"If Kepler were to look down at a small town on Earth at night from space," says NASA's James Fanson, the Kepler project manager, "it would be able to detect the dimming of a porch light as someone passed in front." Still, to make any real discoveries, Kepler will have to look at a lot of lights on a lot of porches. With perhaps 70 sextillion stars in the universe (that's 7 followed by 22 zeros), the spacecraft can't possibly survey them all. Instead, it will sample about 100,000 in a region of our galaxy known as Cygnus-Lyra. That spot was chosen both because it's rich in stars and because it lies above our own orbital plane. Kepler—which was launched into not an Earth orbit but a solar orbit—can thus simply train its gaze up and never have to worry about any bodies in the home solar system blocking its view.

An unblinking look at Cygnus-Lyra is important because even if Kepler were to detect any telltale fluctuations in stellar light, it would have to keep looking and see if the flickering is repeated roughly once a year, or about the time it would take an Earth-like planet to circle around its star and pass in front again—hence the 3½-year mission.

Even a few sightings can tell us much. Spot a handful of Earth-like planets among 100,000 stars, then factor up to 70 sextillion, and you've got whole lot of warm, cozy worlds potentially cooking up a whole lot of life. On one of those worlds, someone may even be looking back as our own planet passes in front of the porch light of our sun.

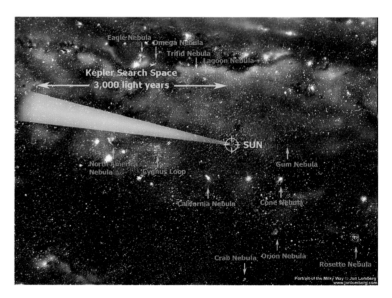

FIELD OF VIEW *Kepler will focus its gaze on a relatively small swatch of the sky, an area in the Cygnus-Lyra region of our Milky Way galaxy*

PLANET HUNTER *Designed to serve one purpose—the search for Earth-style planets friendly to life in other solar systems—Kepler is a relatively small spacecraft at about 12 ft. (3.6 m) in length. Above, workers put finishing touches on the telescope at a service facility in Titusville, Fla., before its launch from nearby Cape Canaveral*

ZOOMING IN *Kepler's entire field of view, above, is about the size of two dippers of the familiar Big Dipper formation. Two regions are expanded*

ZOOMING DEEPER *In this image, Kepler has focused in further on the quadrant at top left of the previous image, where a planet, TrES-2, had previously been found orbiting a star*

Index

Index